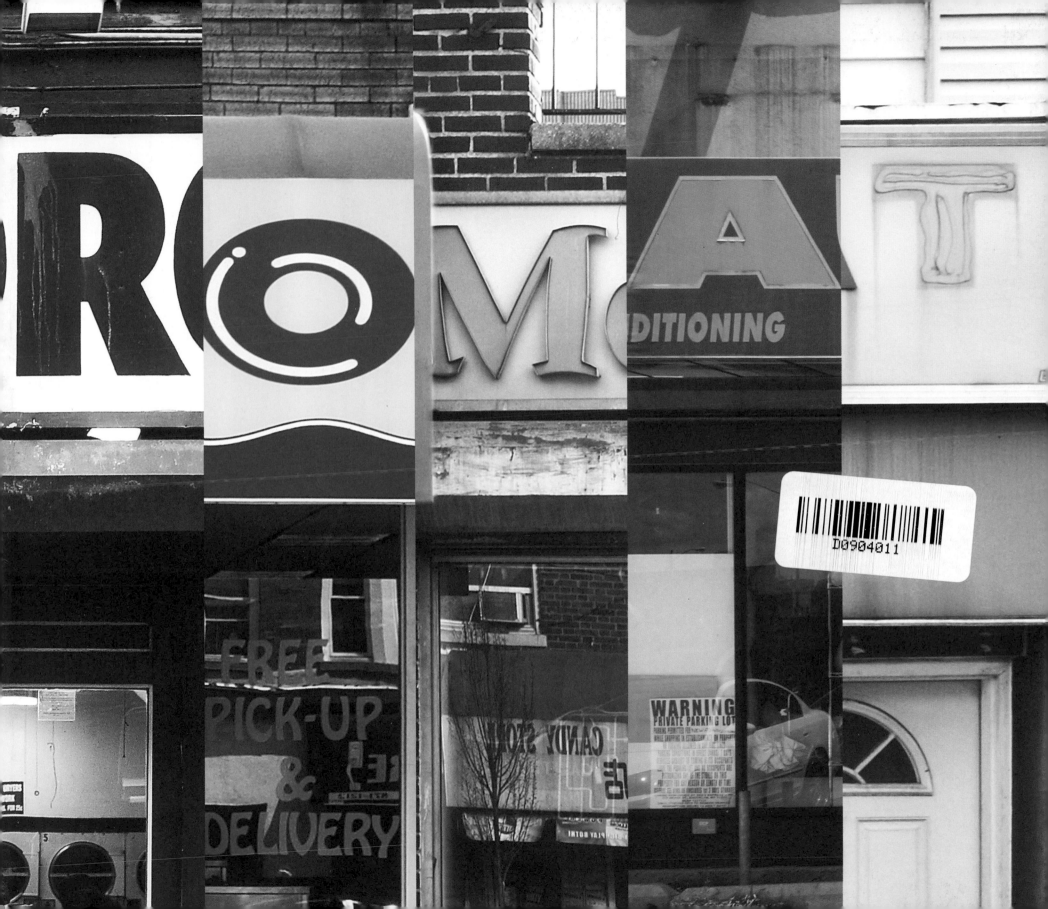

LAUNDROMAT

SNORRI BROS.

pH powerHouse Books
BROOKLYN, NY

CONTENTS:

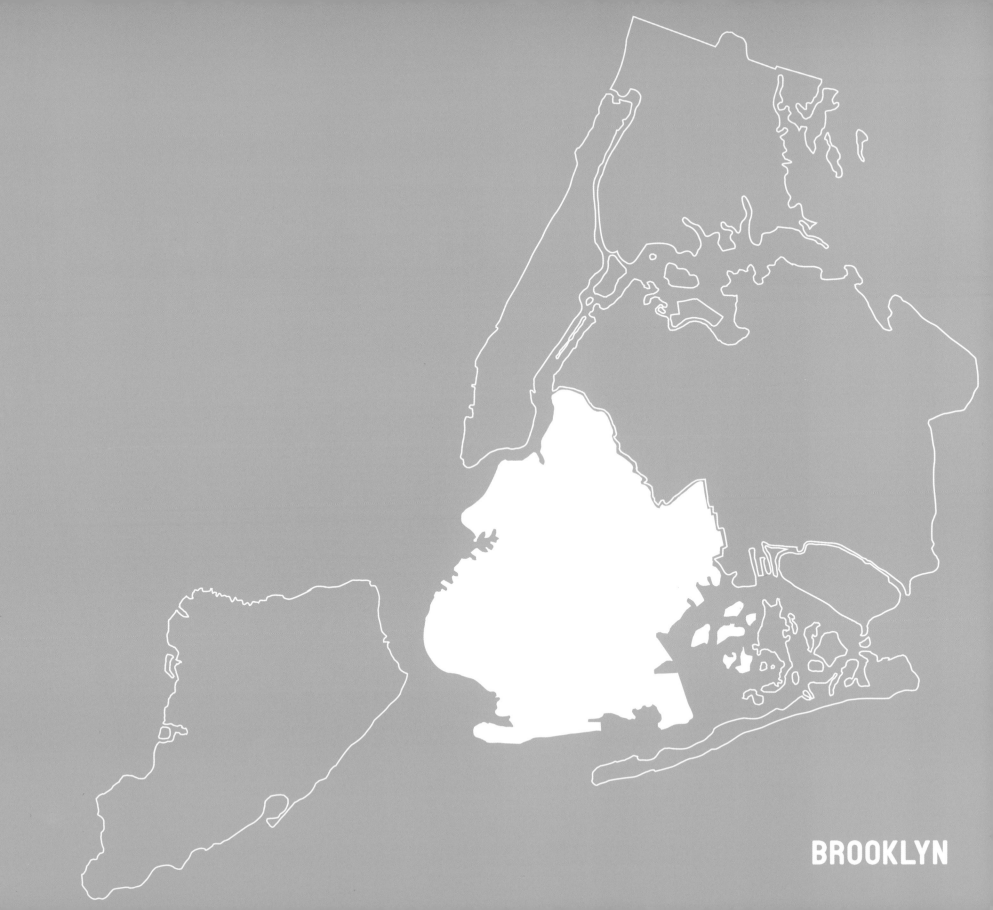

BROOKLYN

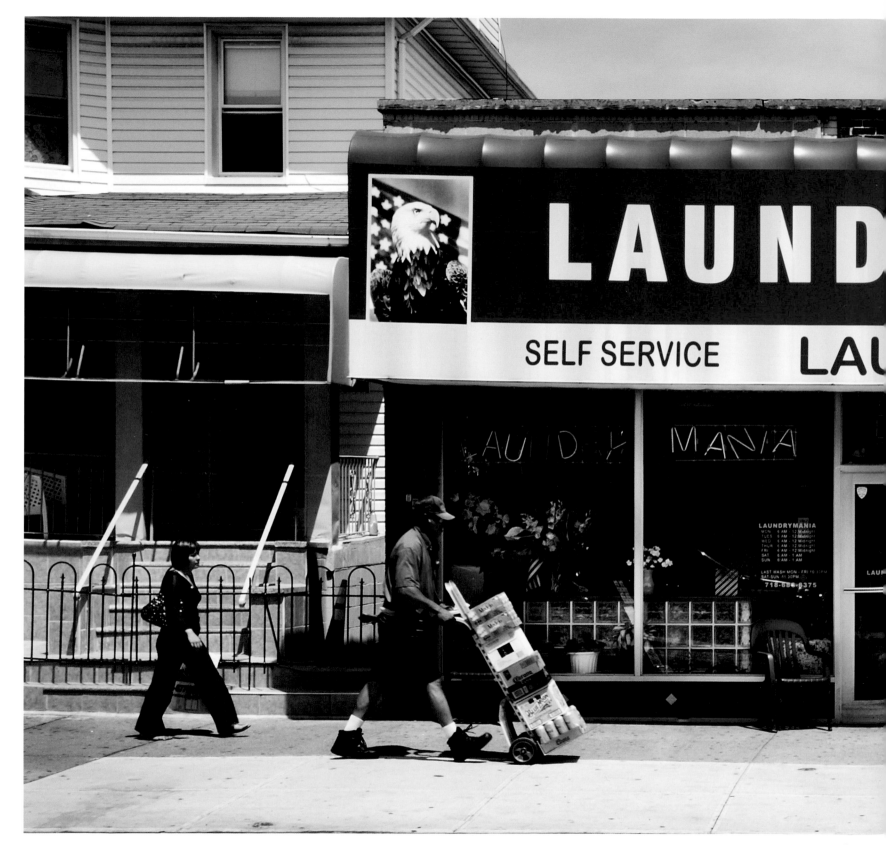

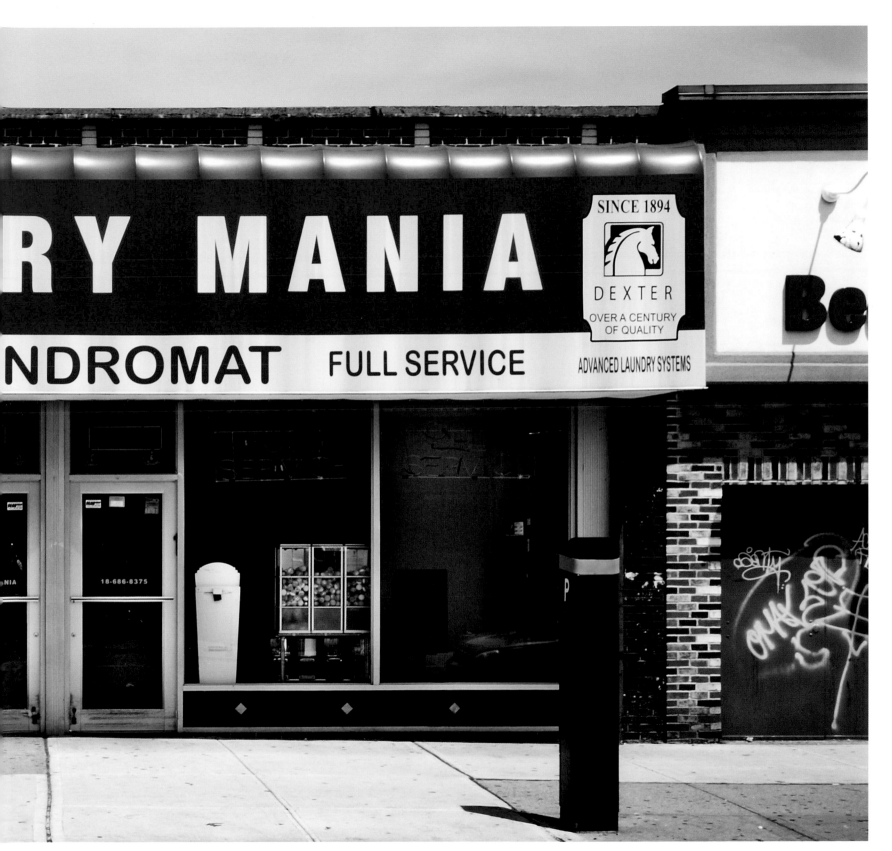

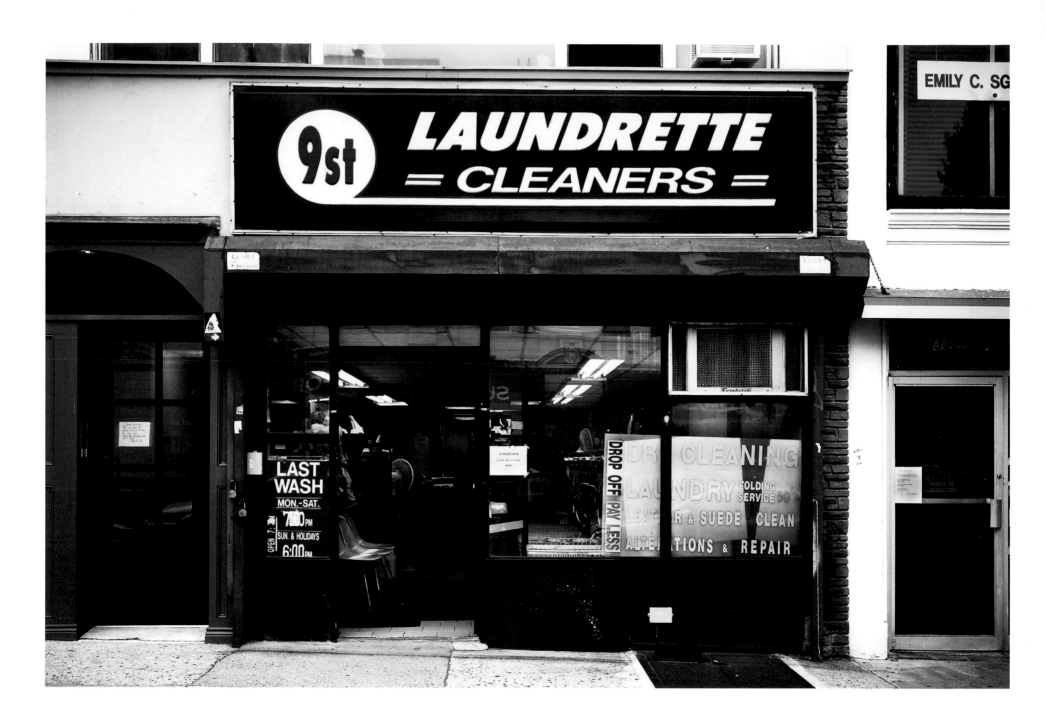

332 9th Street

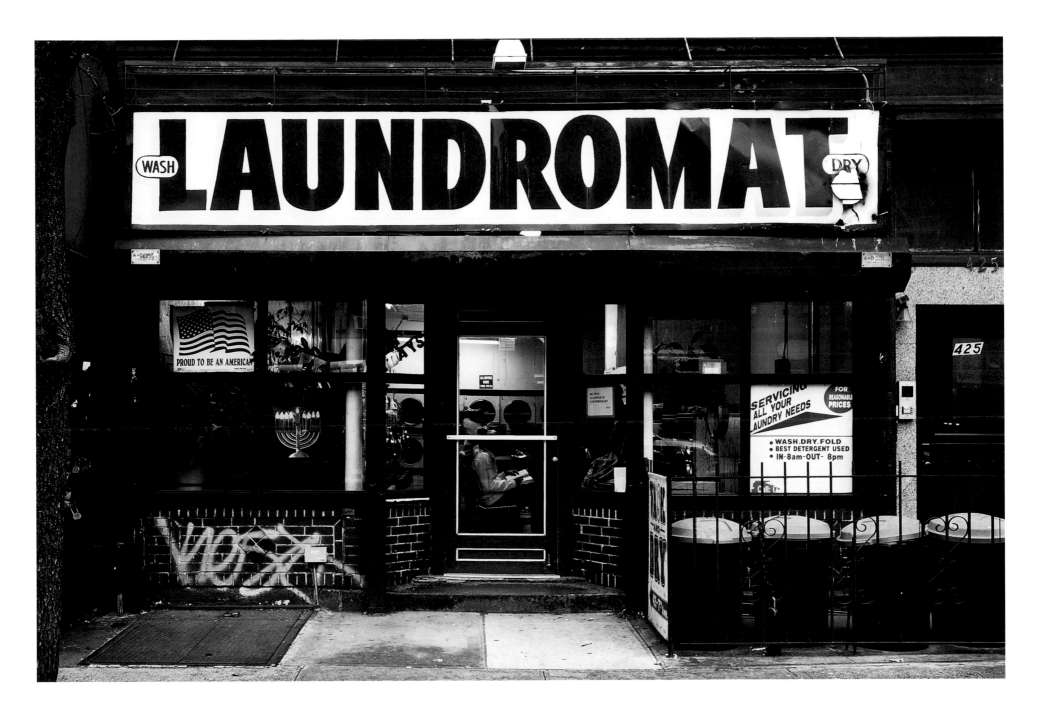

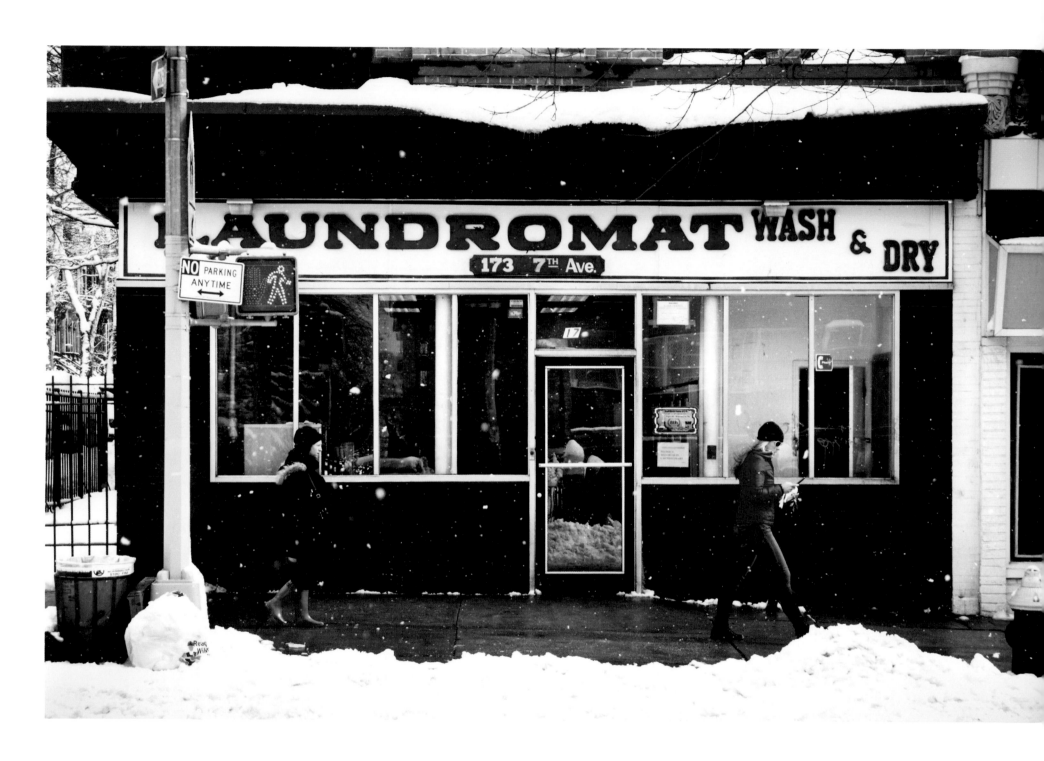

173 7th Avenue

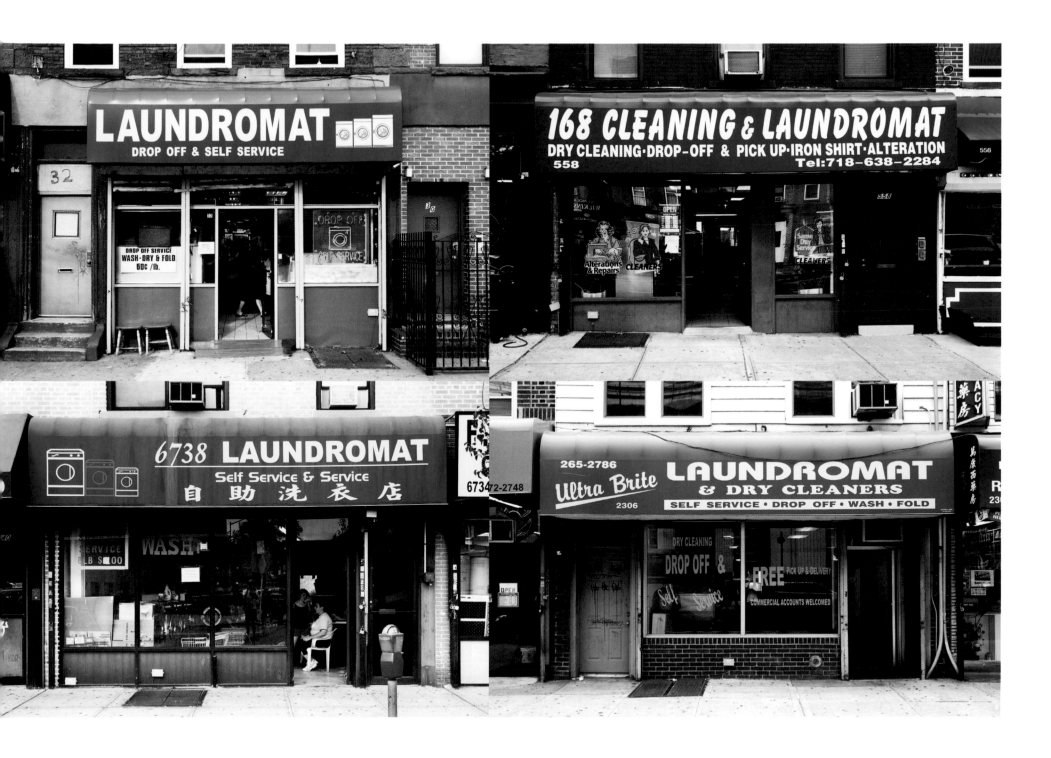

32 Rockaway Avenue

6738 5th Avenue

558 Vanderbilt Avenue

2306 86th Street

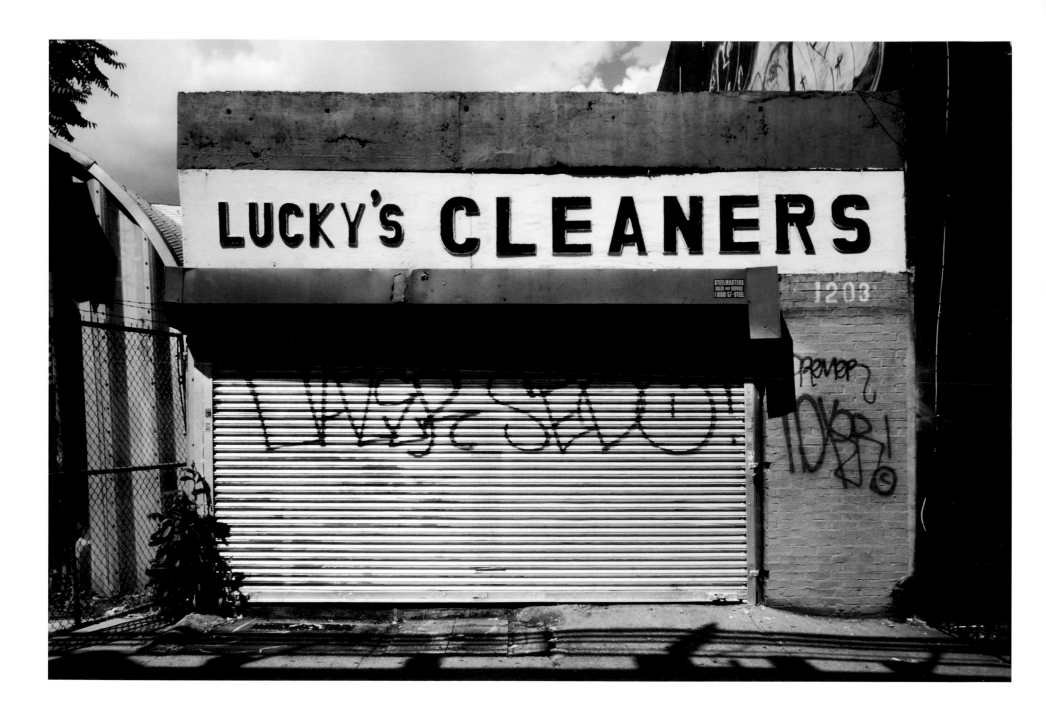

1203 Broadway

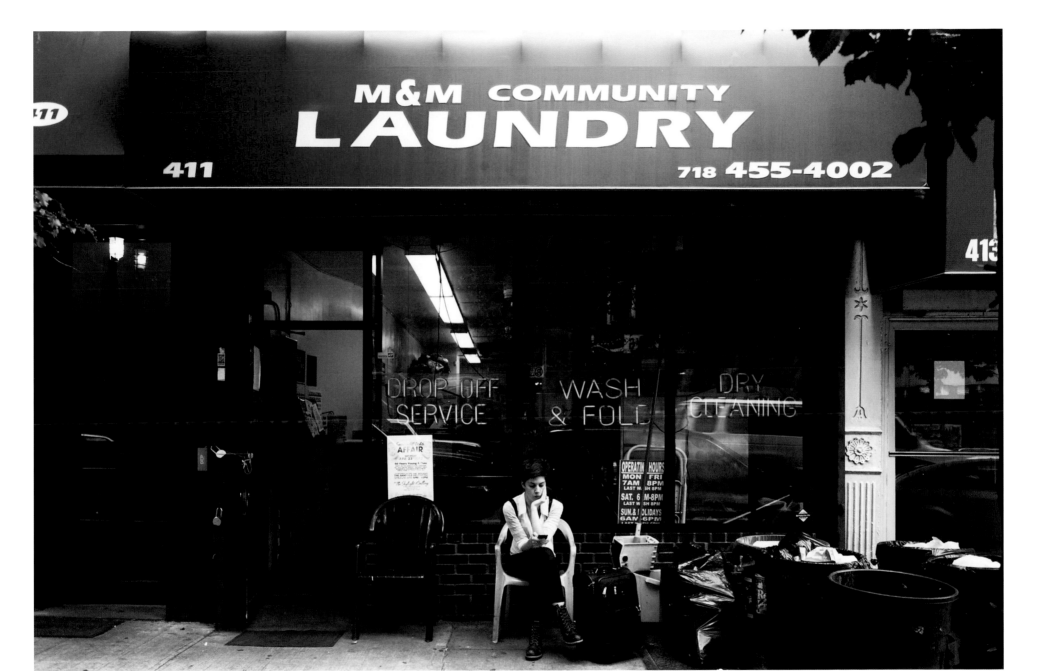

411 Tompkins Avenue

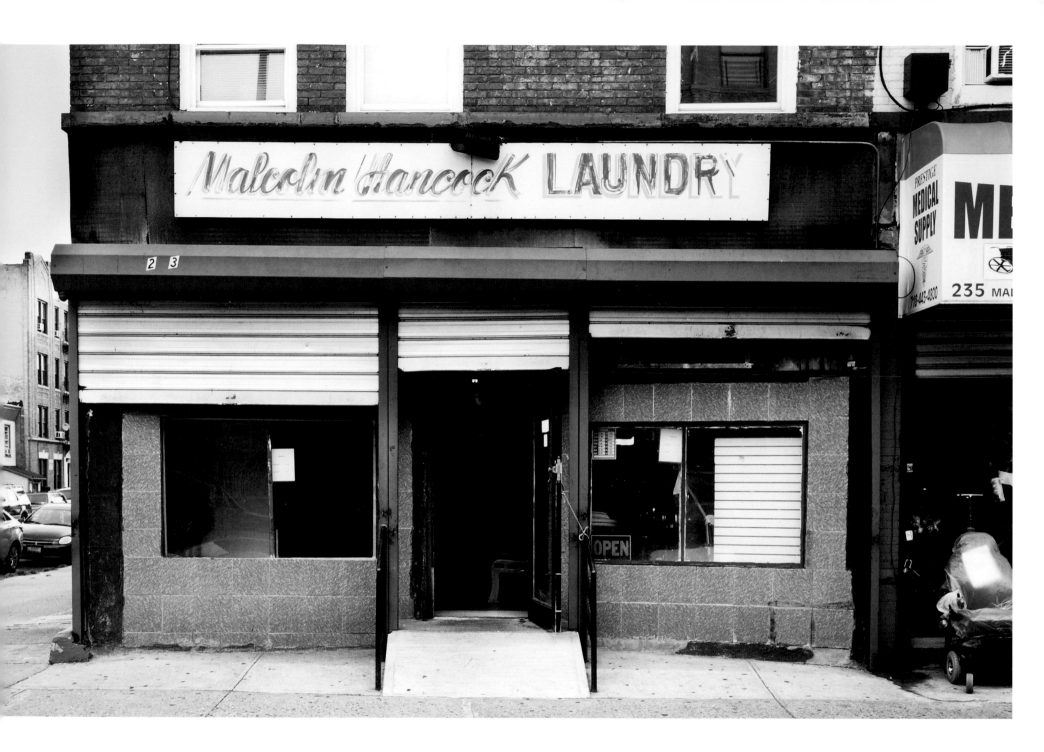

23 Malcolm X Boulevard

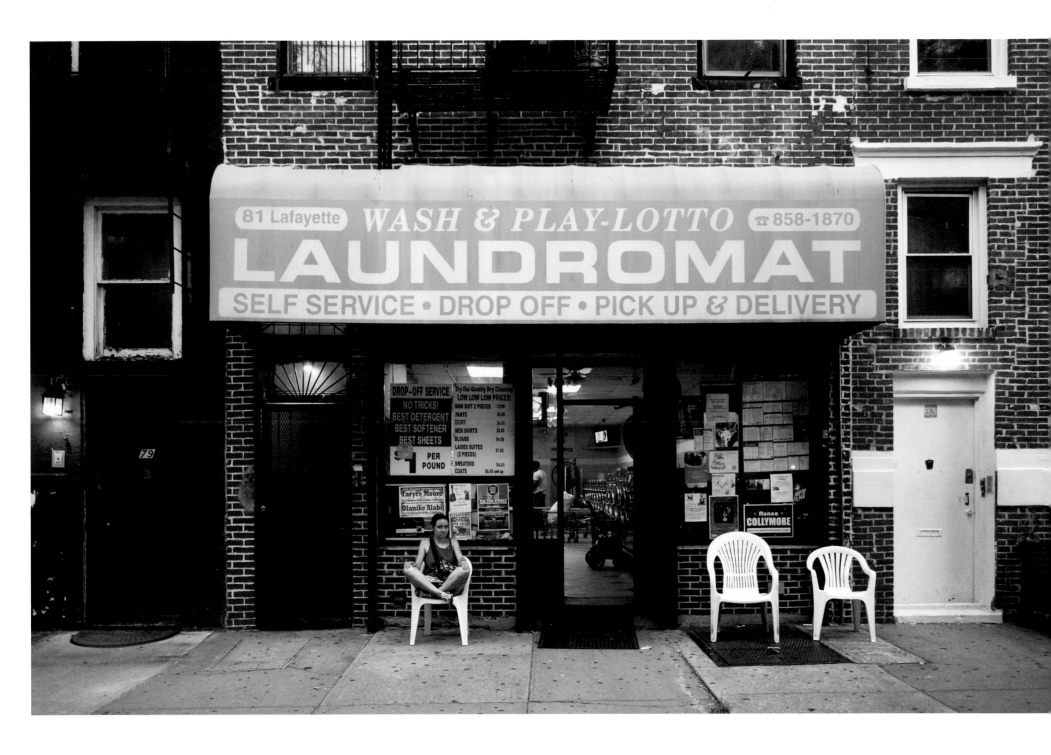

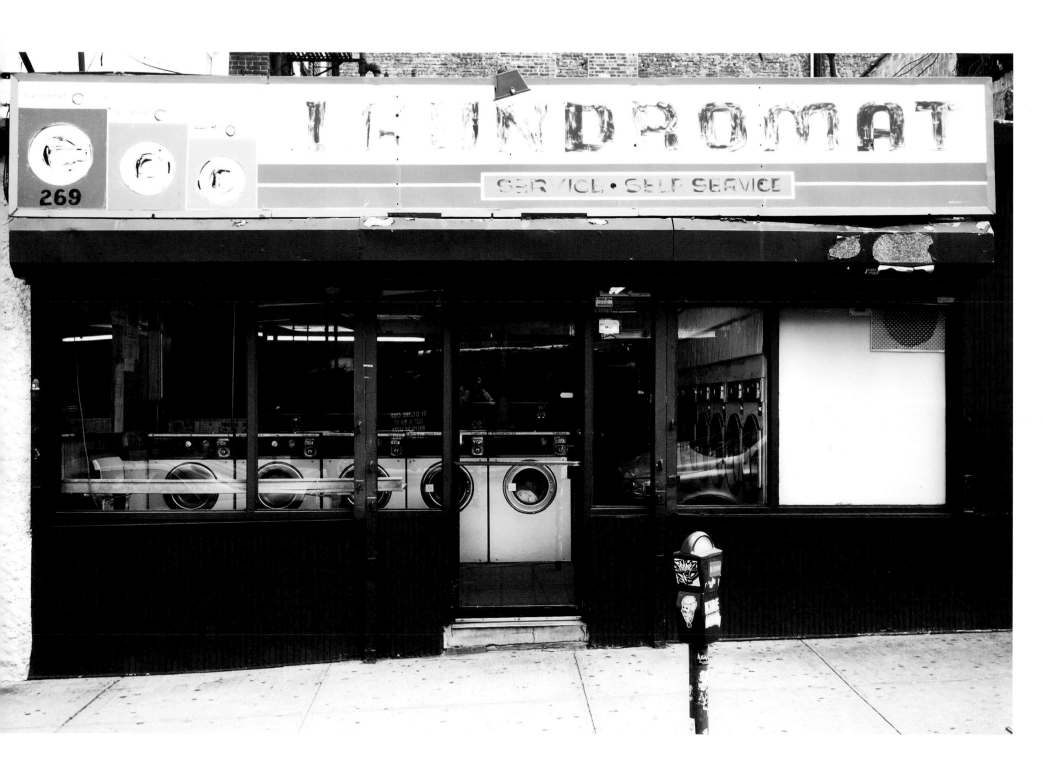

269 13th Street

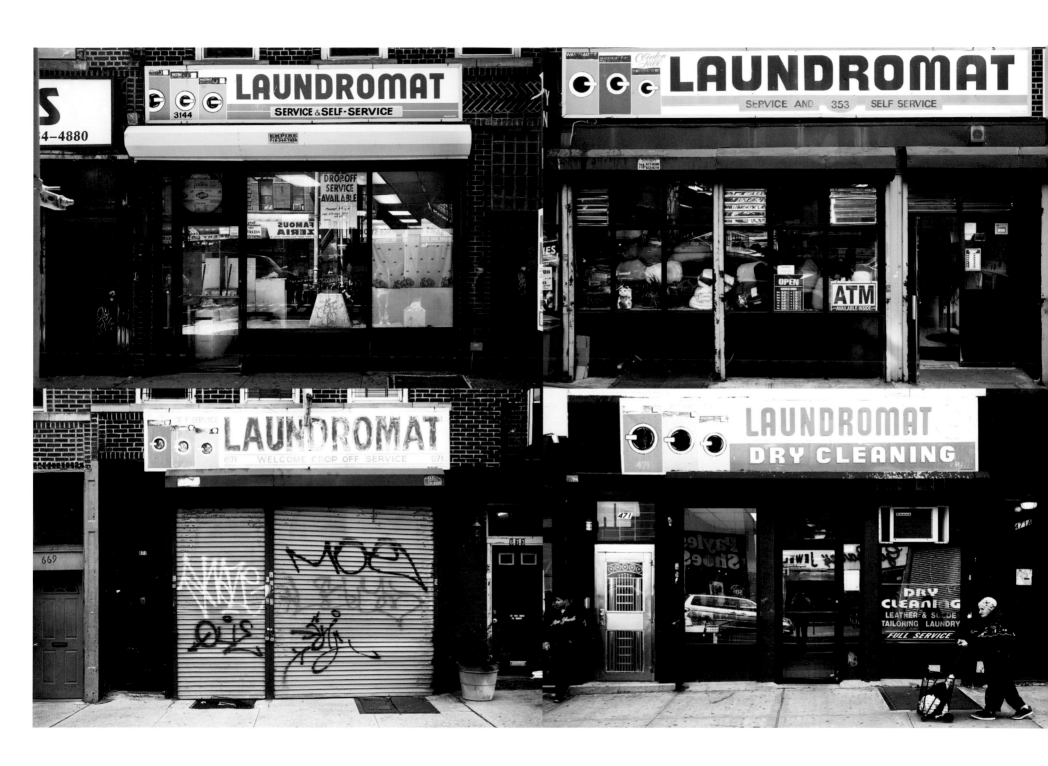

3144 Fulton Street

671 Franklin Avenue

342 Waverly Avenue

471 5th Avenue

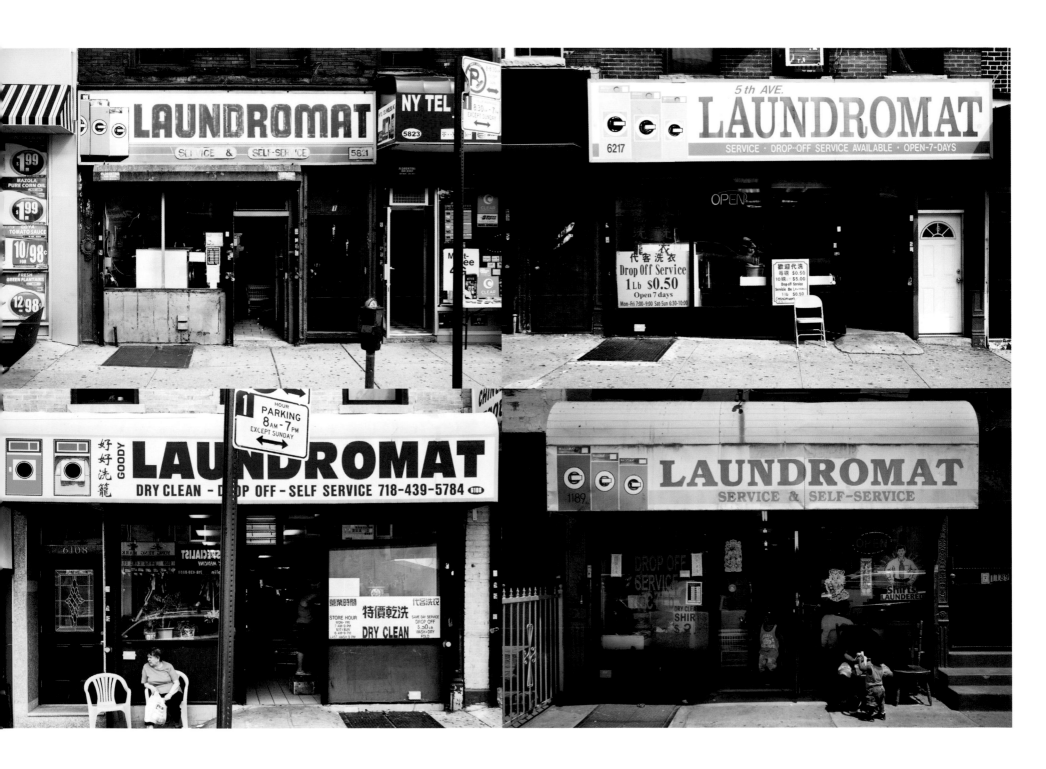

5821 5th Avenue

6108 5th Avenue

6217 5th Avenue

1189 Bedford Avenue

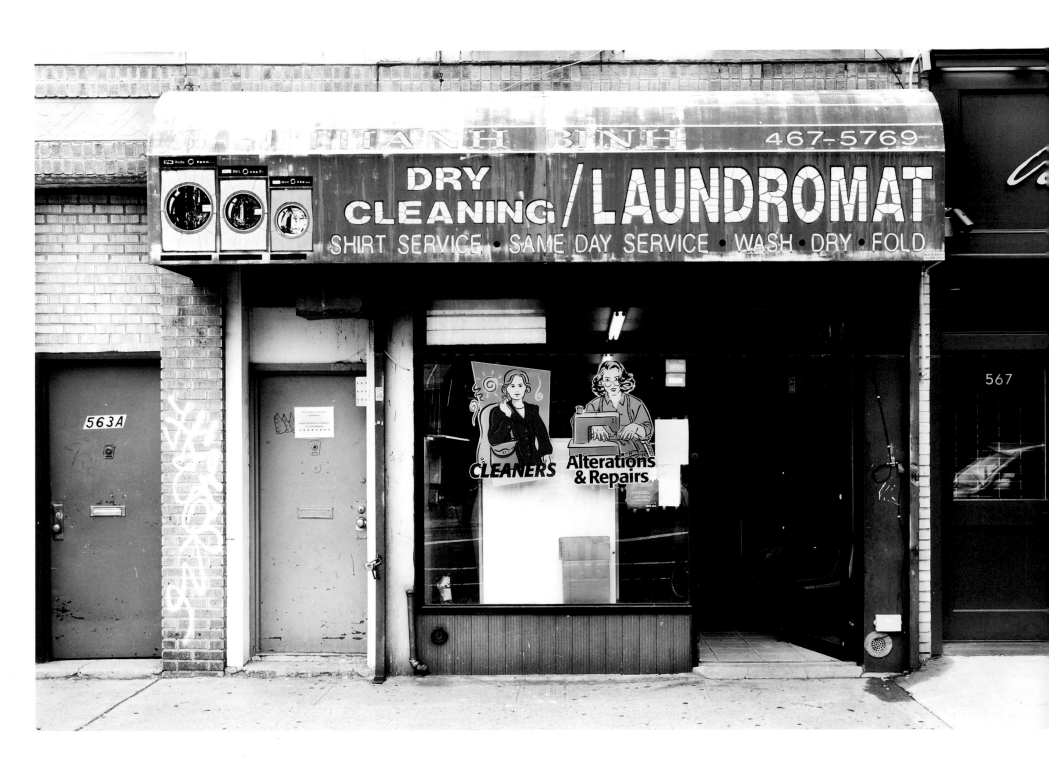

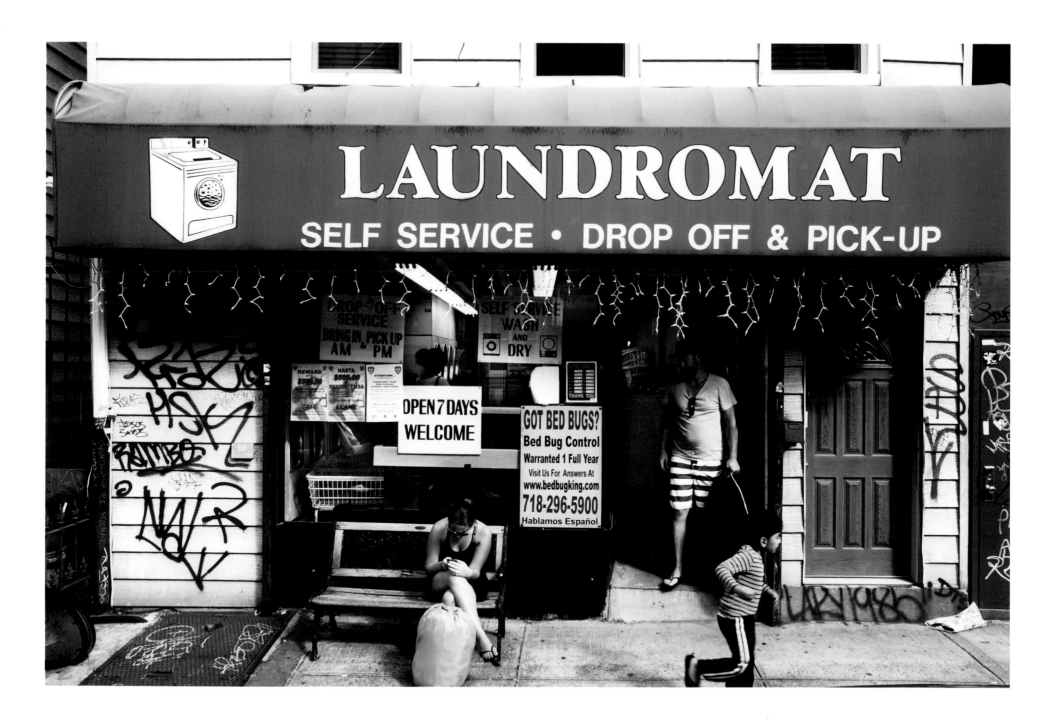

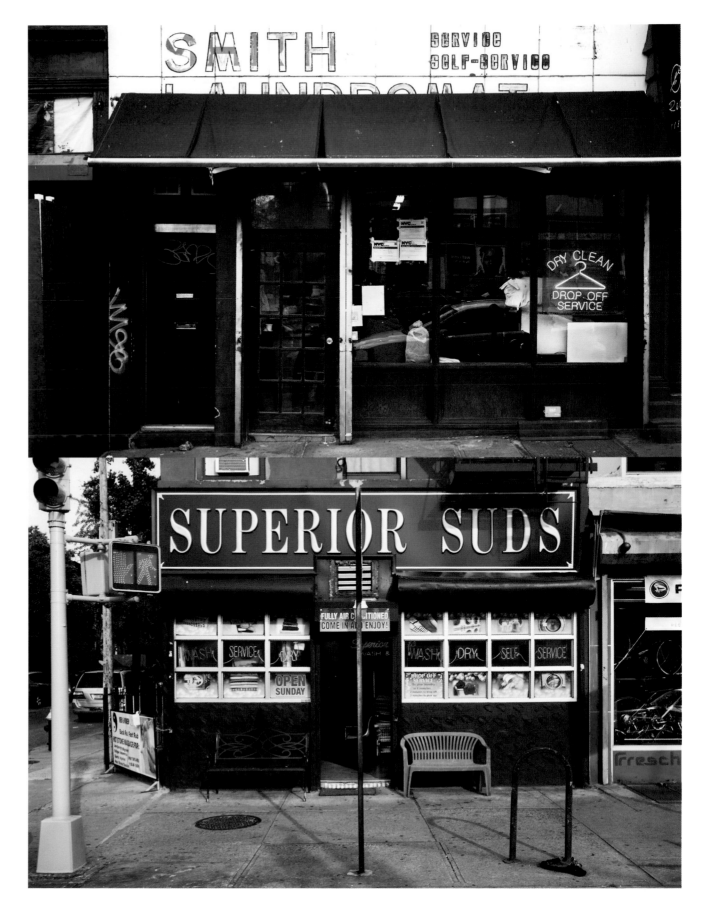

313 Smith Street

99 5th Avenue

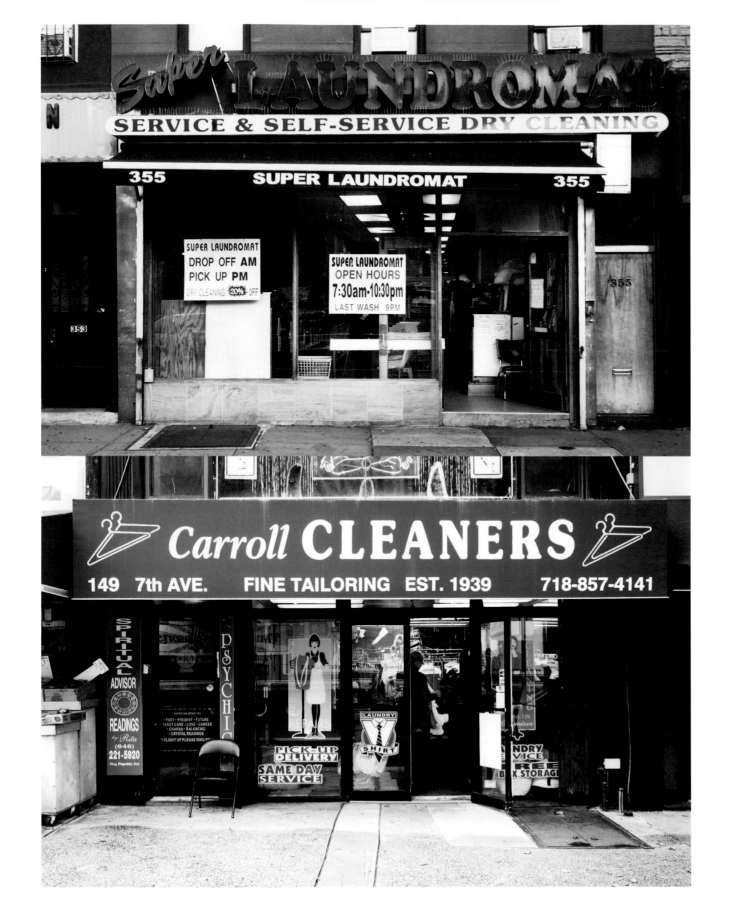

355 Smith Street

149 7th Avenue

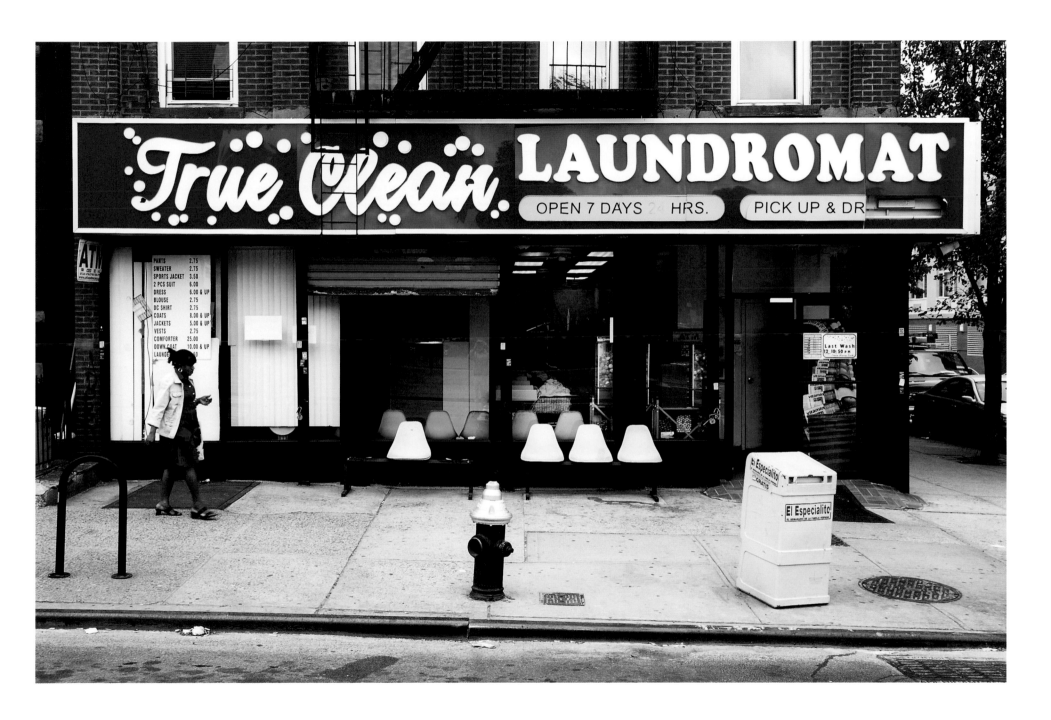

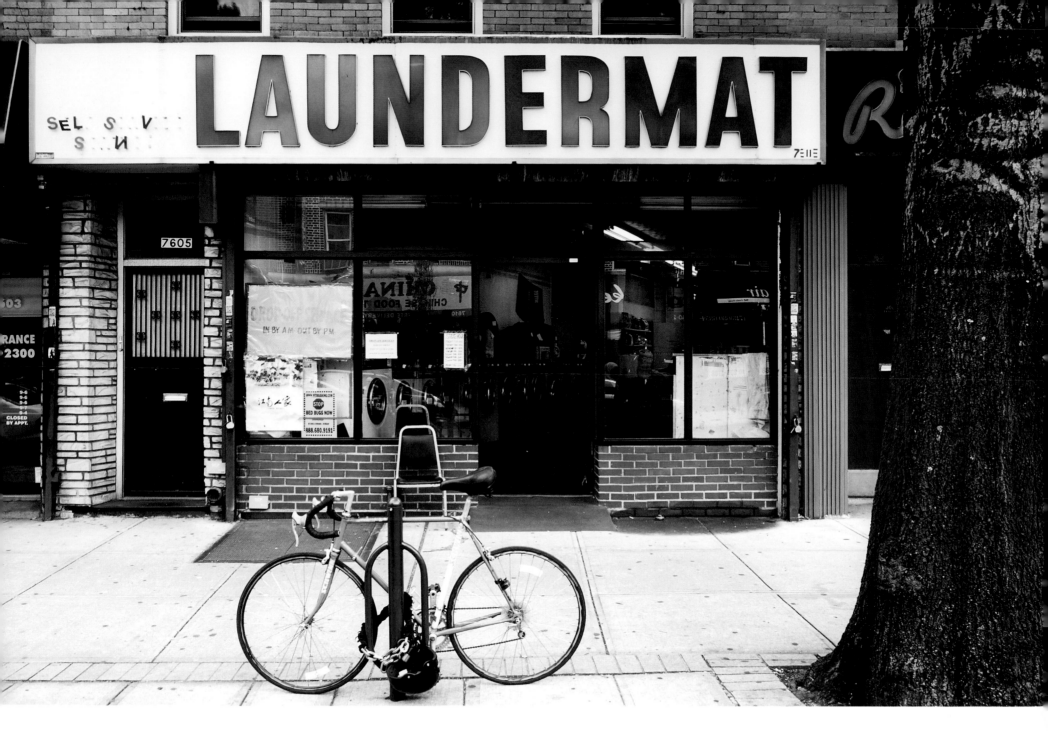

7605 5th Ave

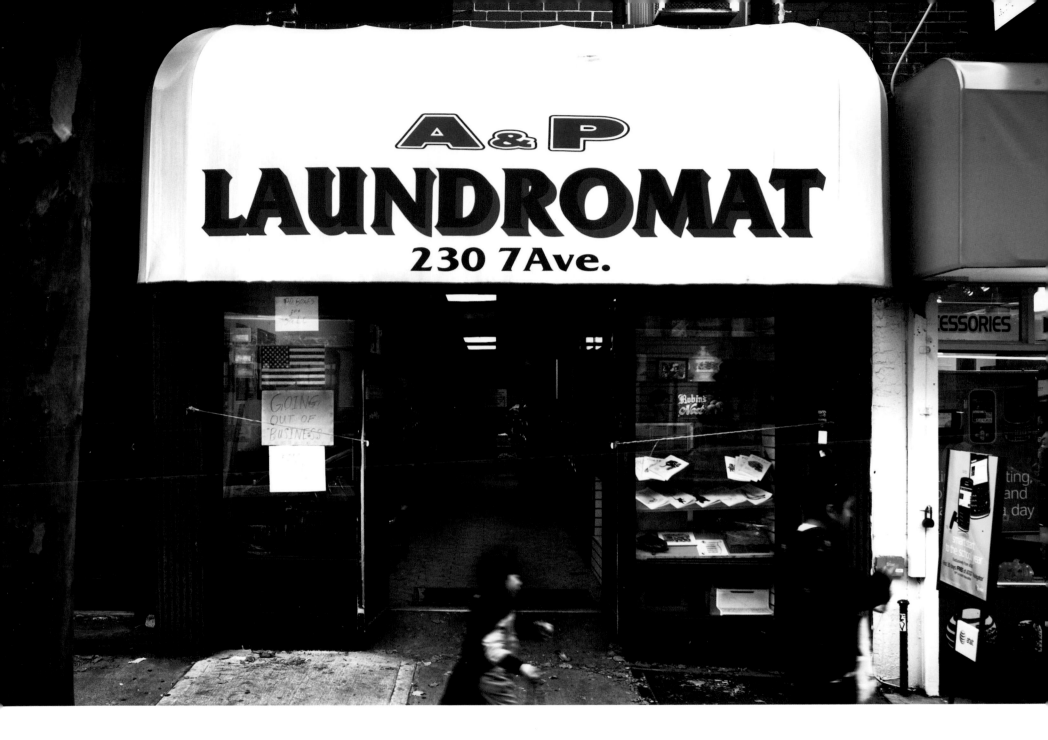

230 7th Avenue

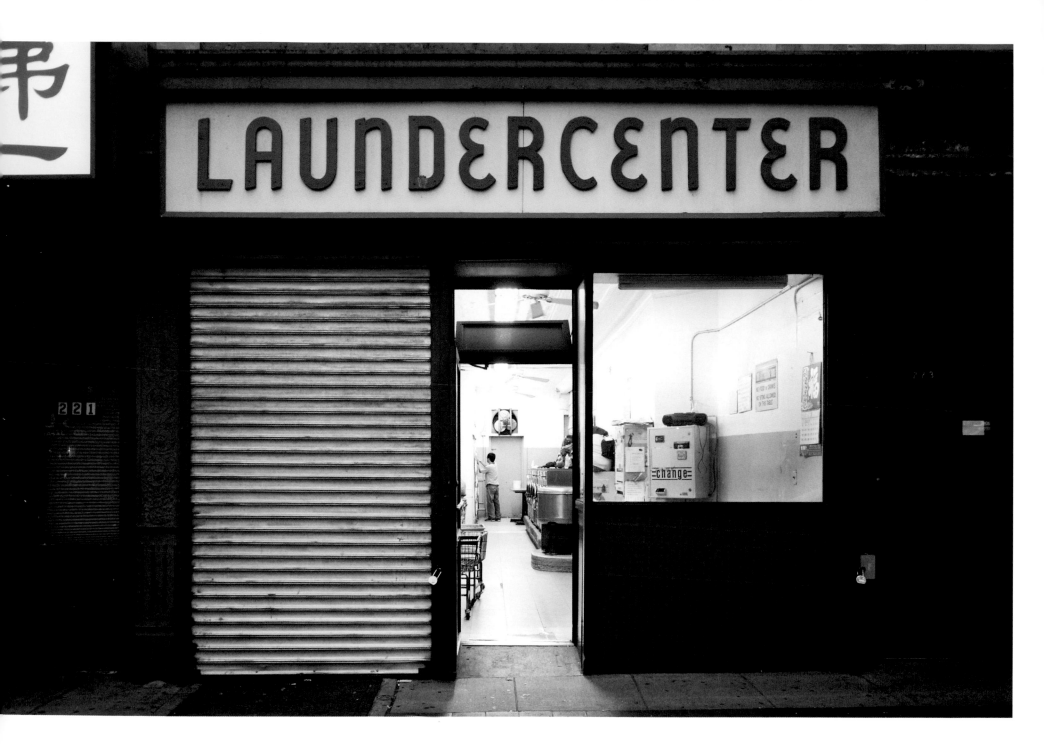

223 Prospect Park West

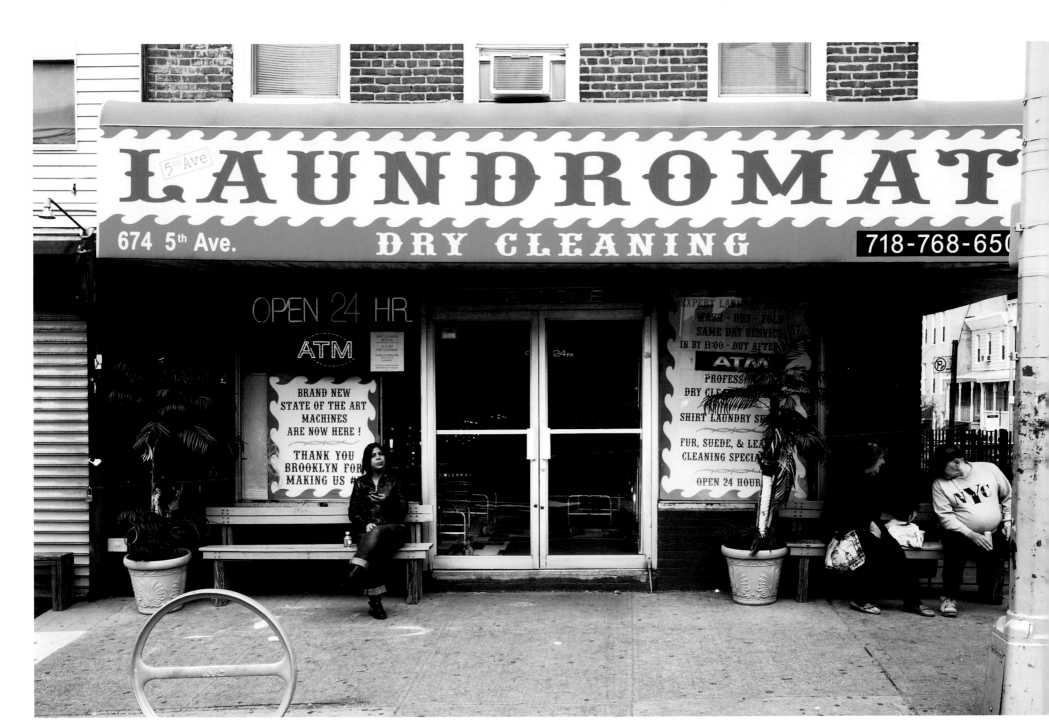

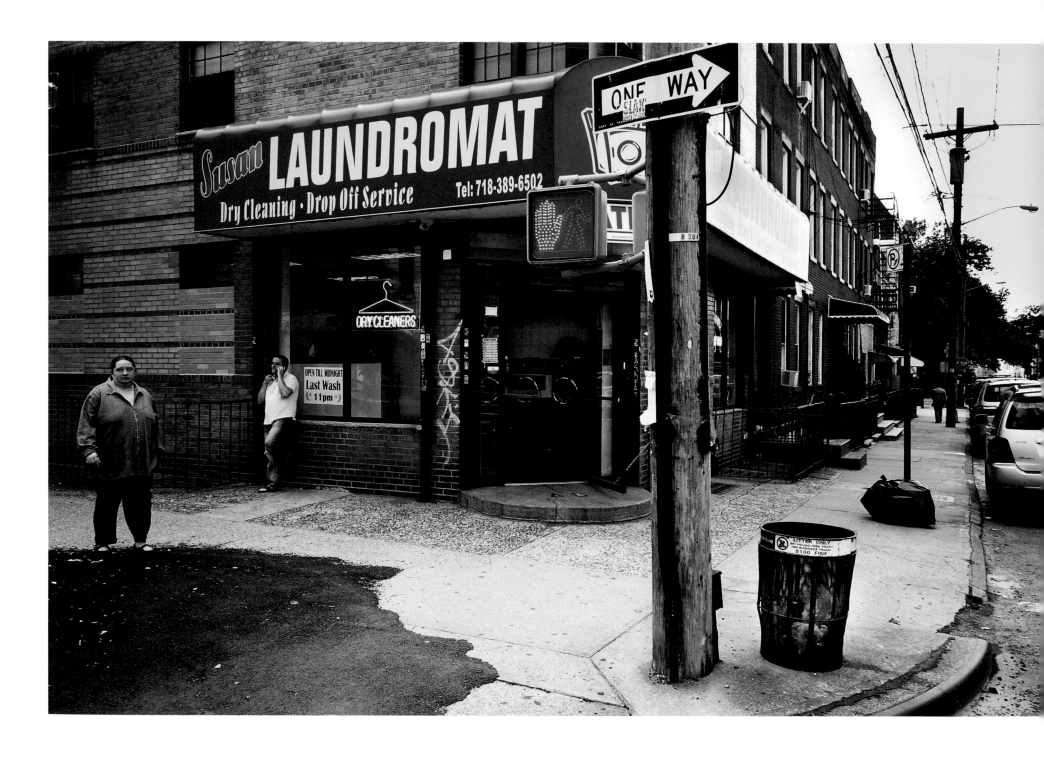

244 Nassau Avenue

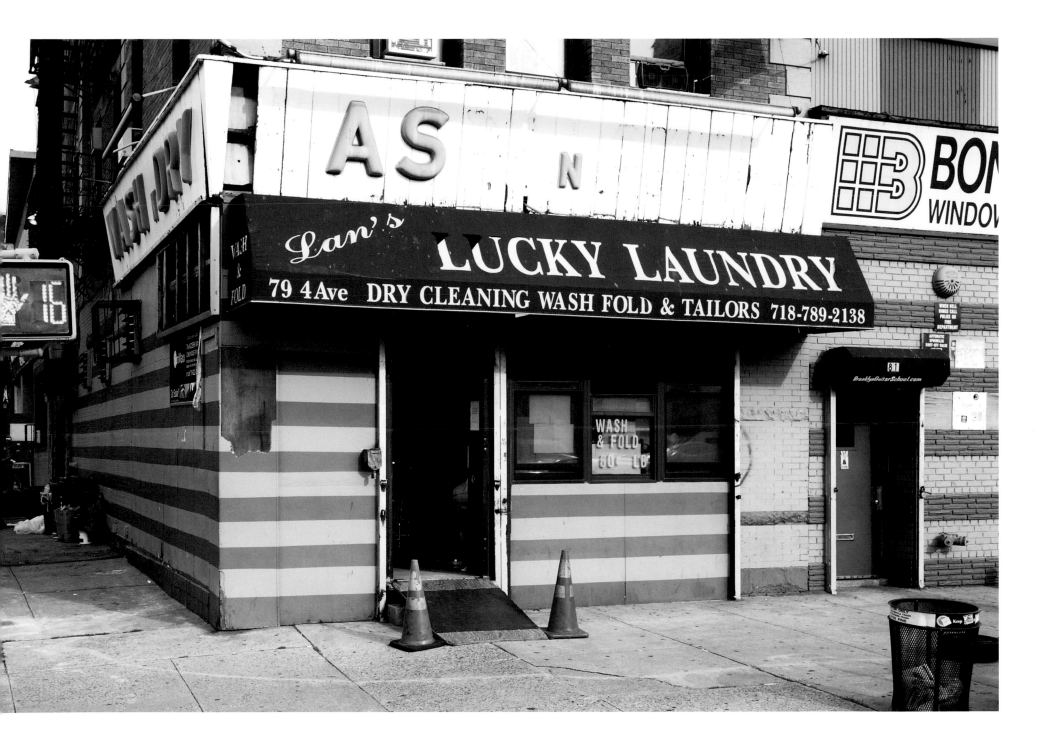

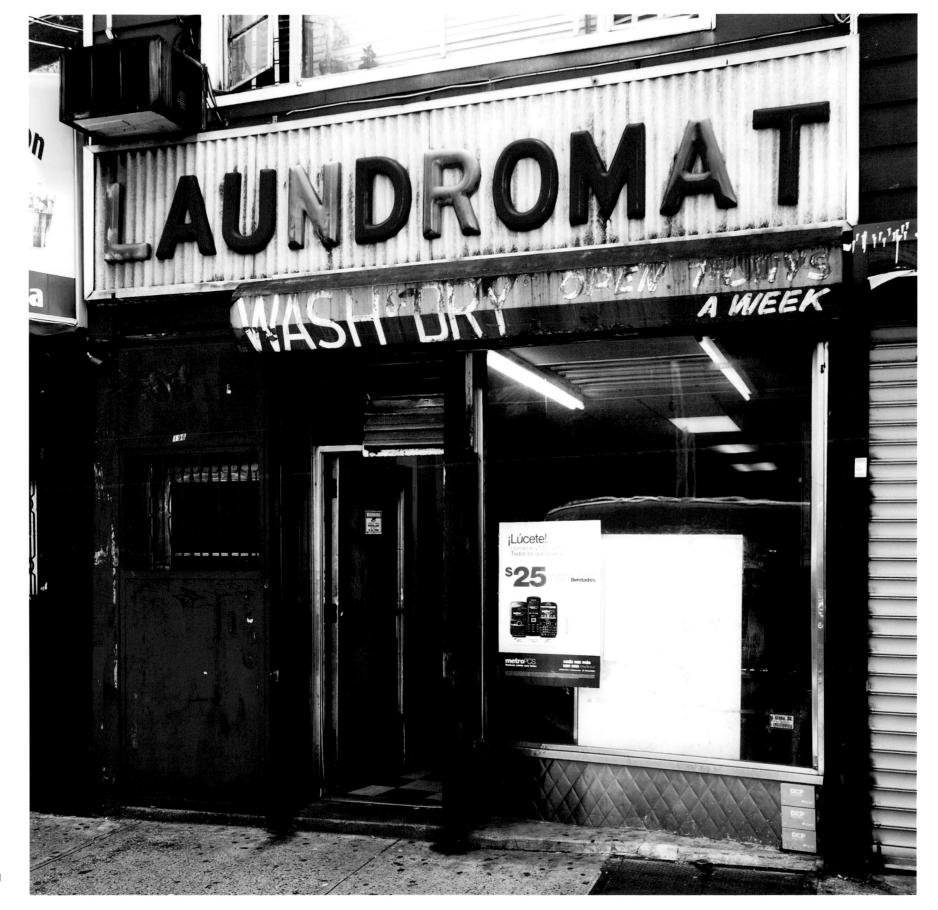

593 4th Avenue

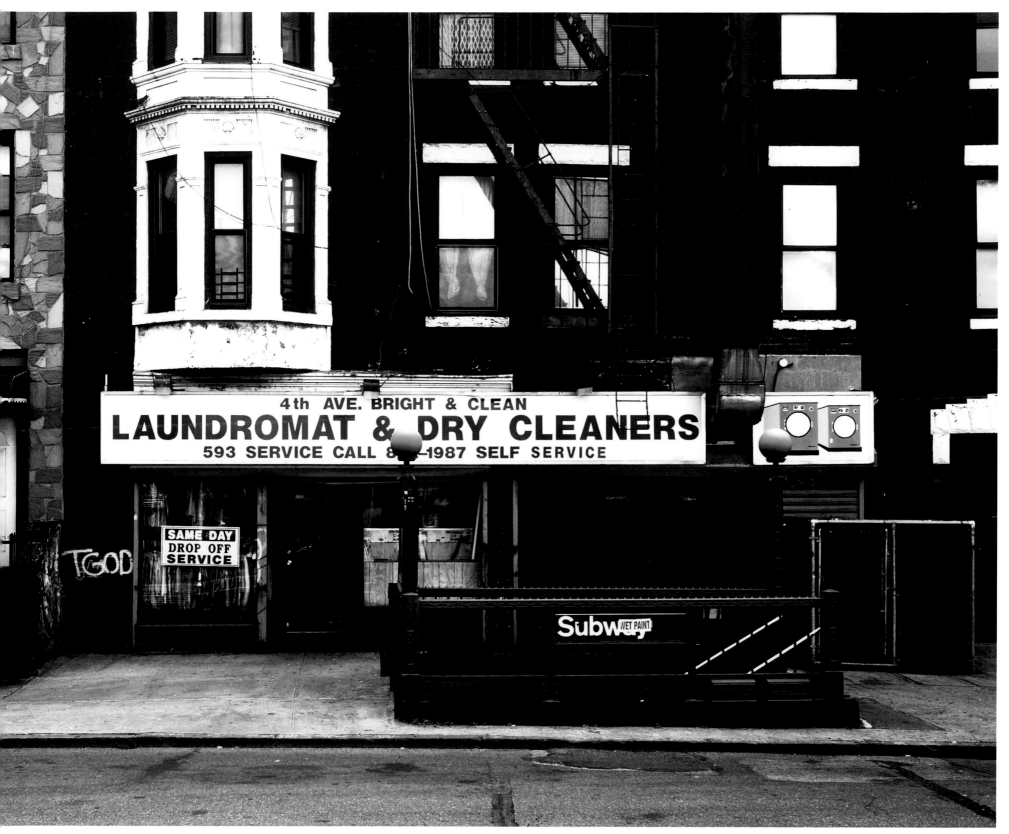

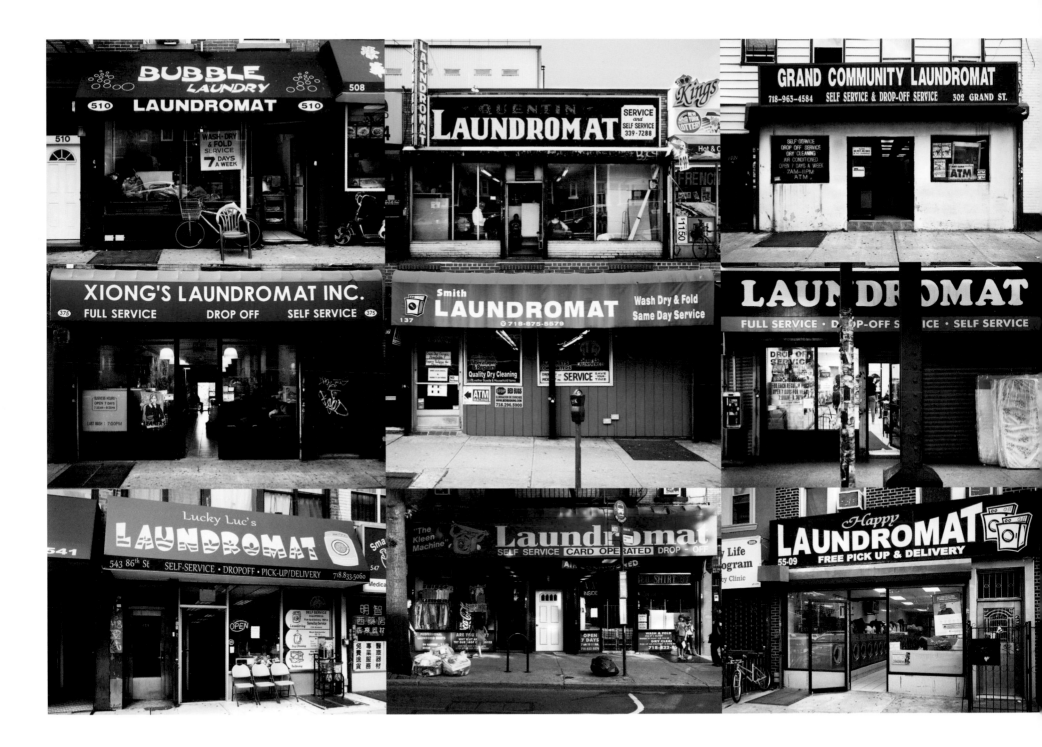

510 Court Street

375 Broadway

543 86th Street

1704 East 16th Street

137 Smith Street

309 5th Avenue

302 Grand Street

299 Broadway

55-09 4th Avenue

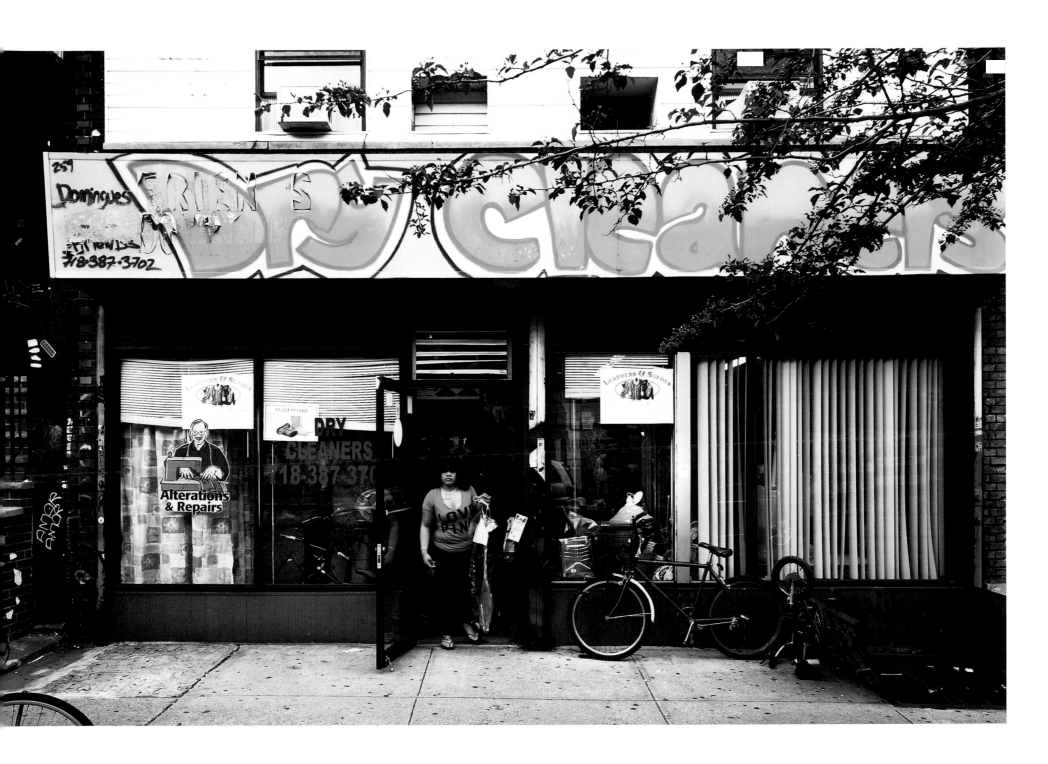

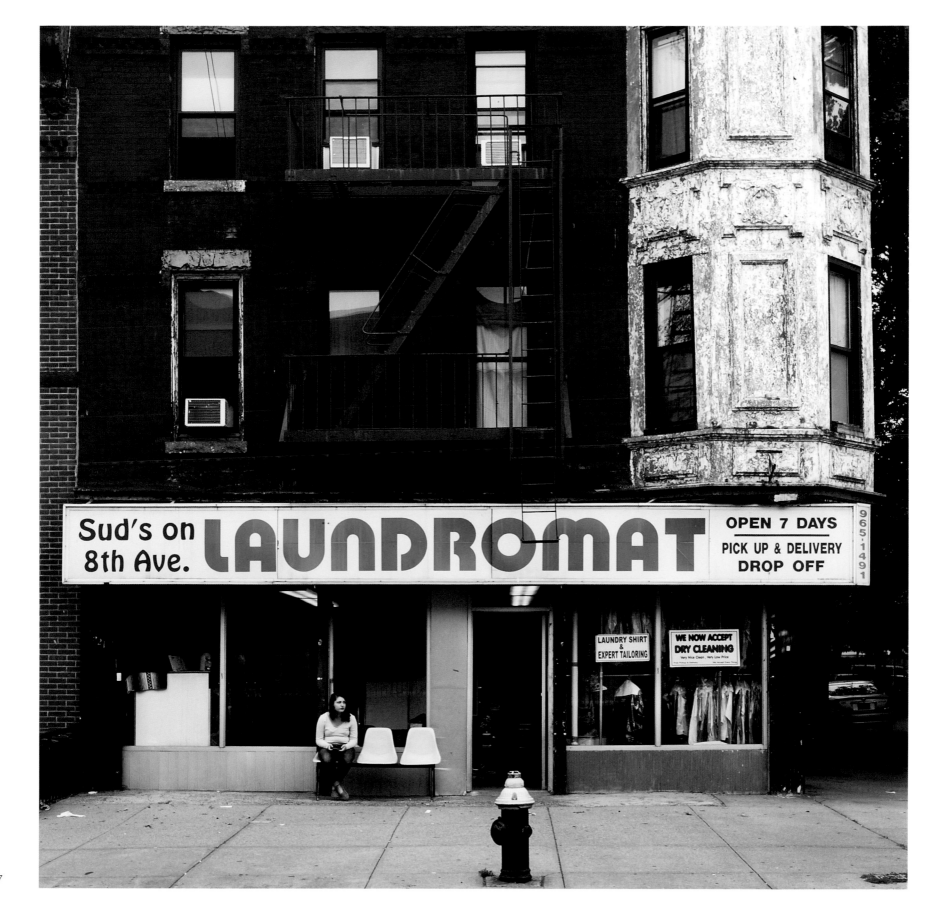

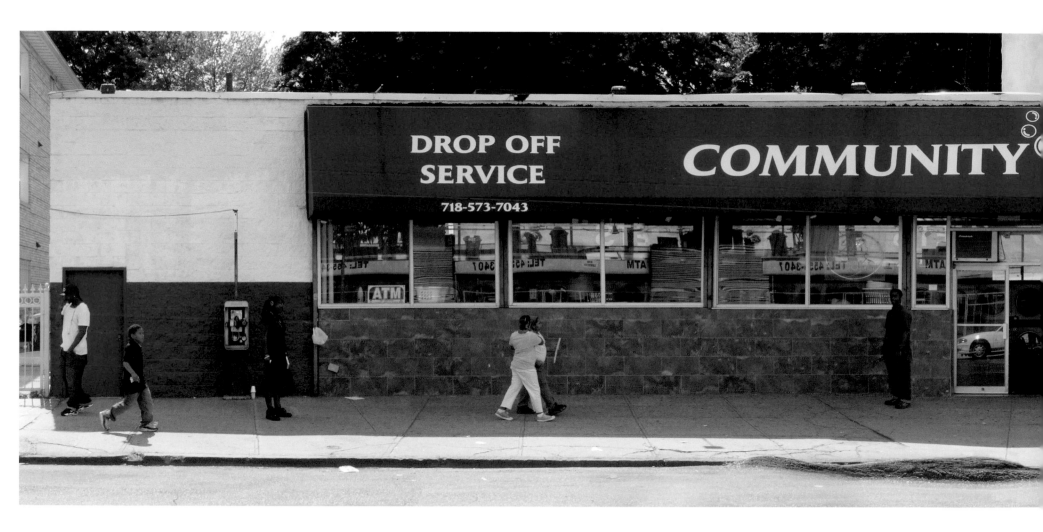

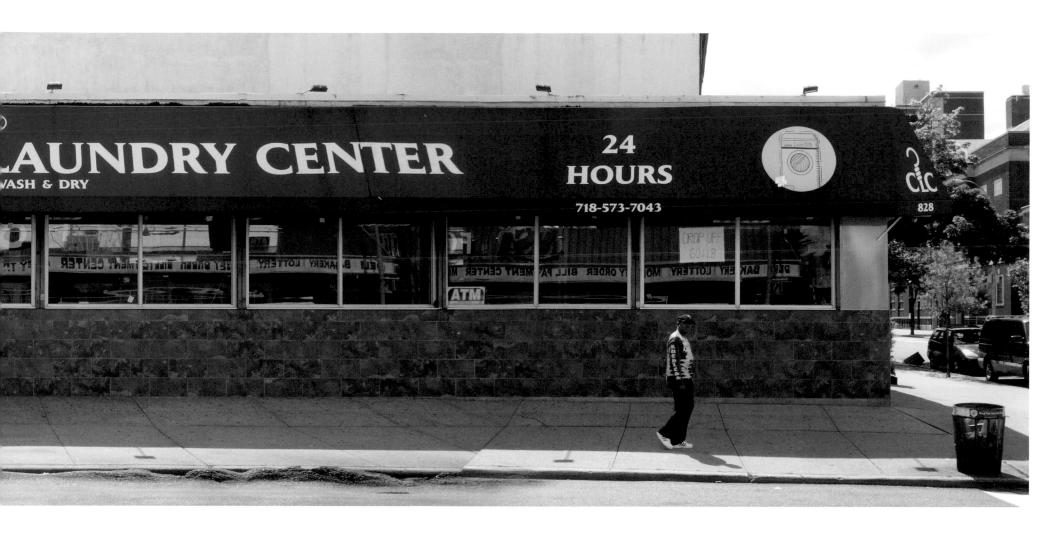

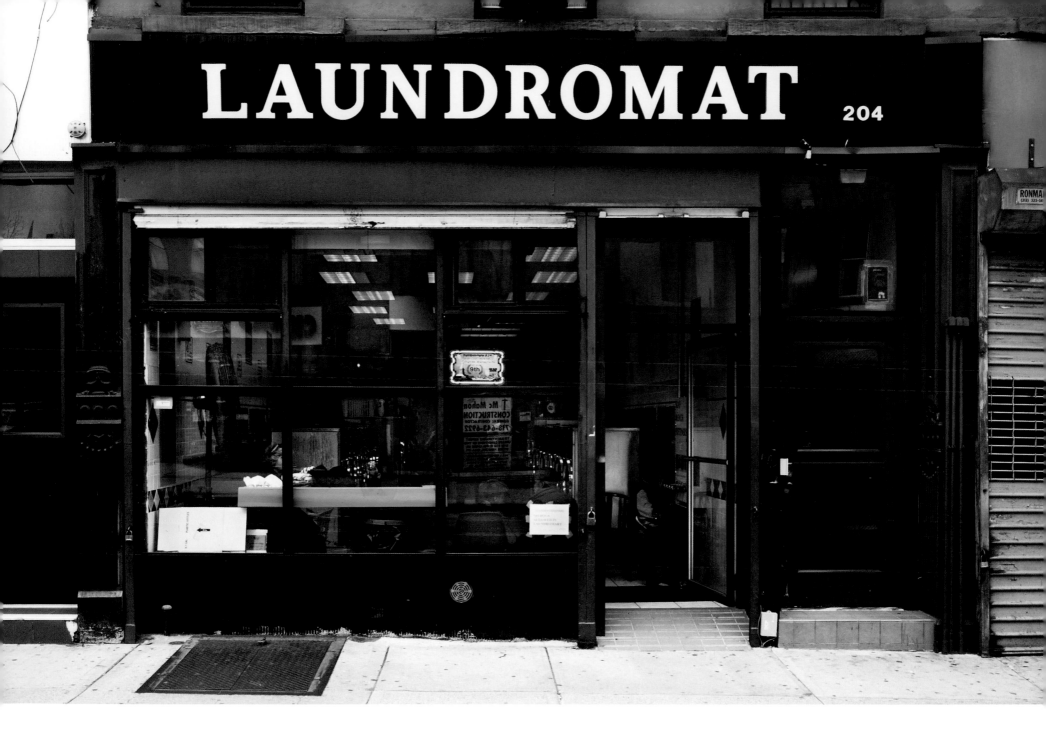

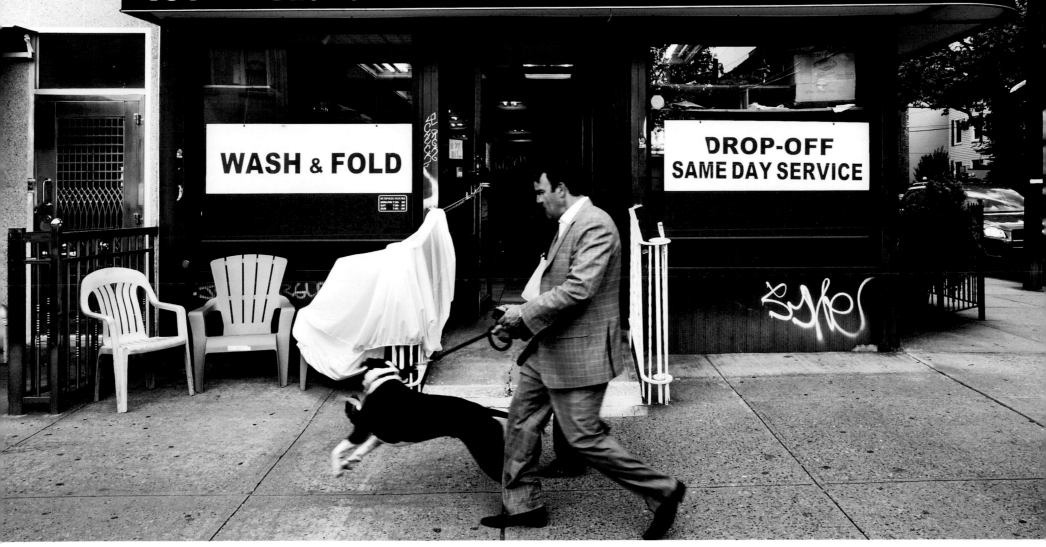

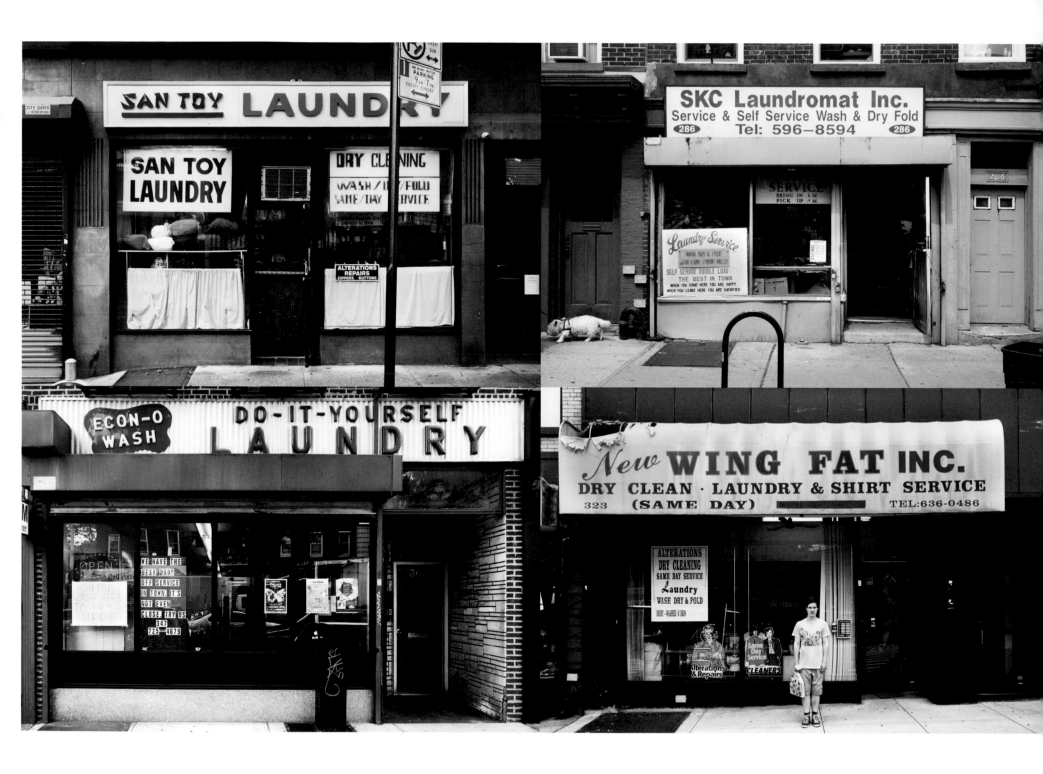

101 7th Avenue

362 Graham Avenue

286 Smith Street

323 Flatbush Avenue

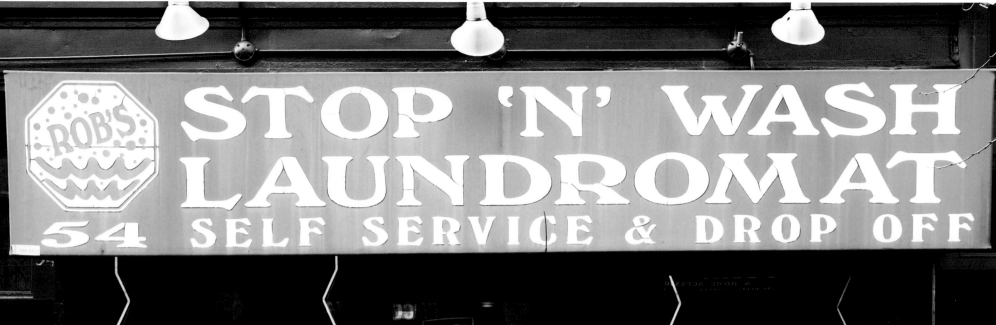

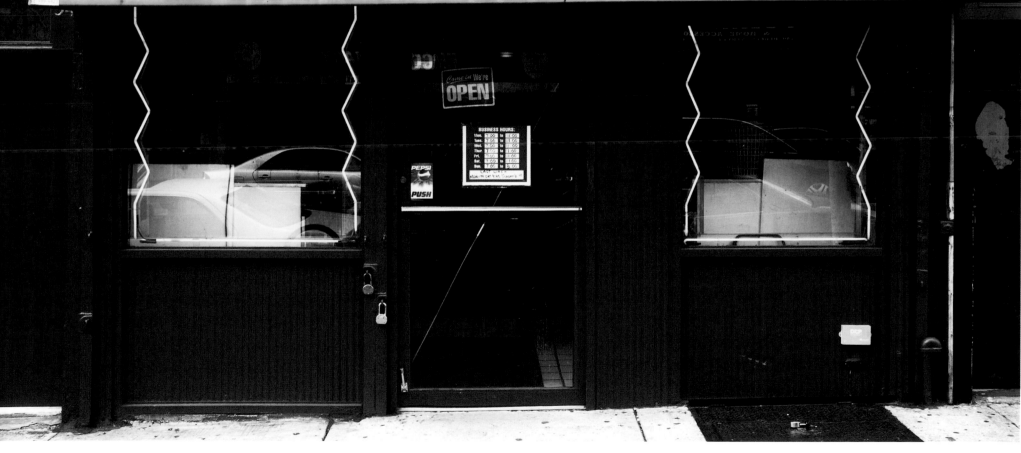

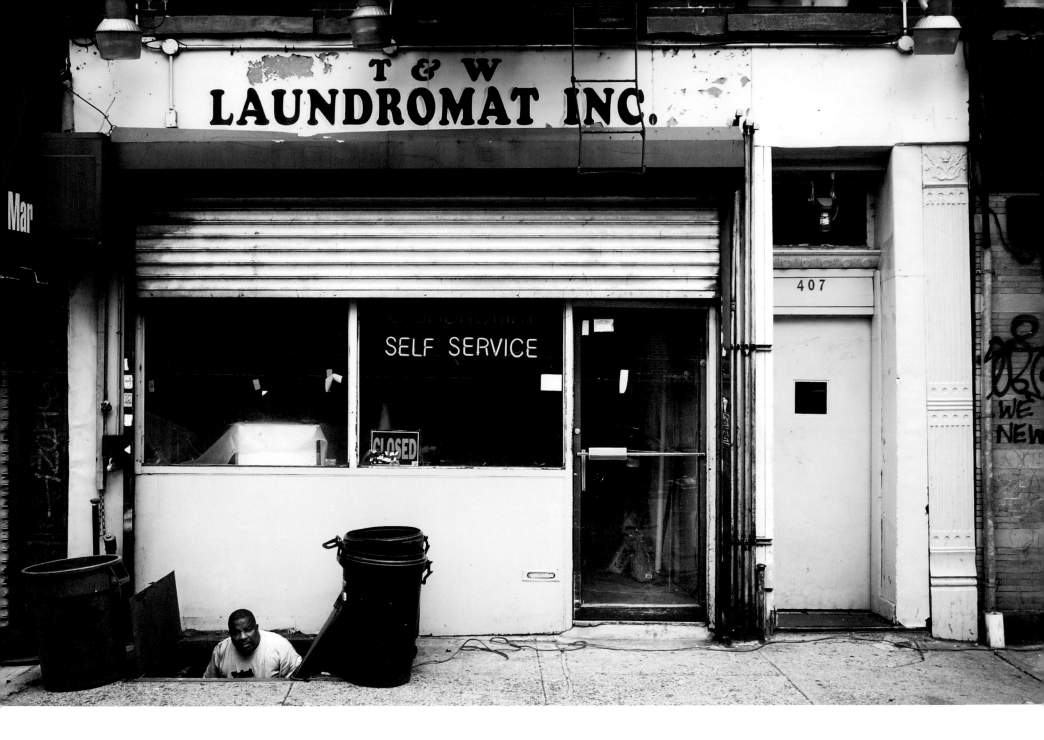

407 Nostrand Avenue

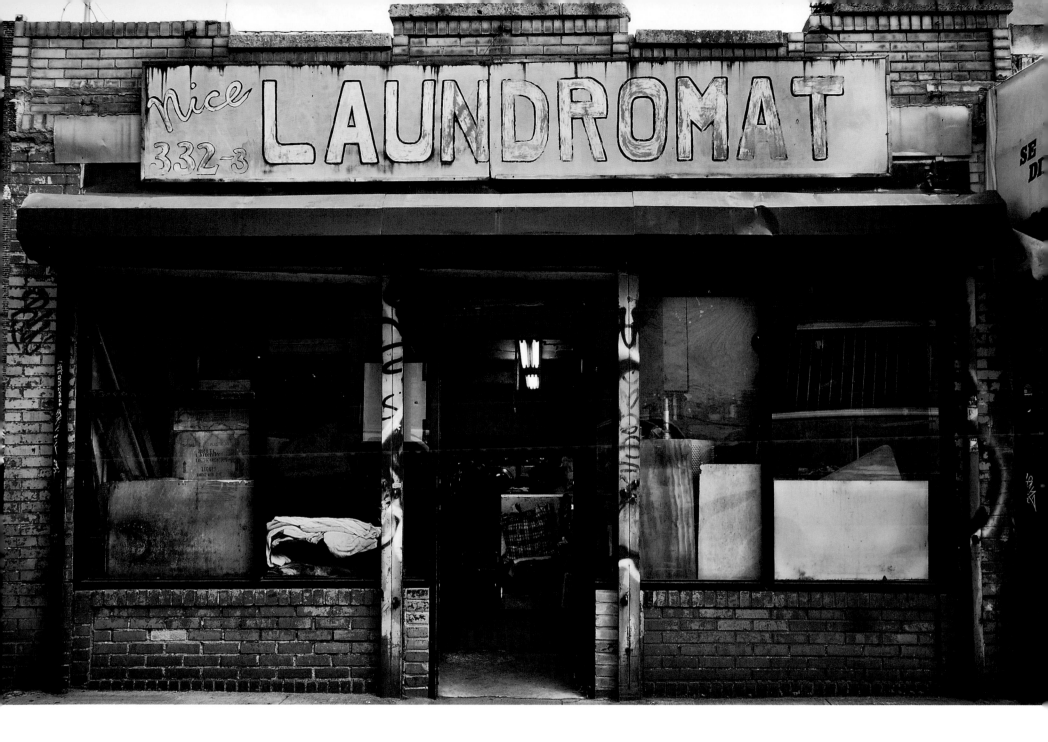

332-3 Hooper Street

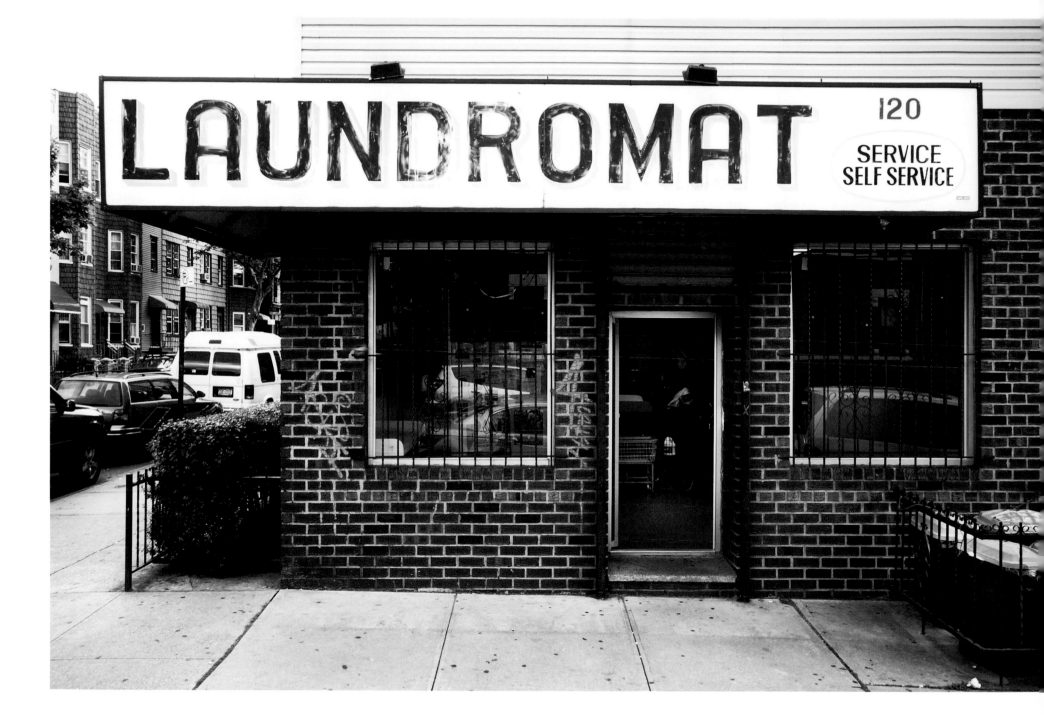

120 Meserole Avenue

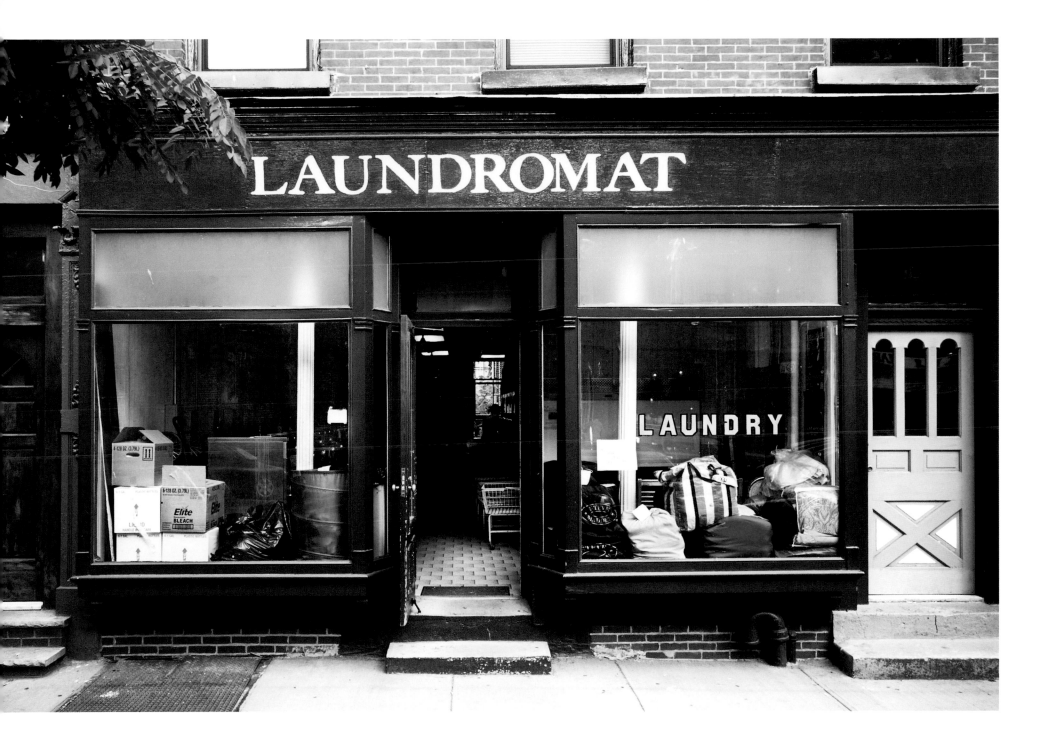

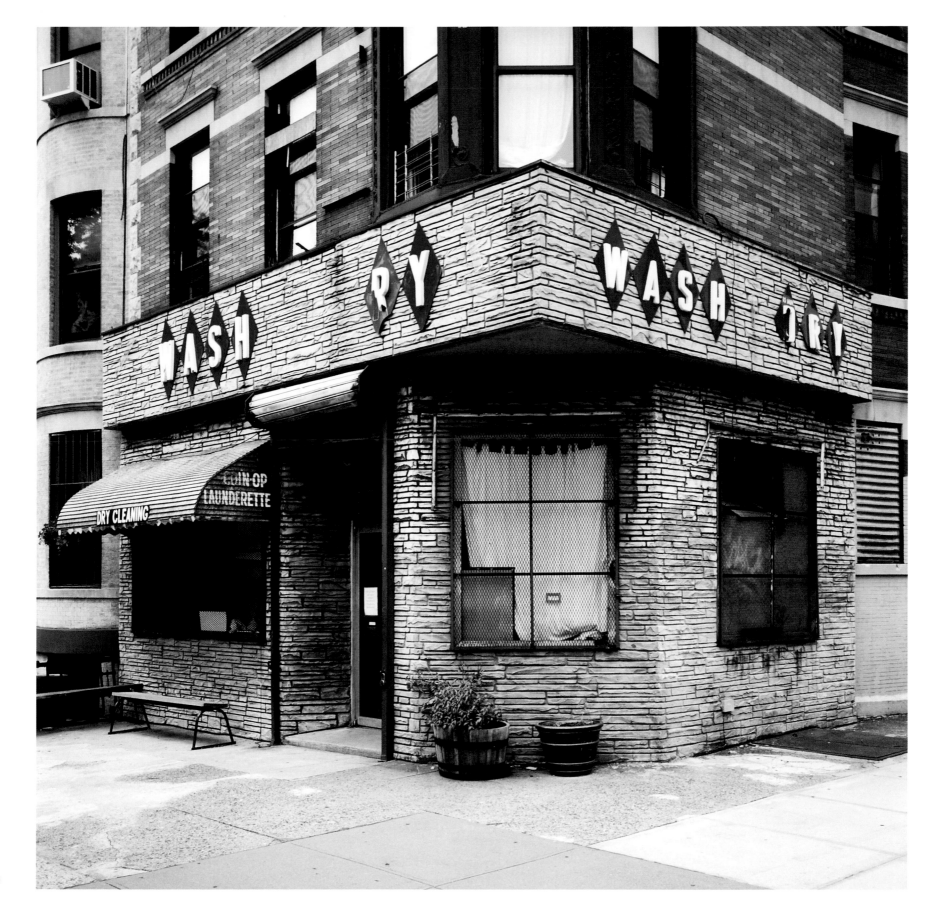

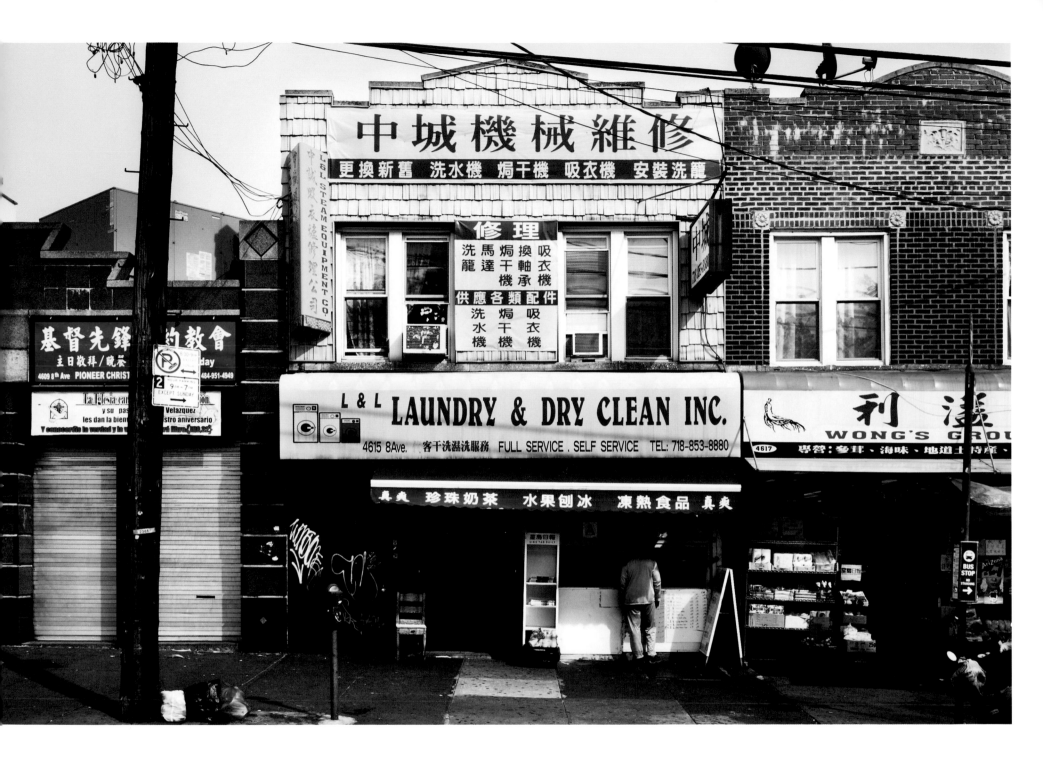

4615 8th Avenue

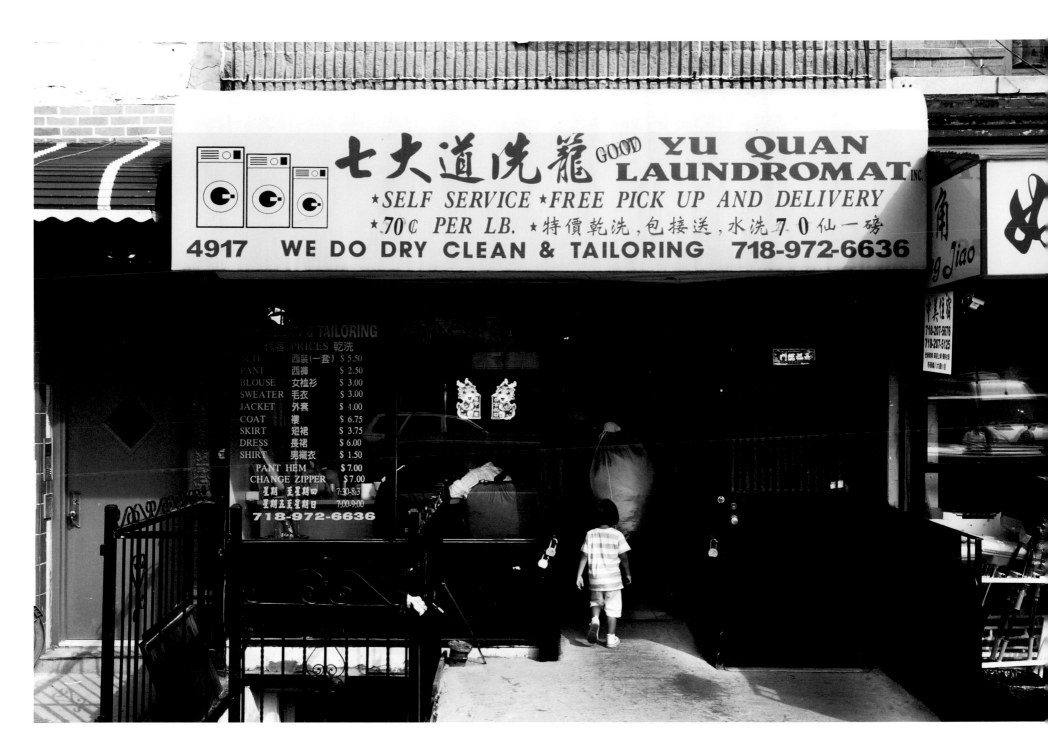

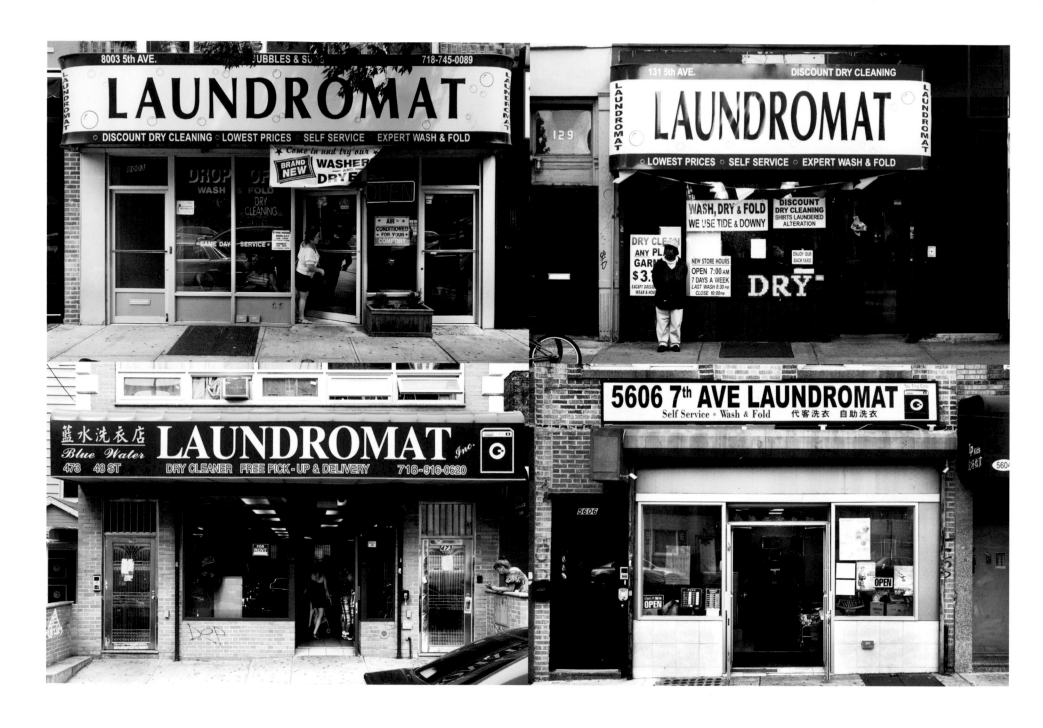

8003 5th Avenue

473 48th Street

<div align="right">

131 5th Avenue

5606 7th Avenue

</div>

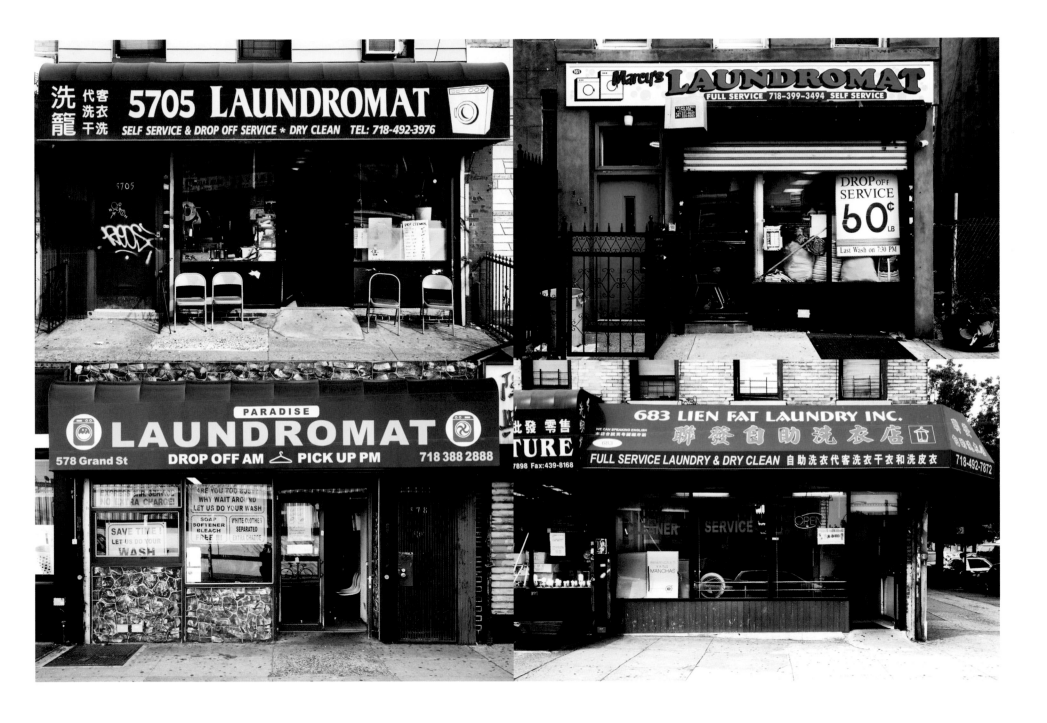

5705 7th Avenue

578 Grand Street

161 4th Avenue

683 60th Street

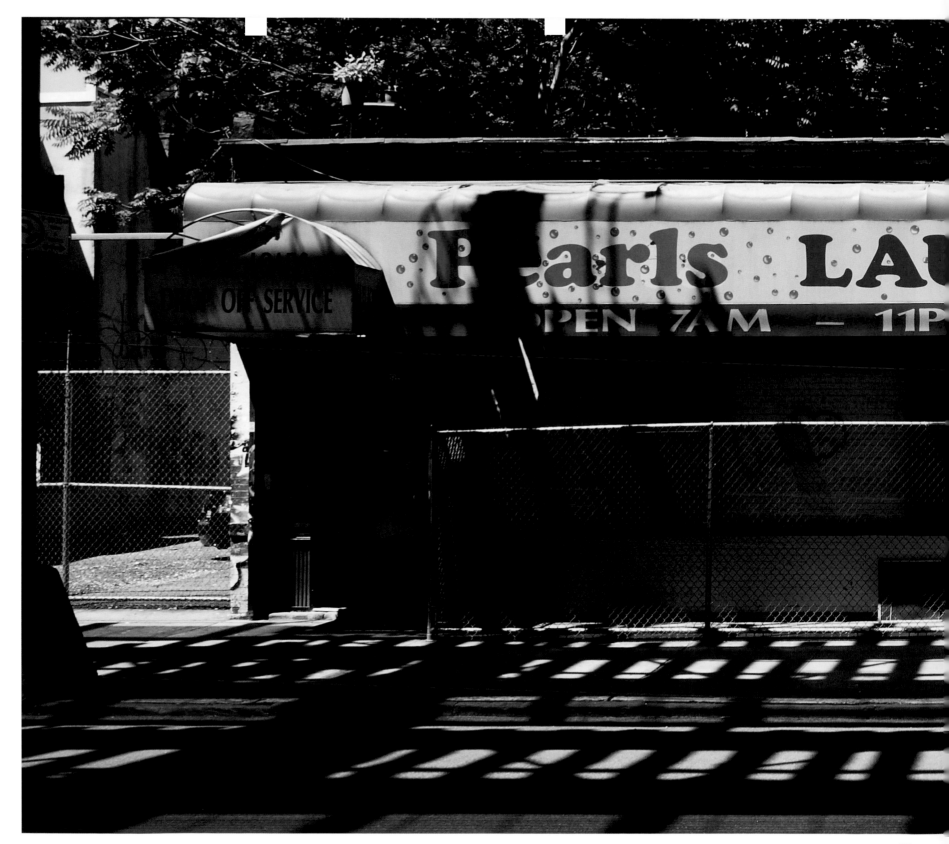

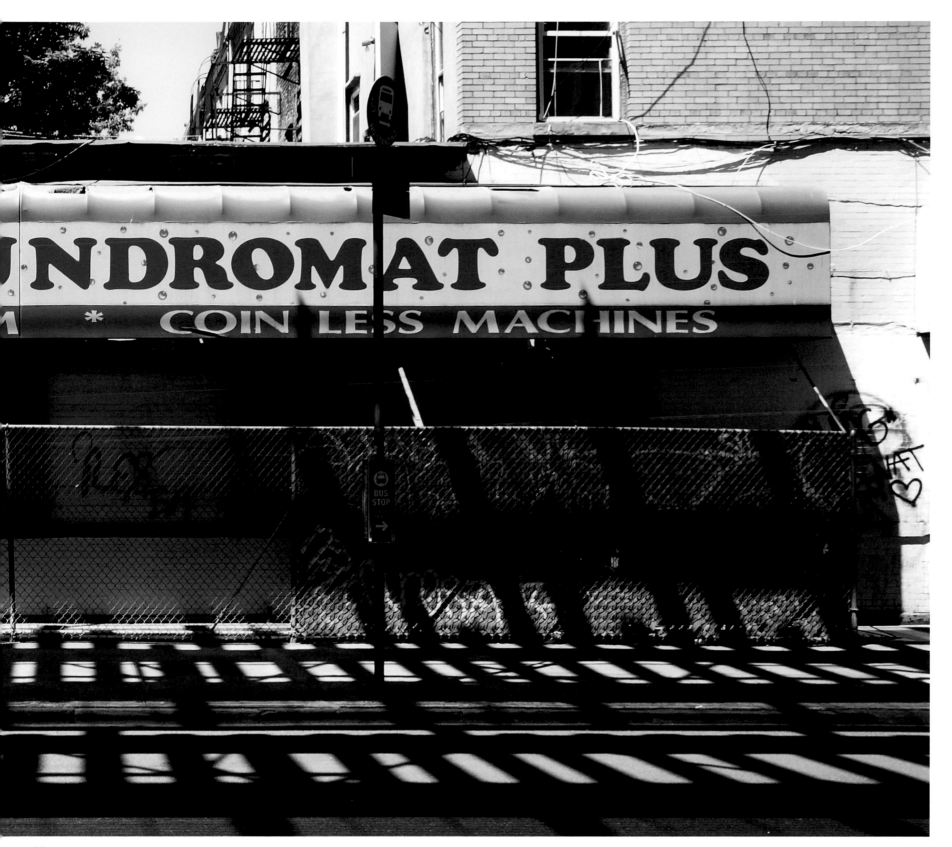

381 Avenue X 611 Avenue Z

510 Foster Avenue 459 Dekalb Avenue

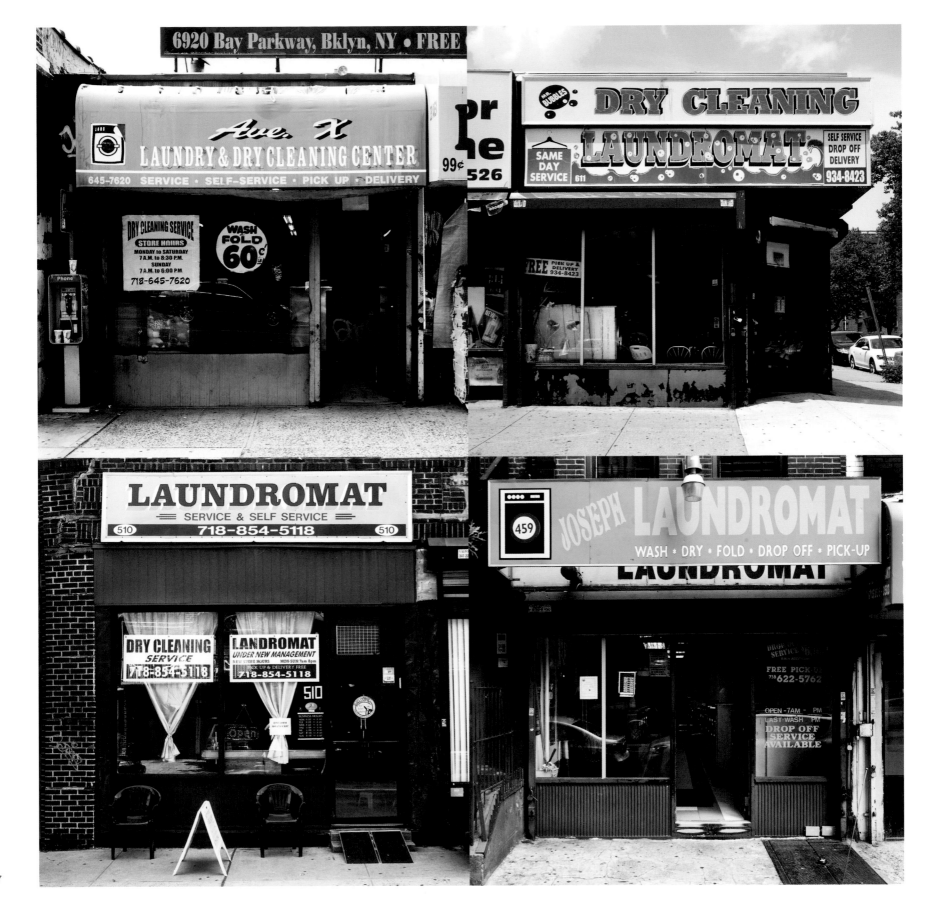

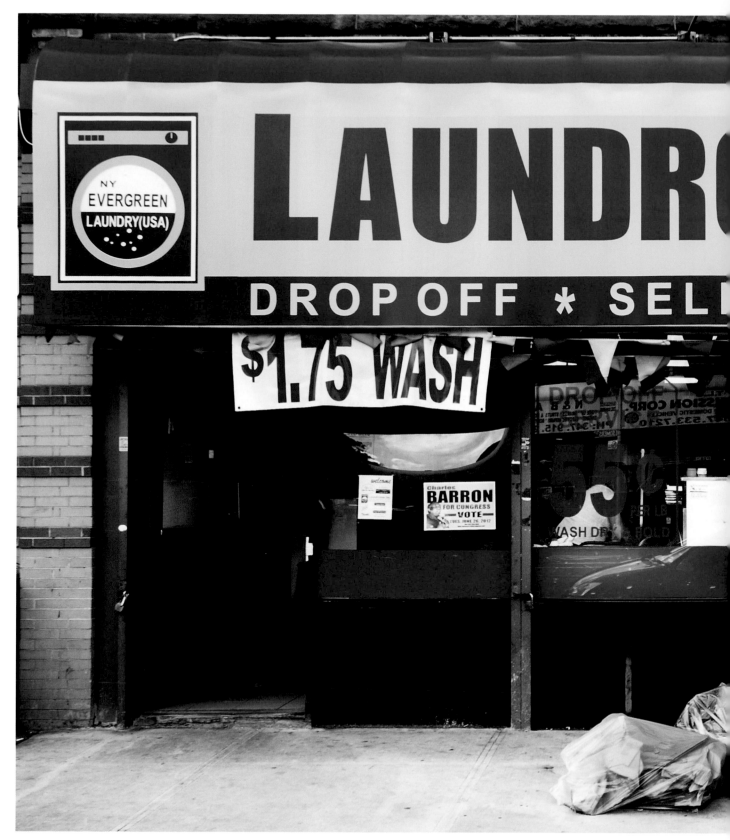

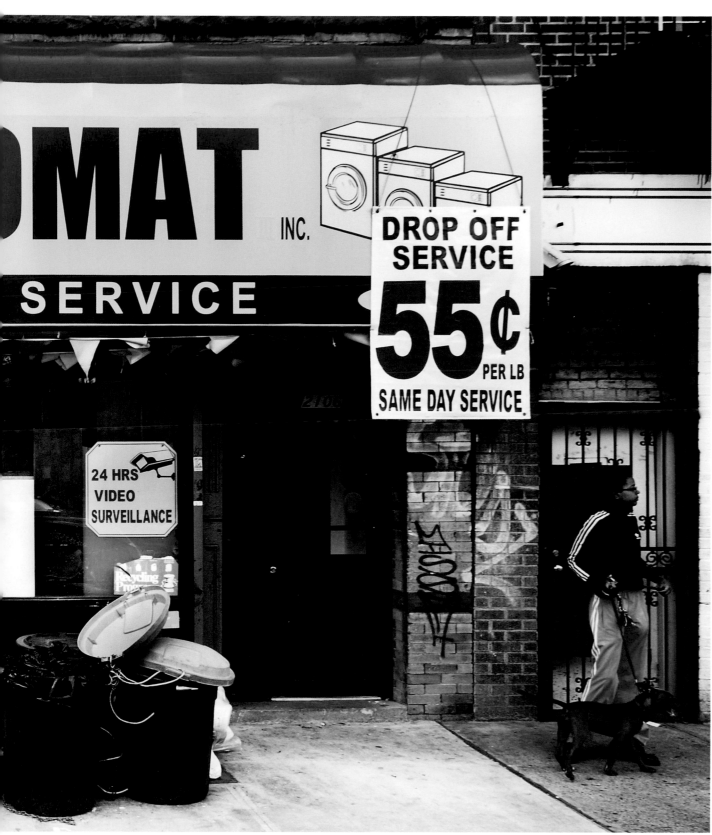

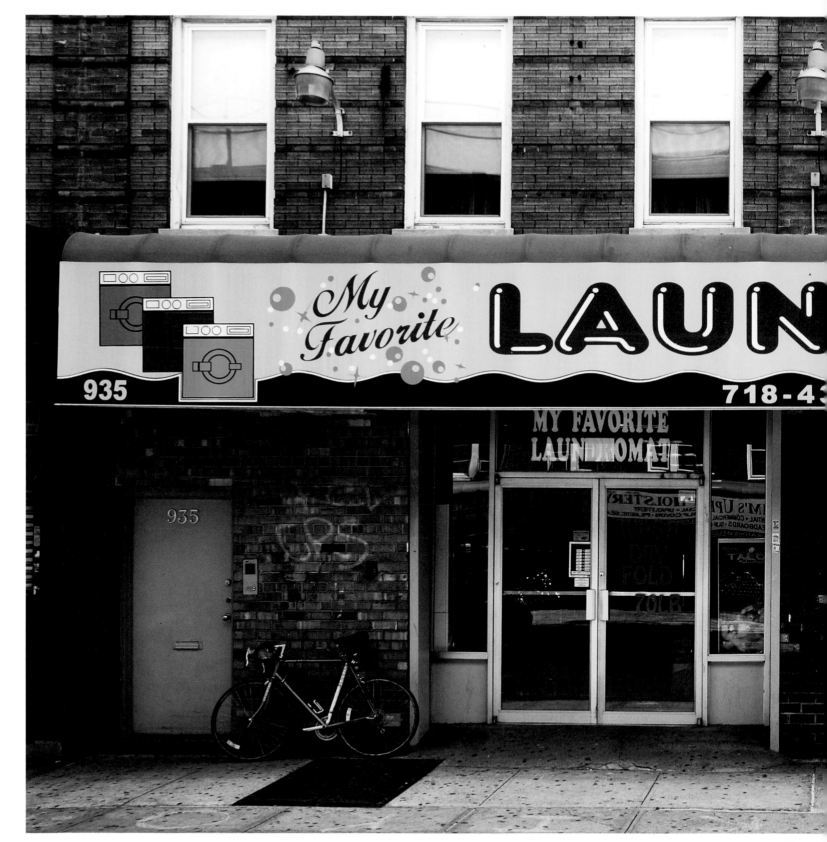

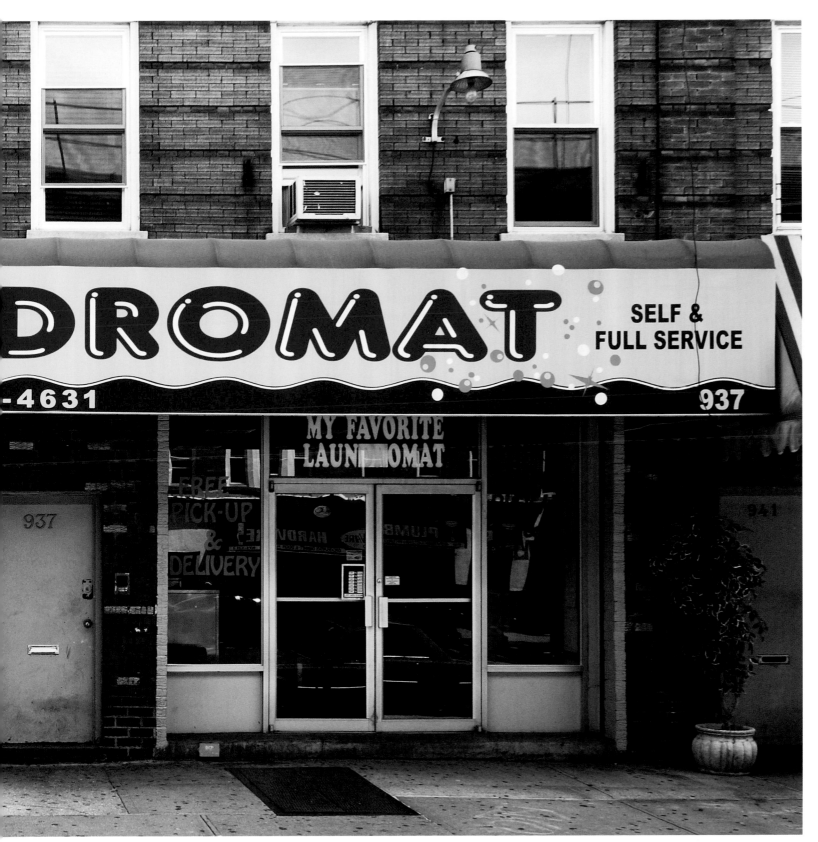

937 McDonald Avenue

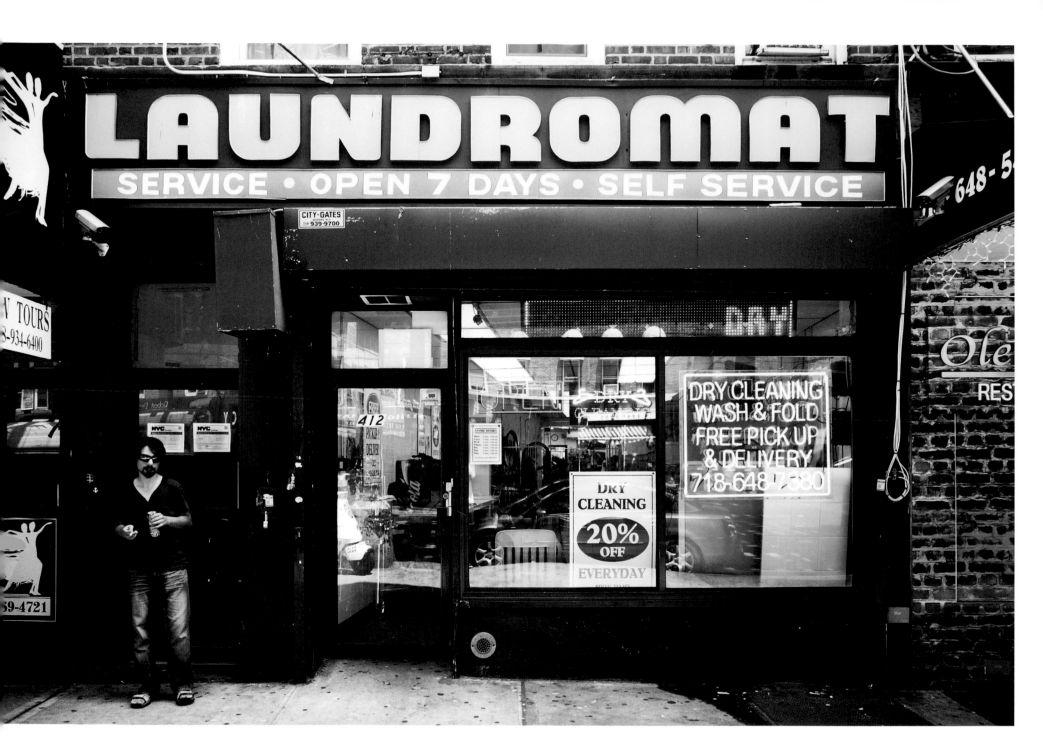

412 Brighton Beach Avenue

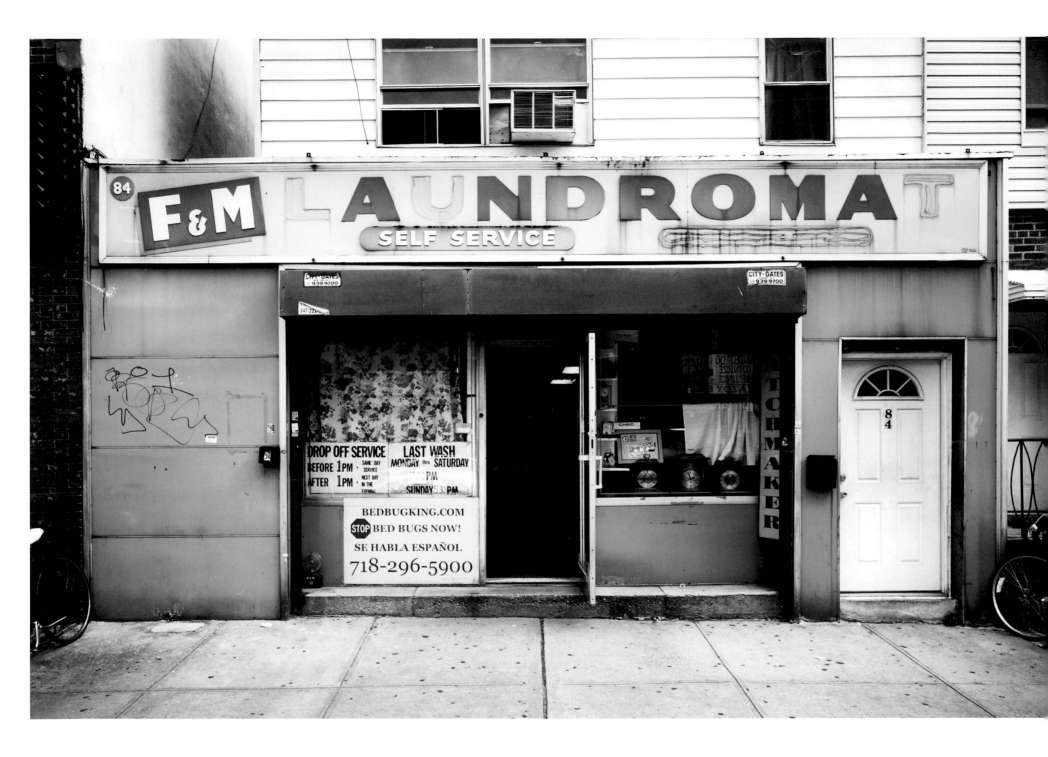

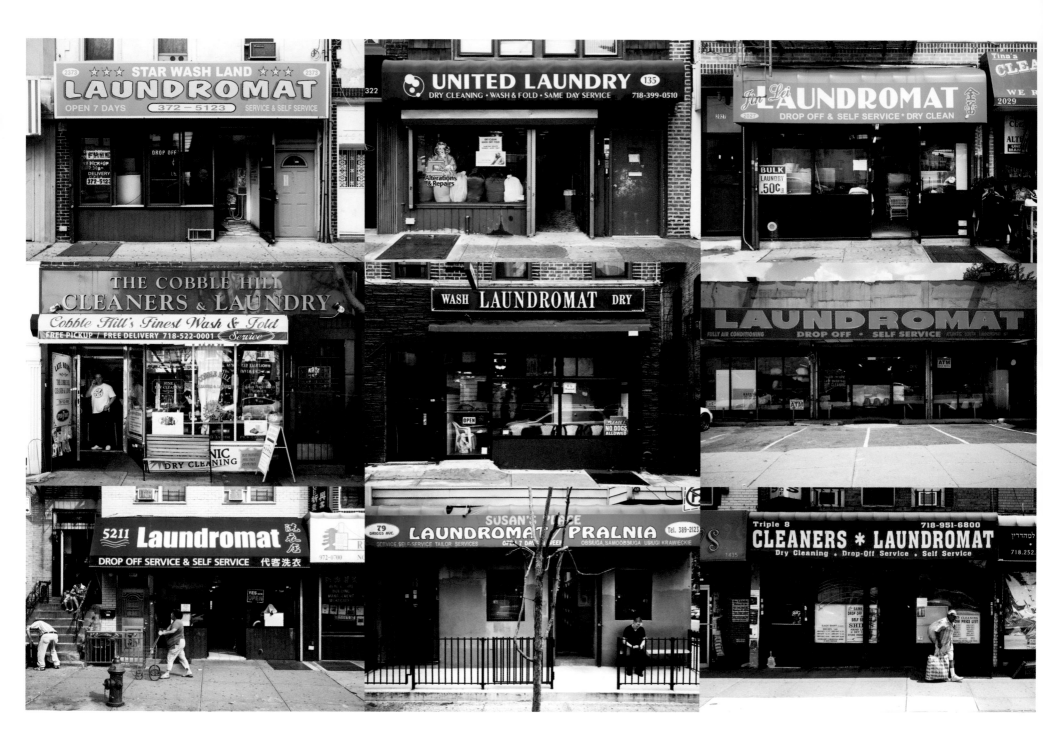

2373 86th Street

226 Court Street

5211 7th Avenue

135 7th Avenue

677 Vanderbilt Avenue

79 Driggs Avenue

2027 Stillwell Avenue

2064 Atlantic Avenue

1437 Coney Island Avenue

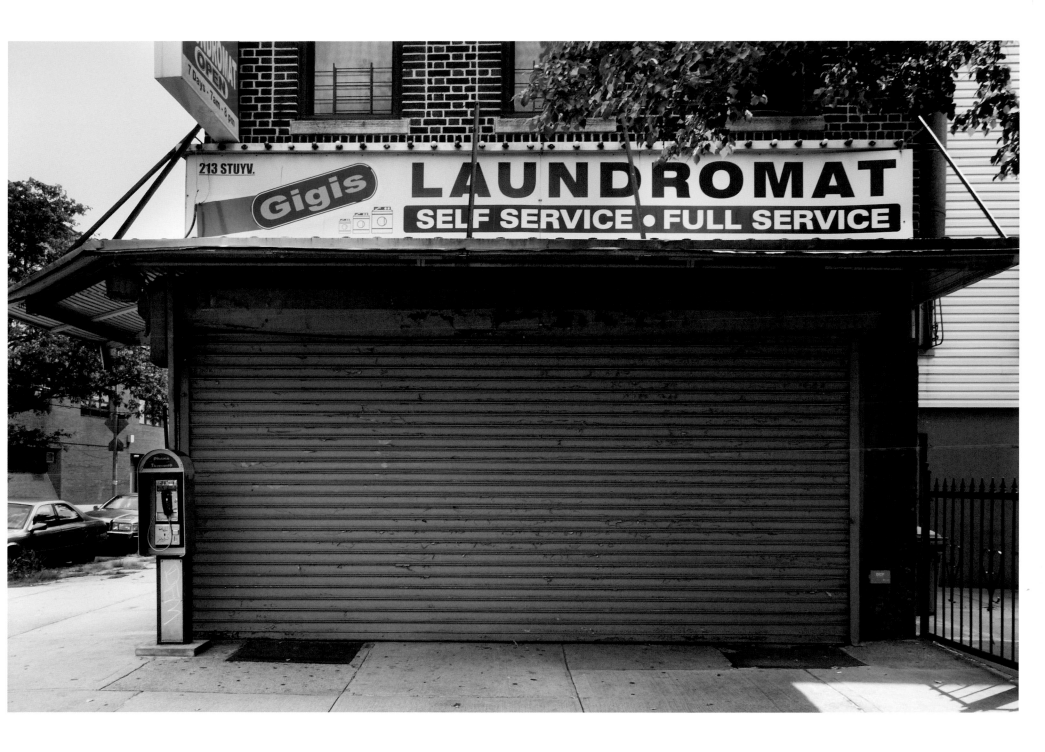

213 Stuyvesant Avenue

MANHATTAN

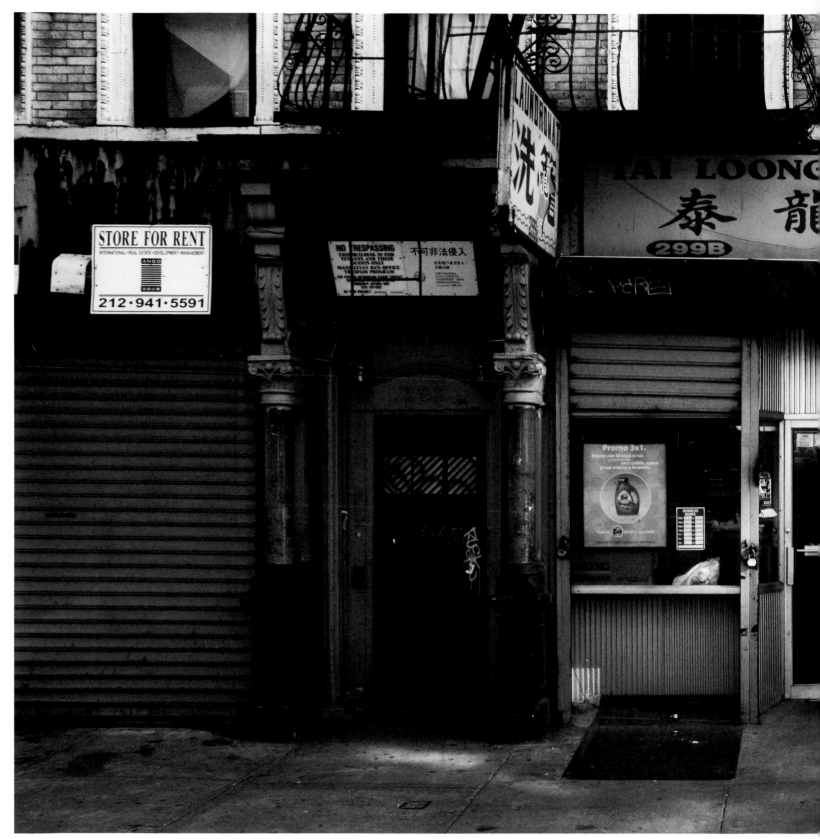

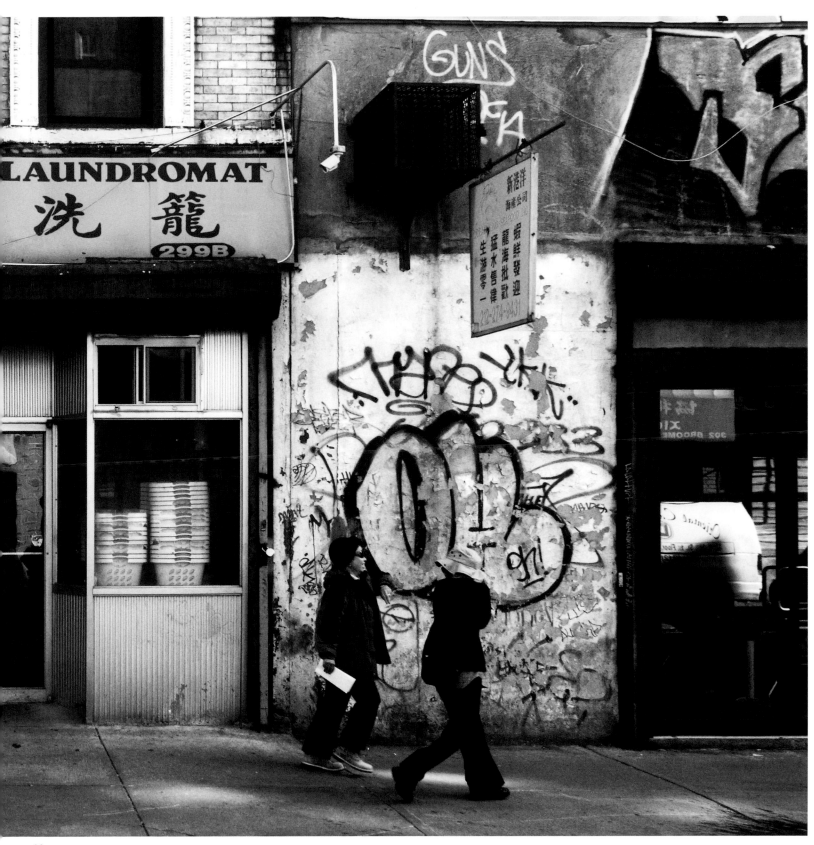

299B Broome Street

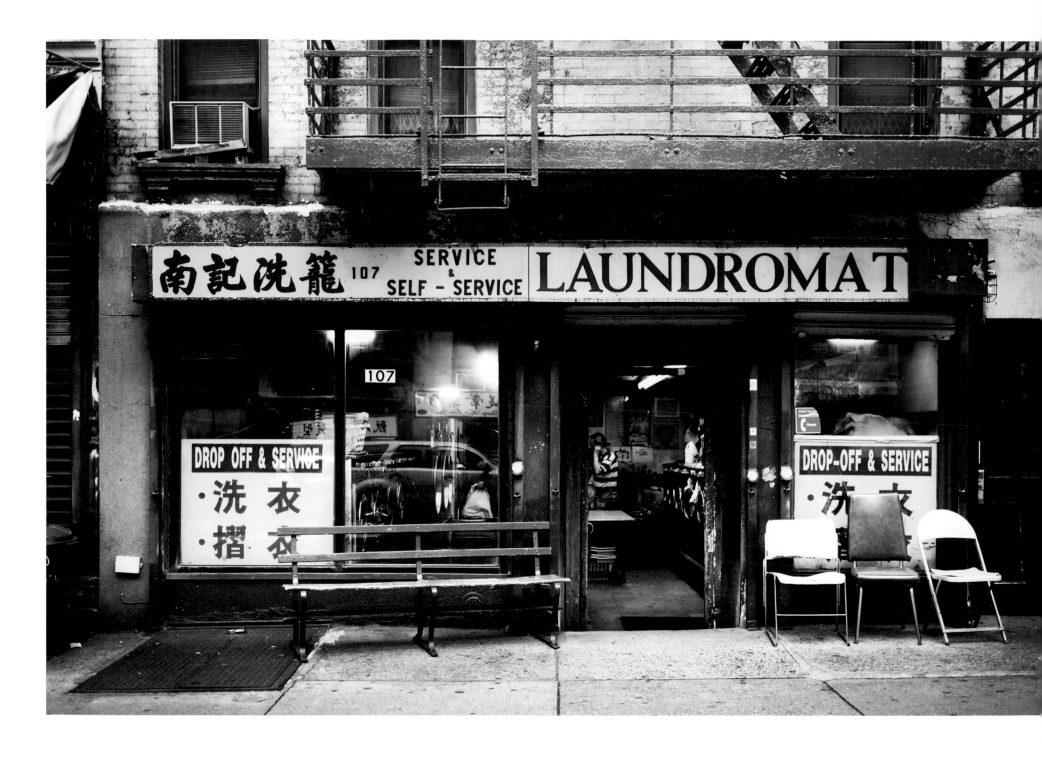

107 Madison Street

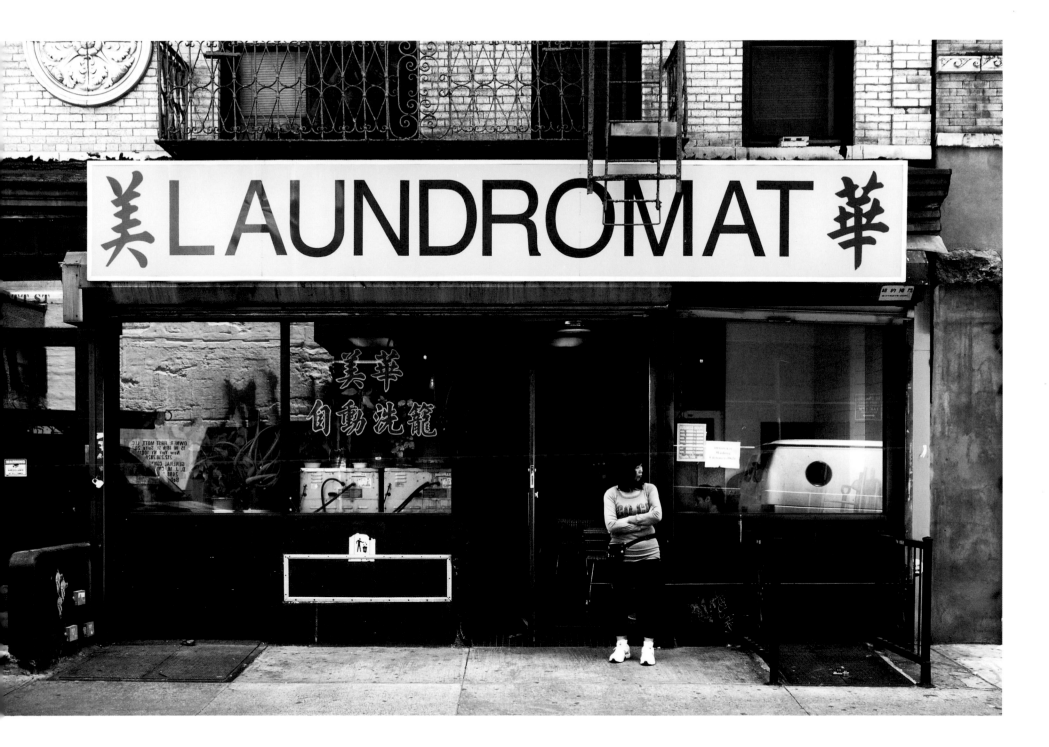

196 Mott Street

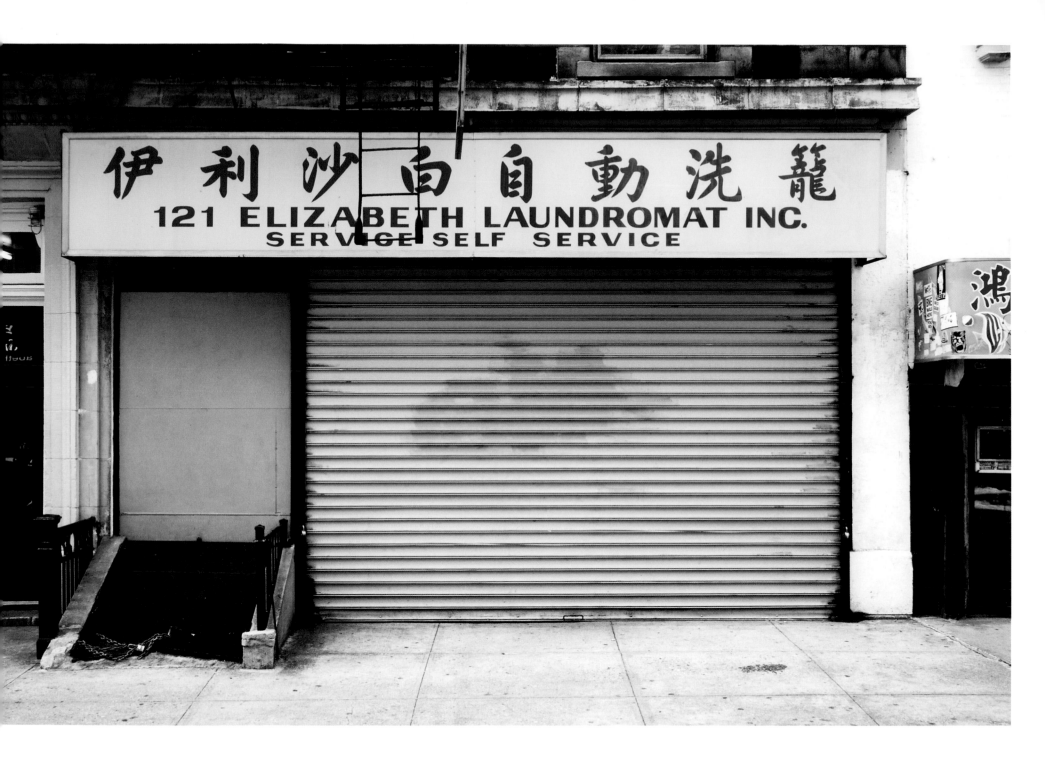

121 Elizabeth Street

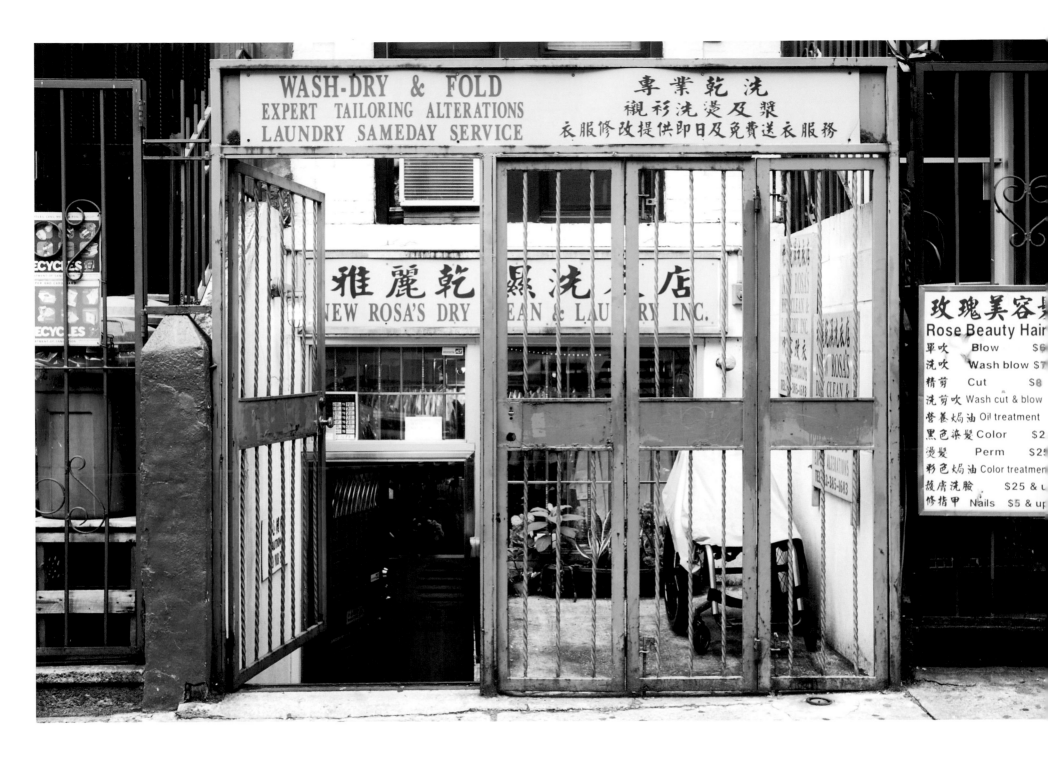

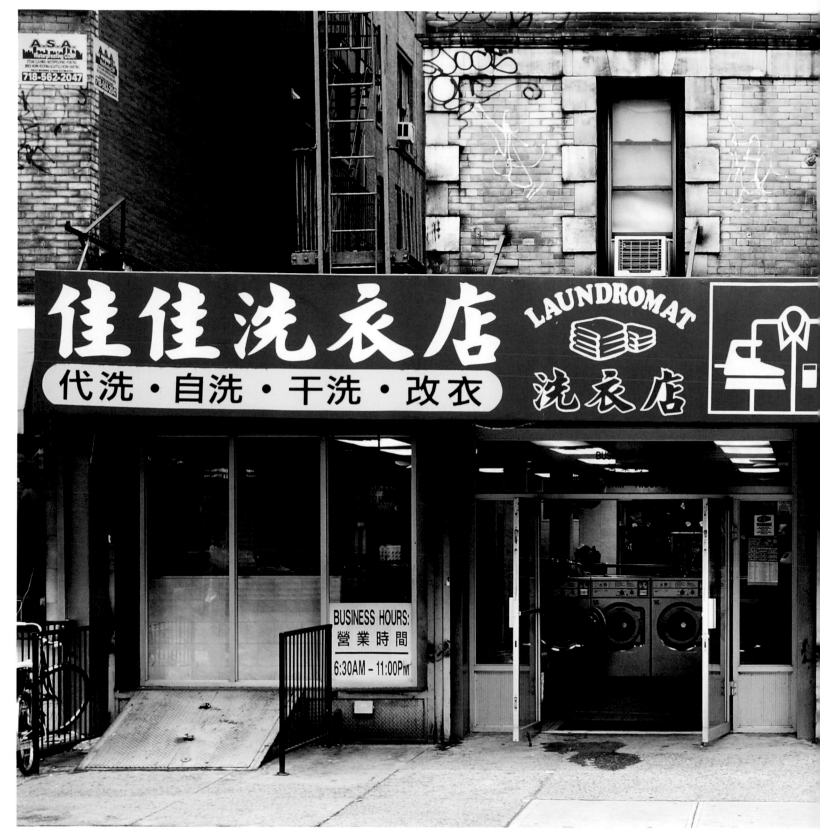

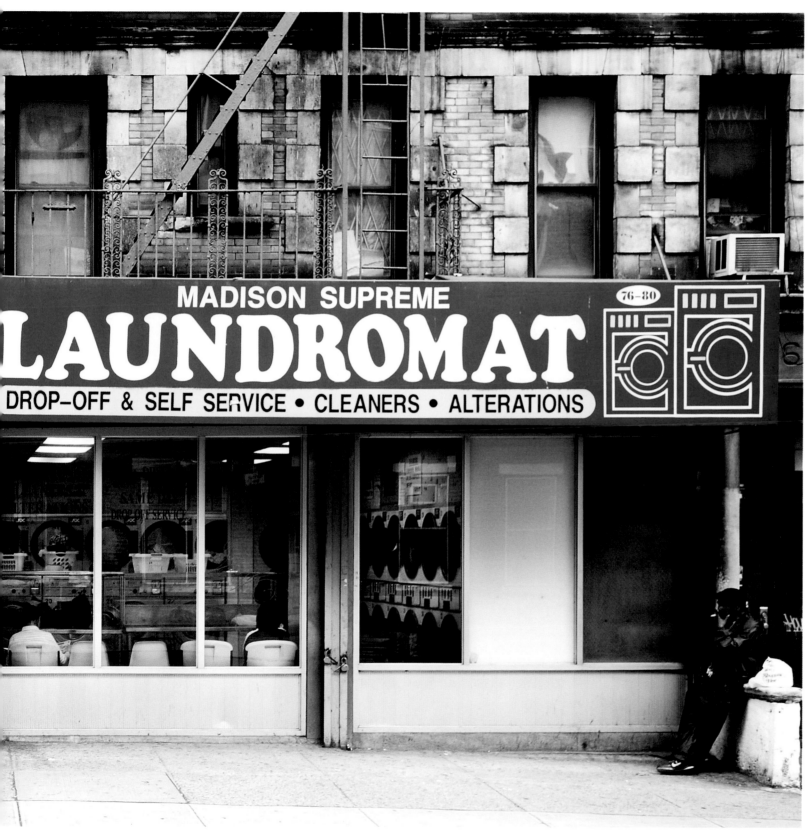

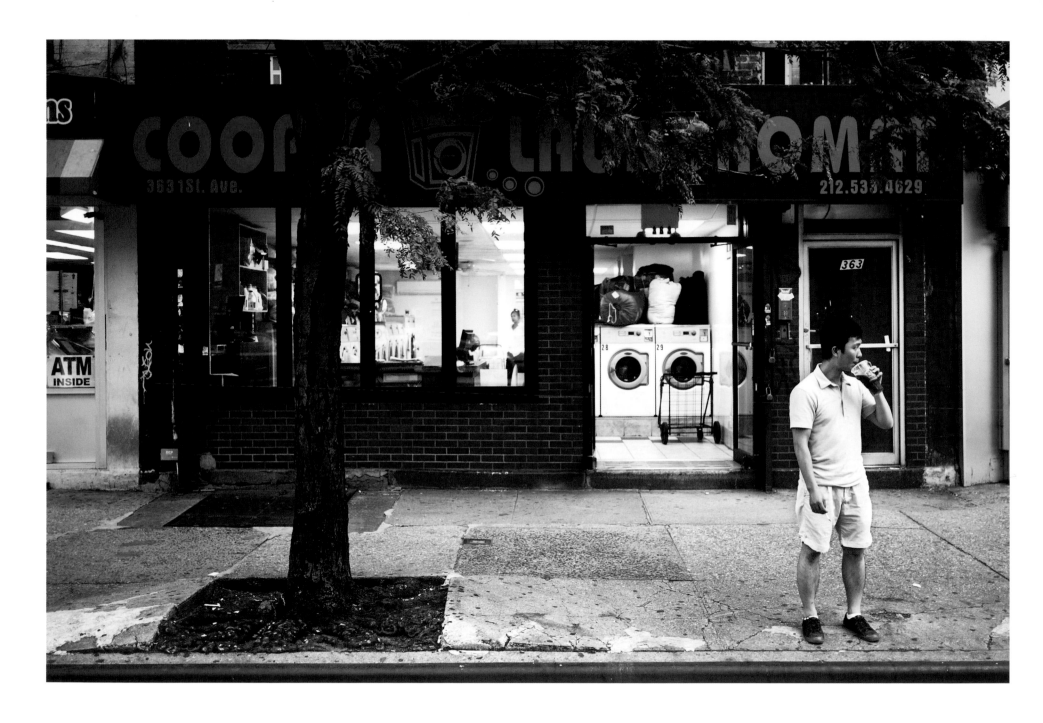

363 1st Avenue

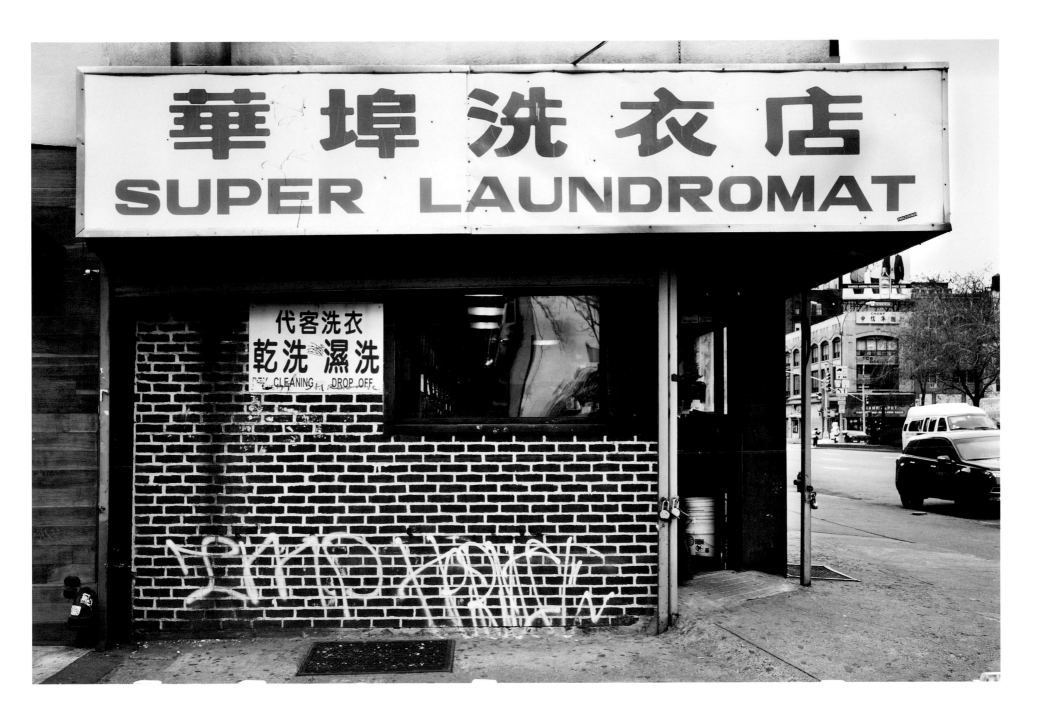

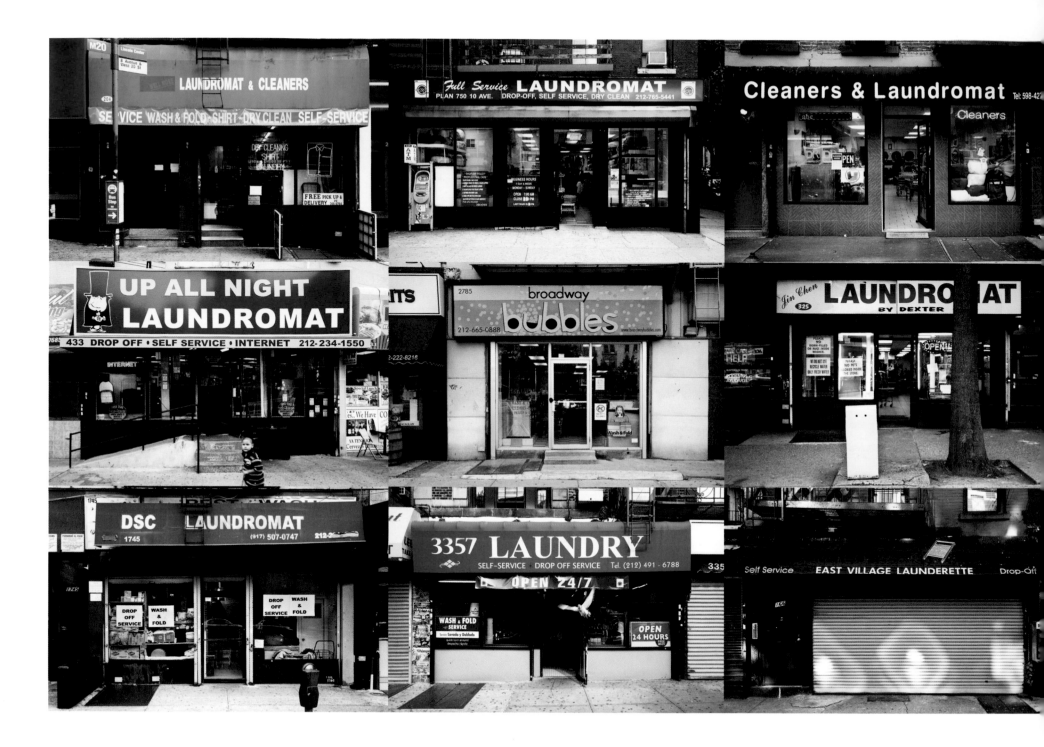

204 8th Avenue

750 10th Avenue

259 3rd Avenue

433 Edgecombe Avenue

2785 Broadway

325 1st Avenue

1745 Amsterdam Avenue

3357 Broadway

166 Avenue B

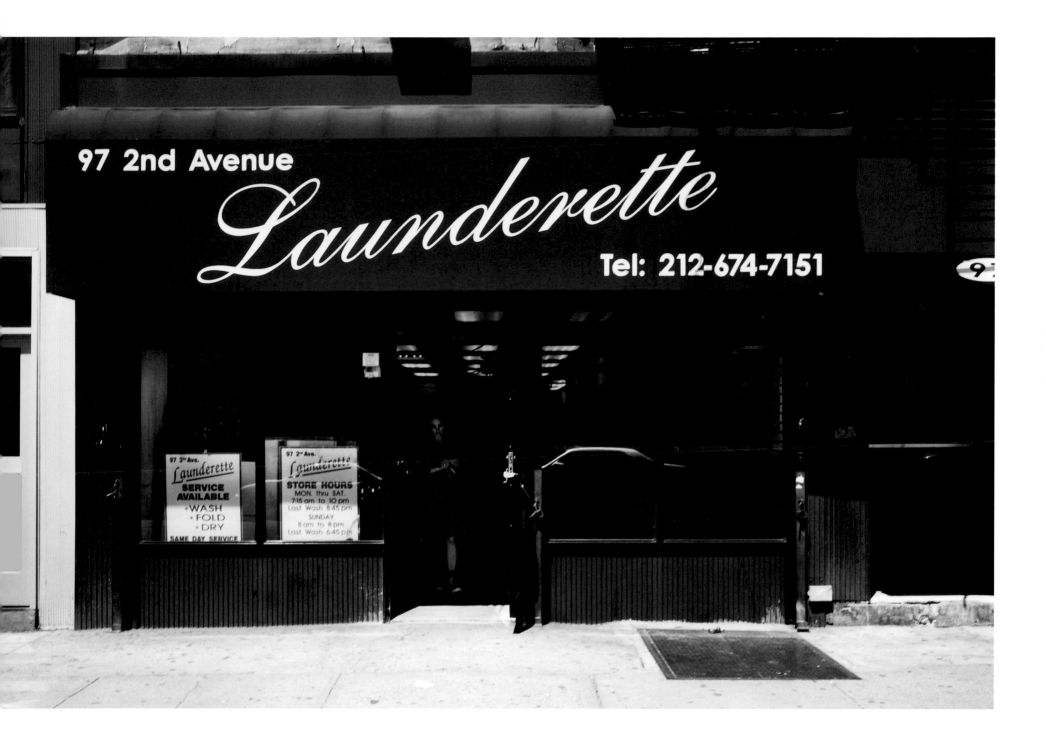

97 2nd Avenue

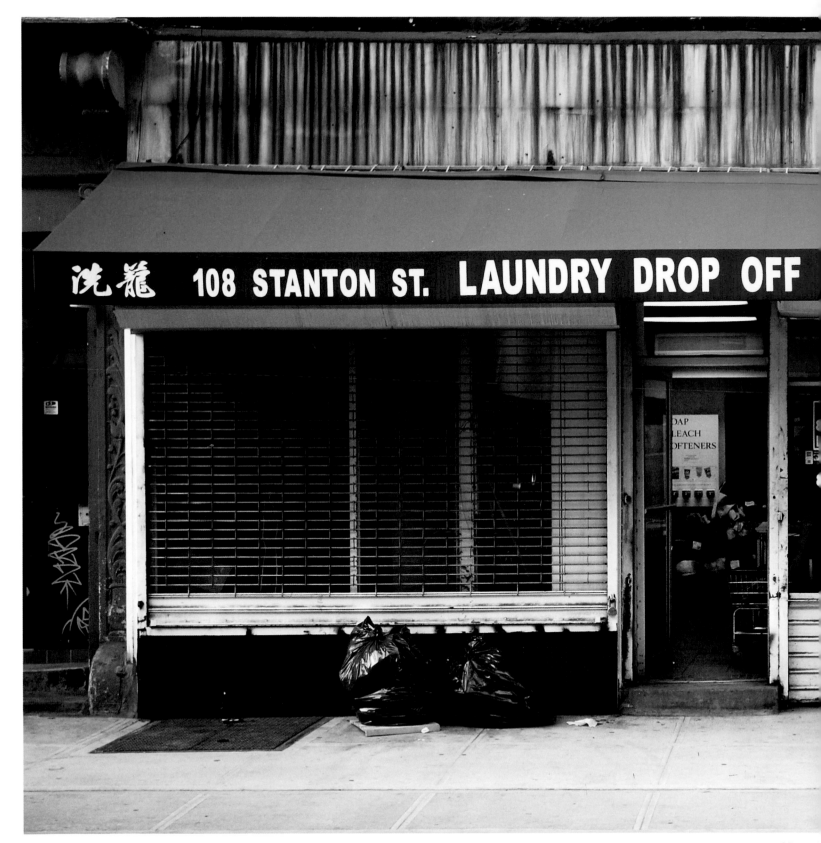

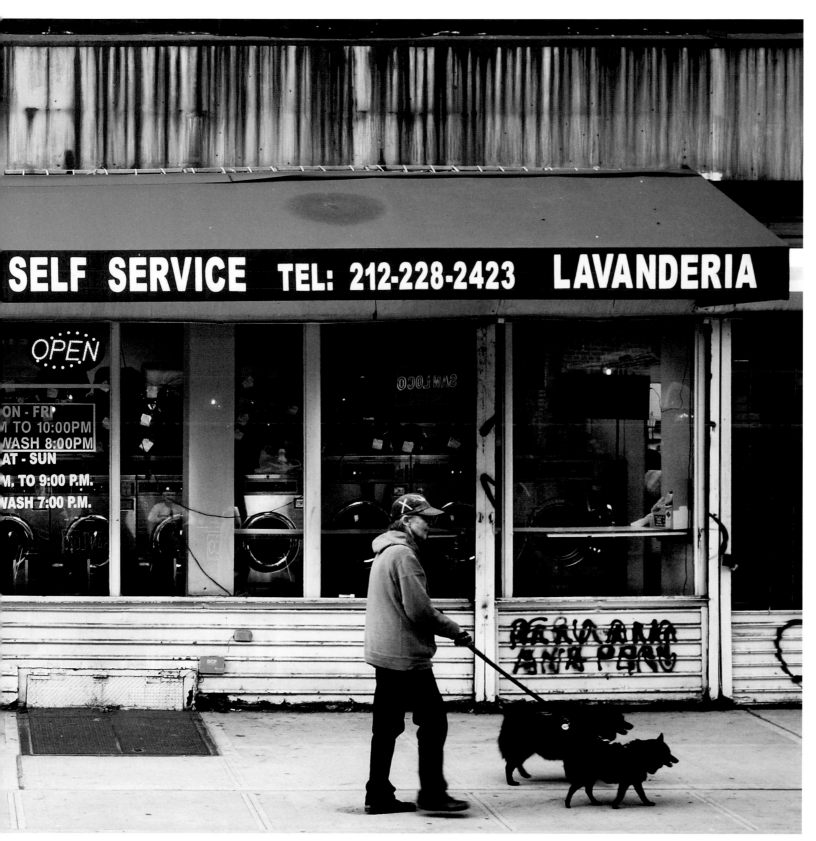

SELF SERVICE TEL: 212-228-2423 LAVANDERIA

OPEN

ON - FRI
M TO 10:00PM
WASH 8:00PM
AT - SUN
M, TO 9:00 P.M.
WASH 7:00 P.M.

108 Stanton Street

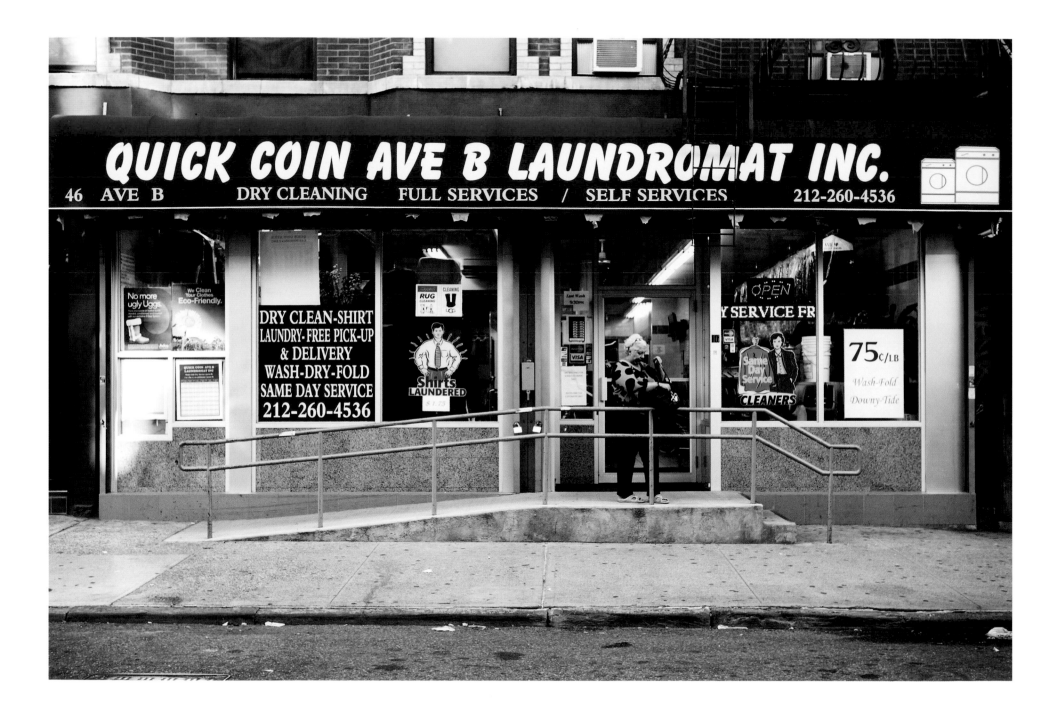

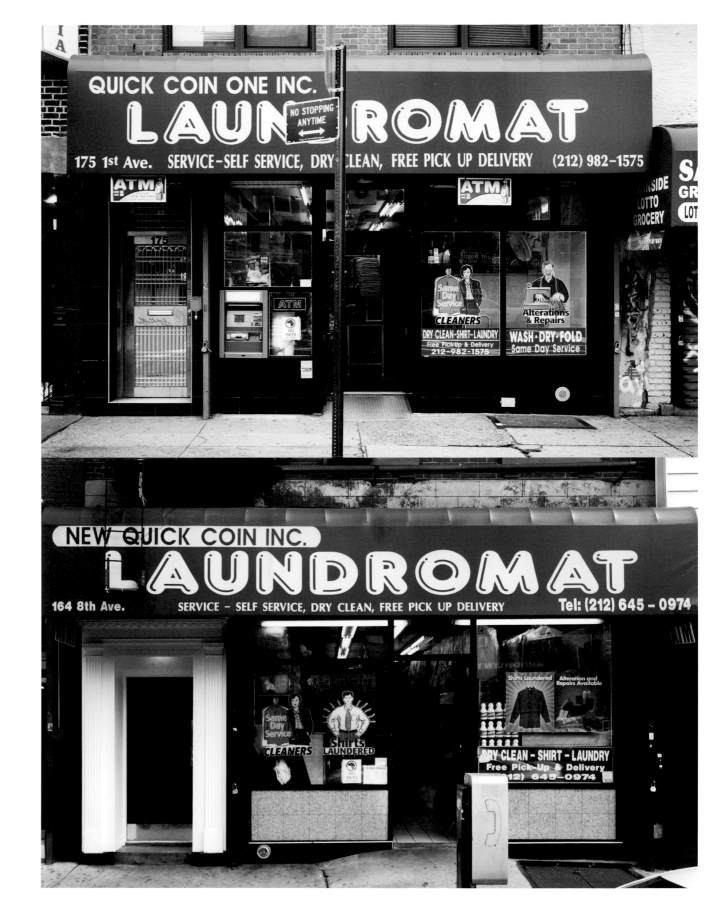

175 1st Avenue

164 8th Avenue

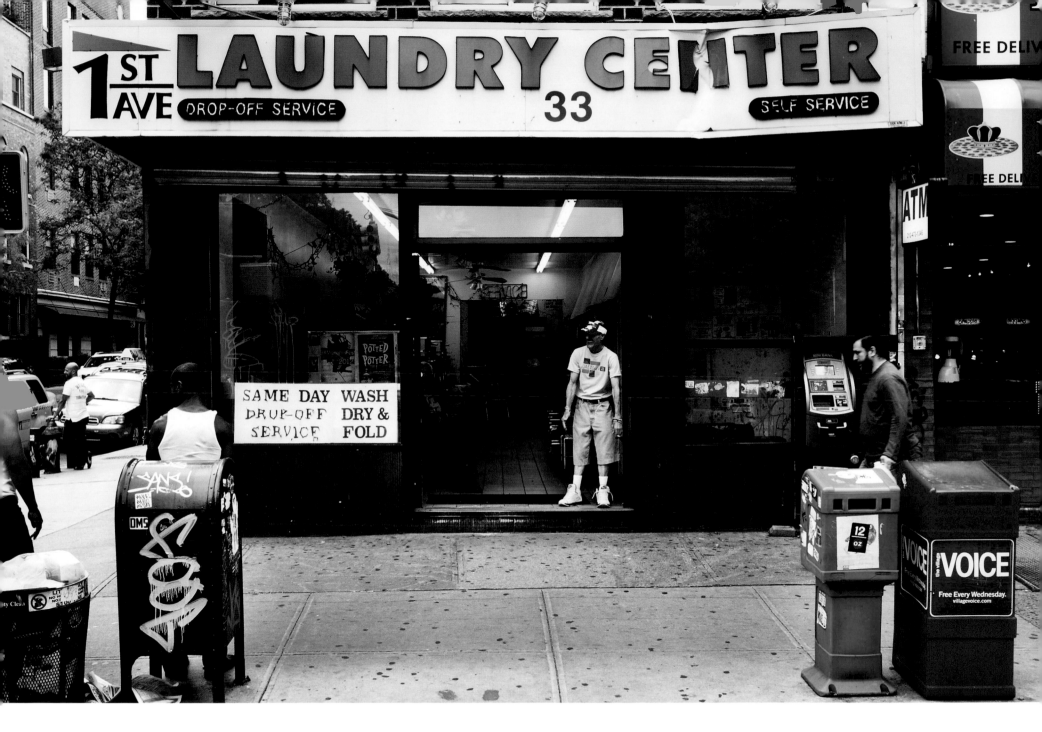

33 1st Avenue

84

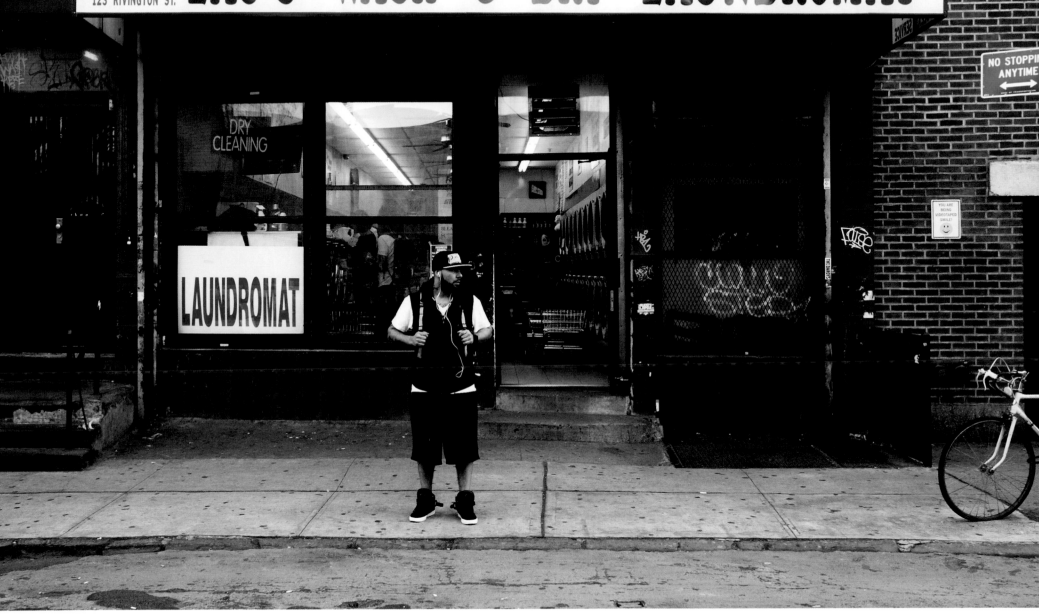

123 Rivington Street

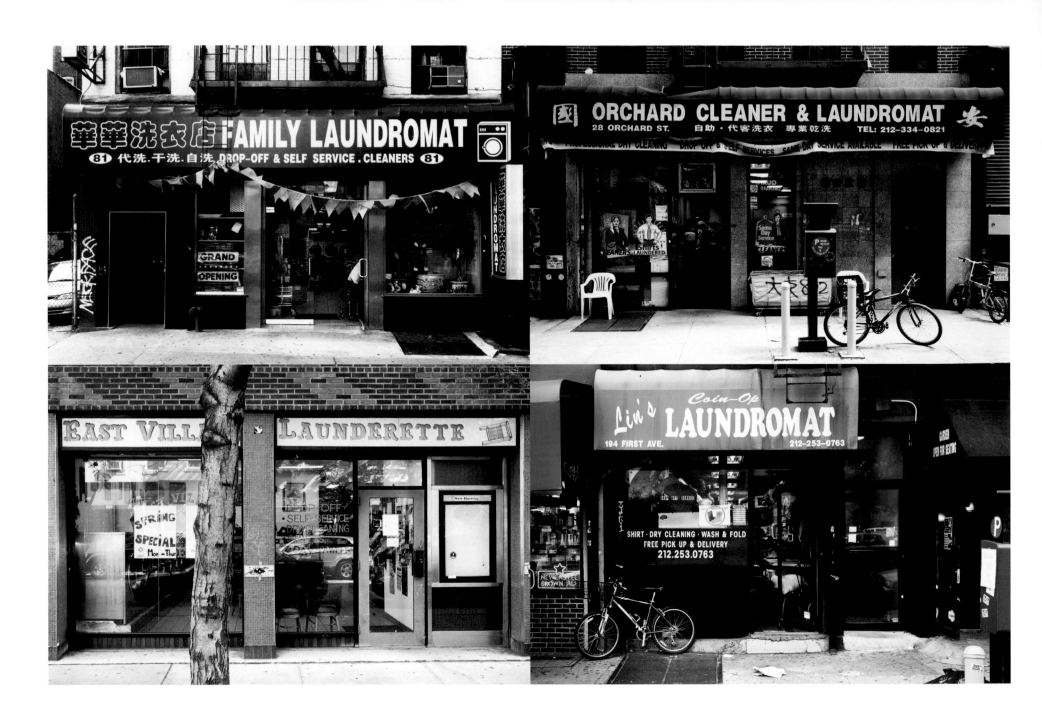

81 Eldridge Street

153 East 3rd Street

28 Orchard Street

194 1st Avenue

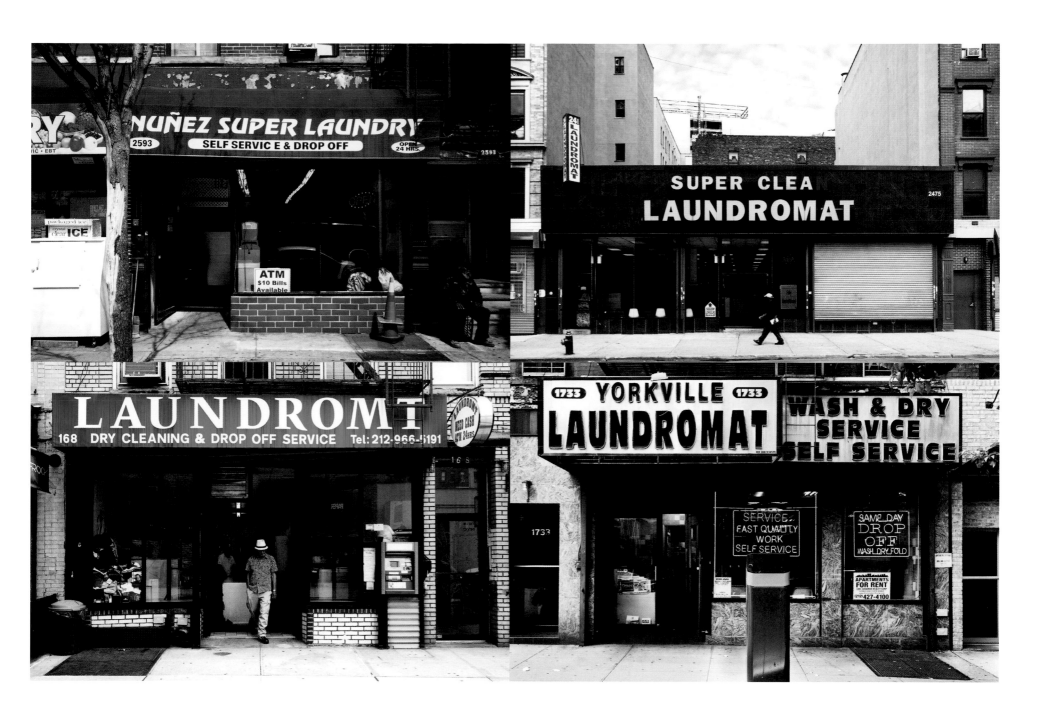

2593 Frederick Douglass Boulevard

168 Elizabeth Street

2475 Frederick Douglass Boulevard

1733 2nd Avenue

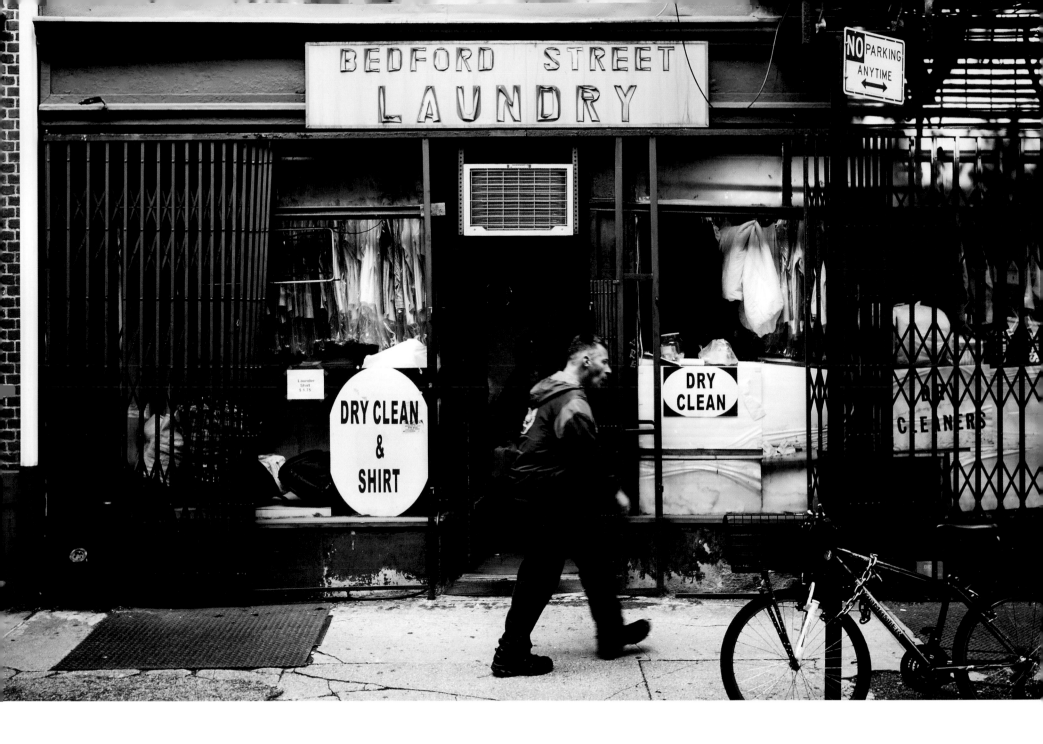

16 Bedford Street

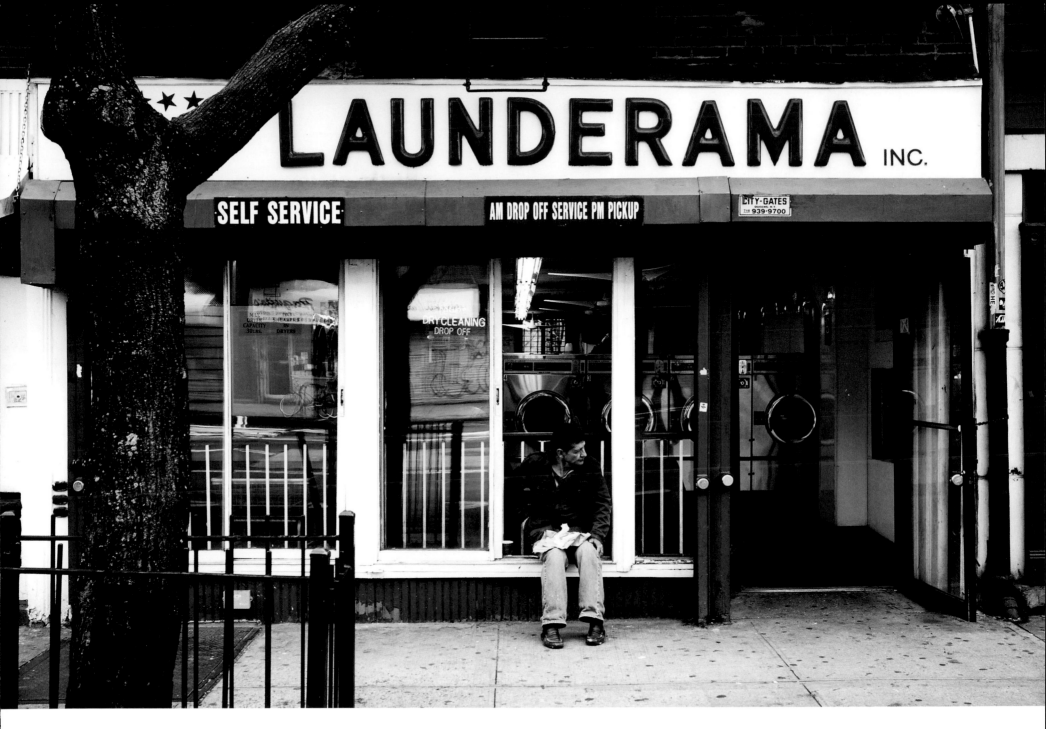

142 1st Avenue

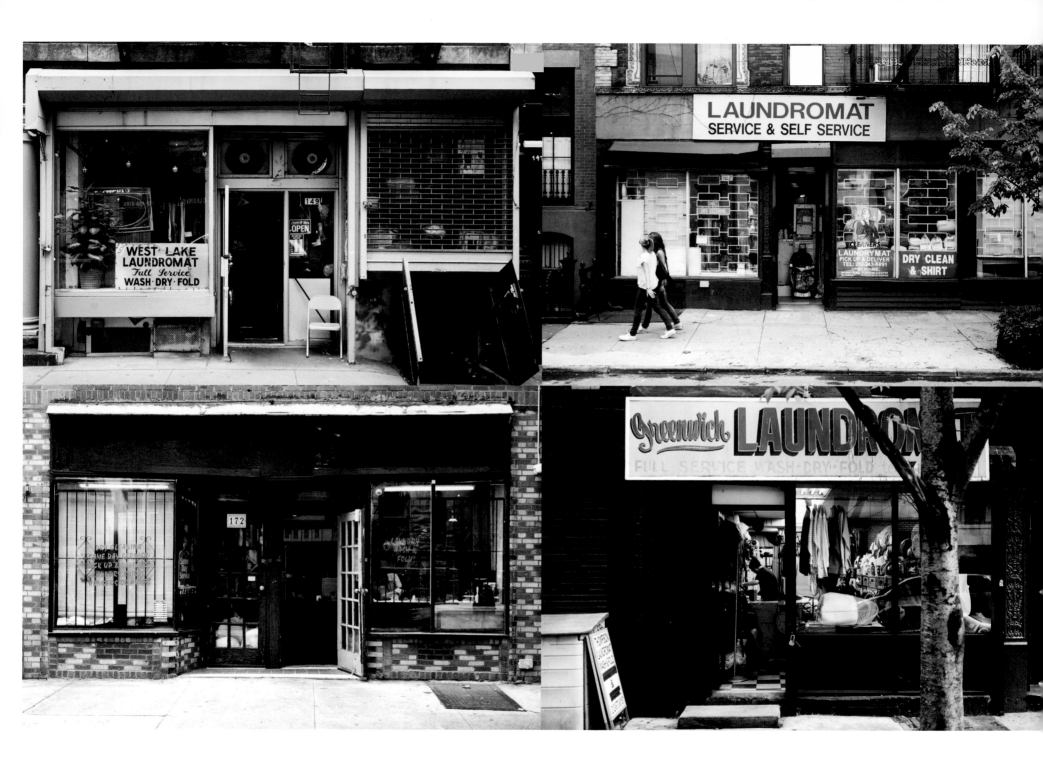

149 Sullivan Street

172 Waverly Place

296 West 4th Street

177 Thompson Street

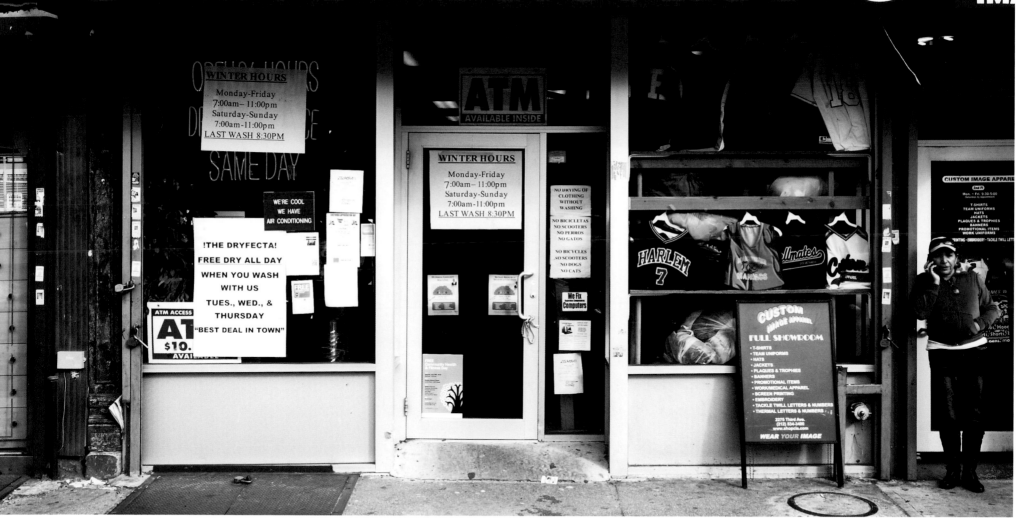

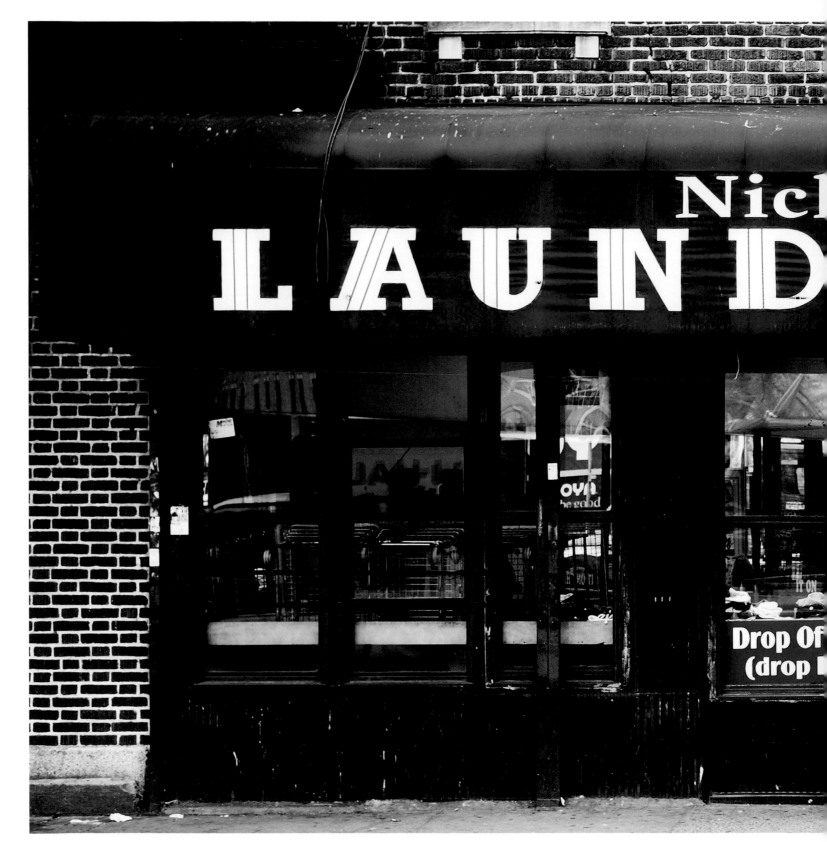

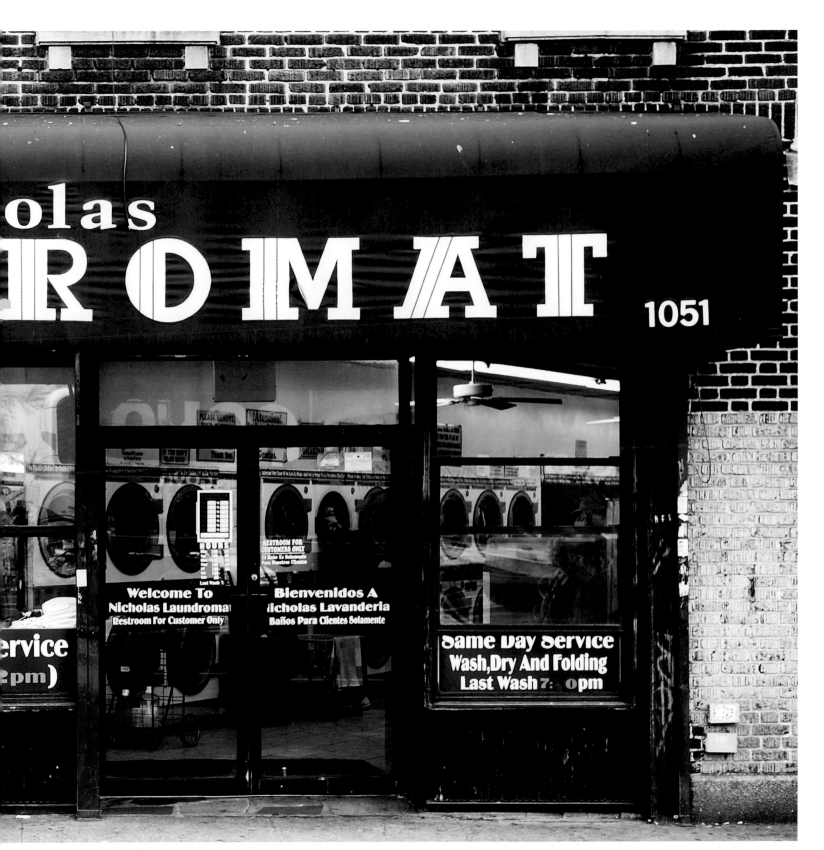

1051 Saint Nicholas Avenue

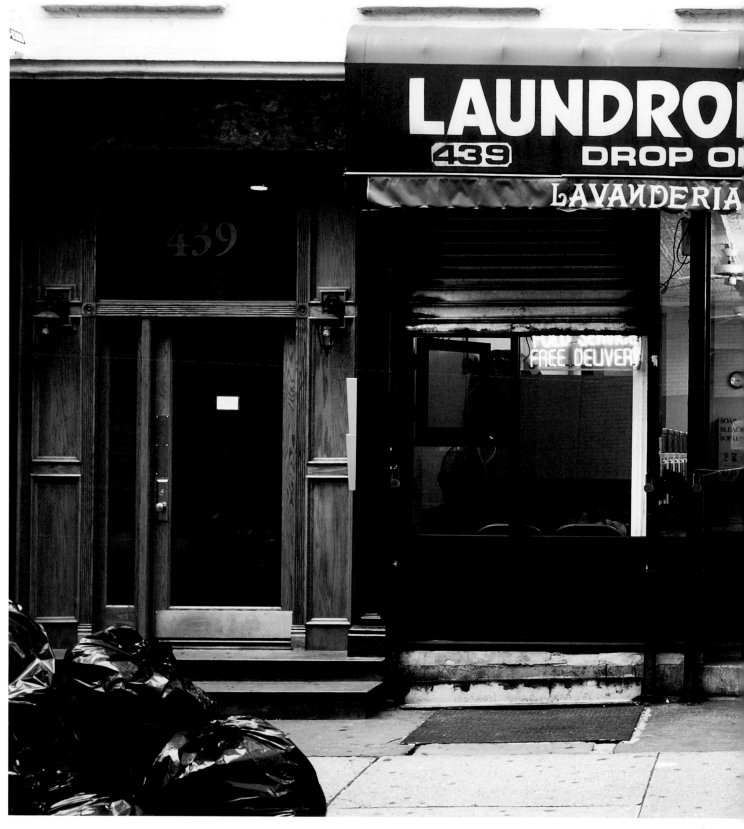

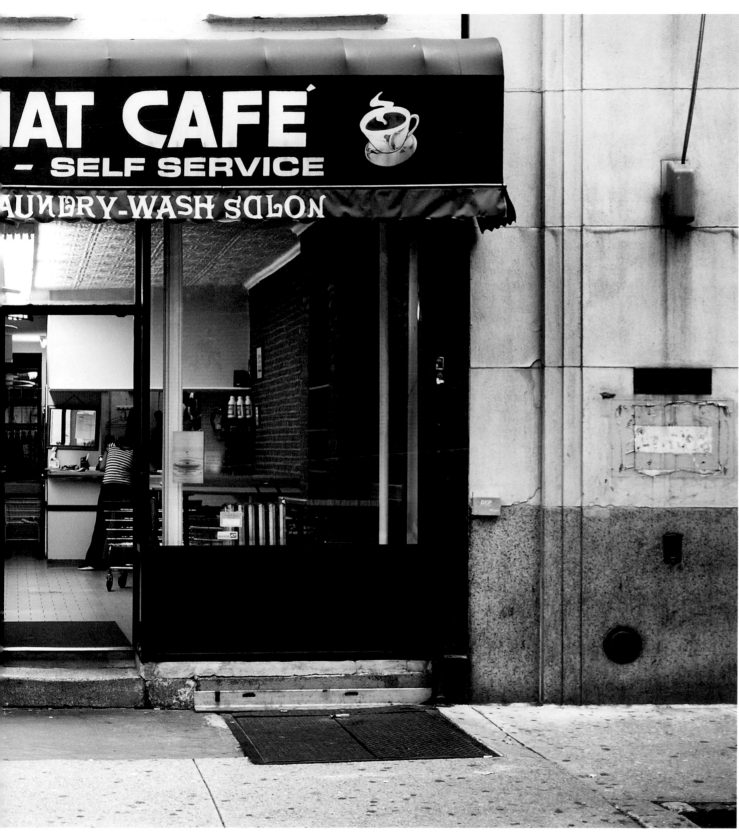

439 West 50th Street

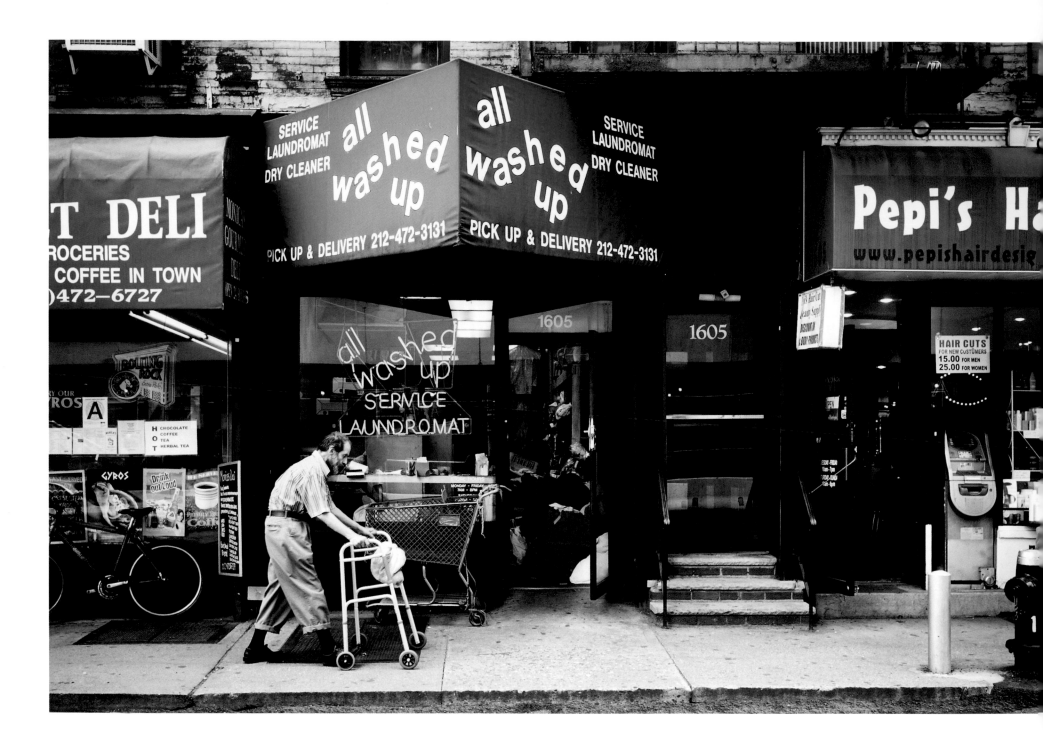

1605 2nd Avenue

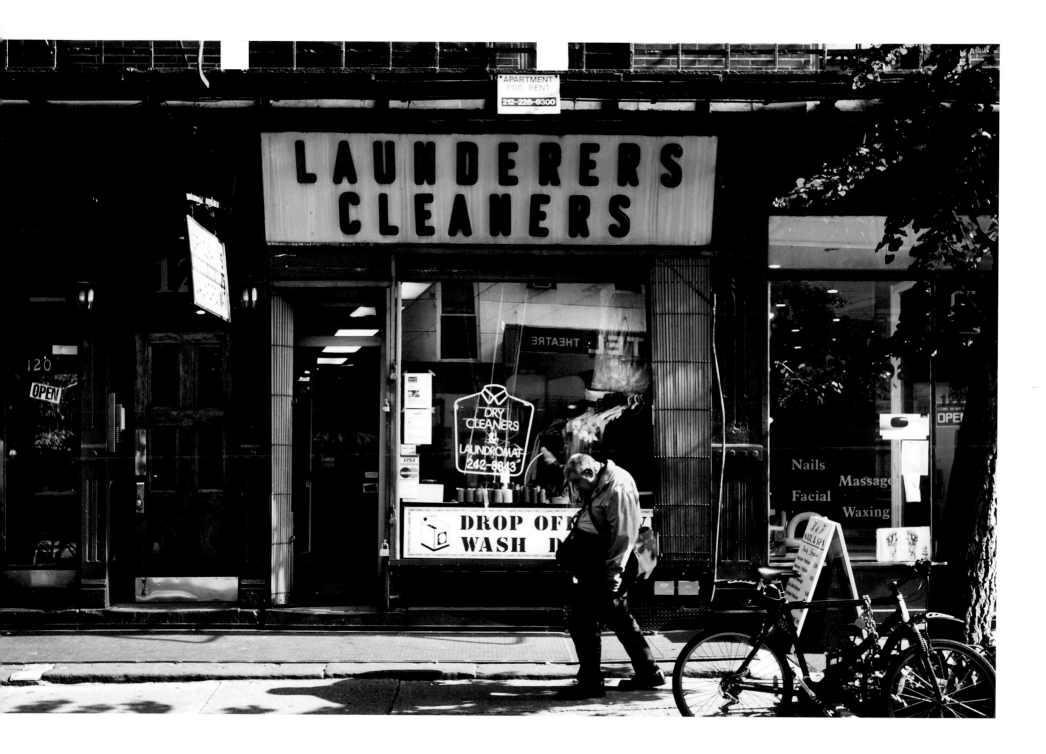

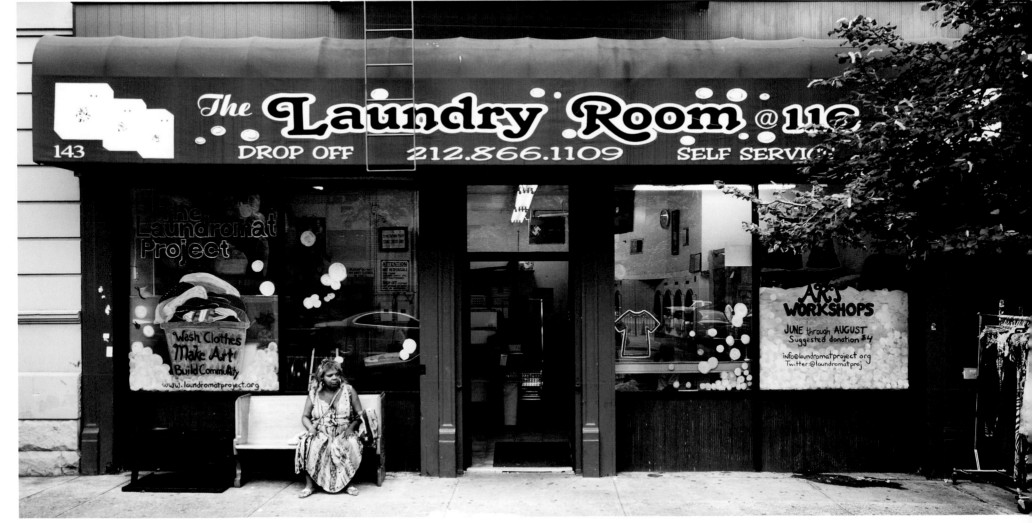

143 West 116th Street

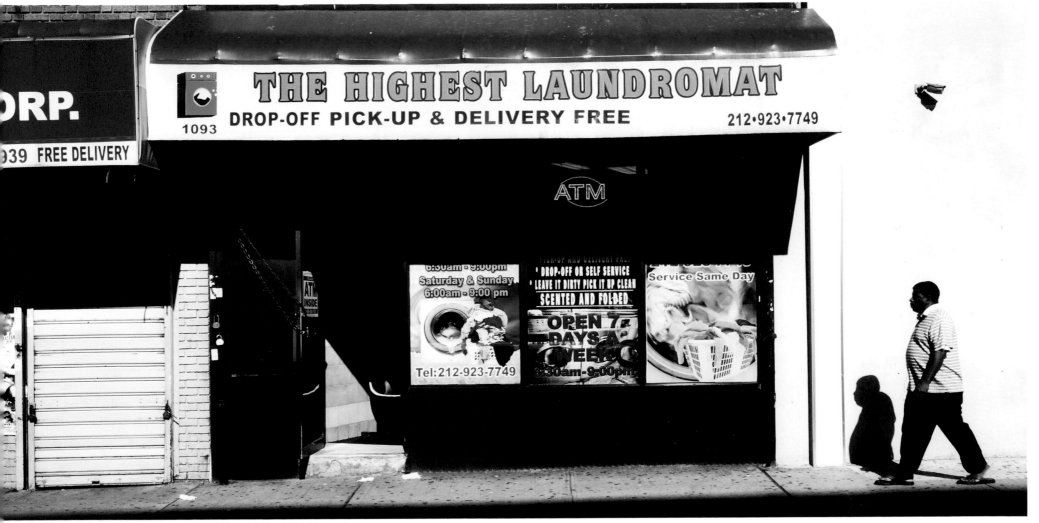

1093 Saint Nicholas Avenue

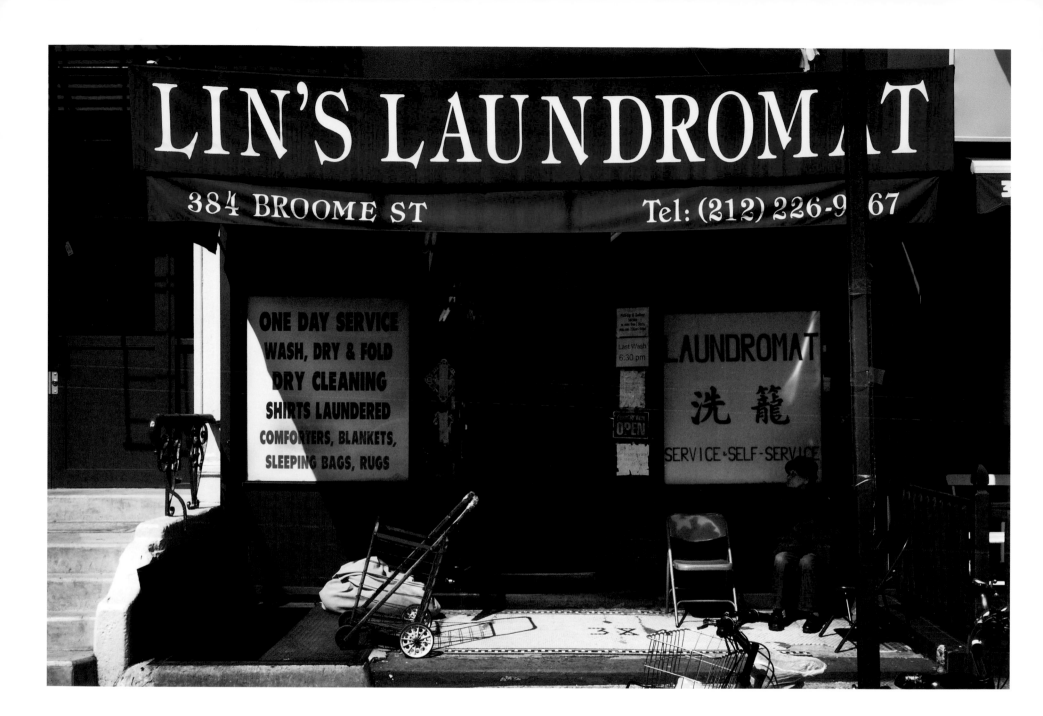

384 Broome Street

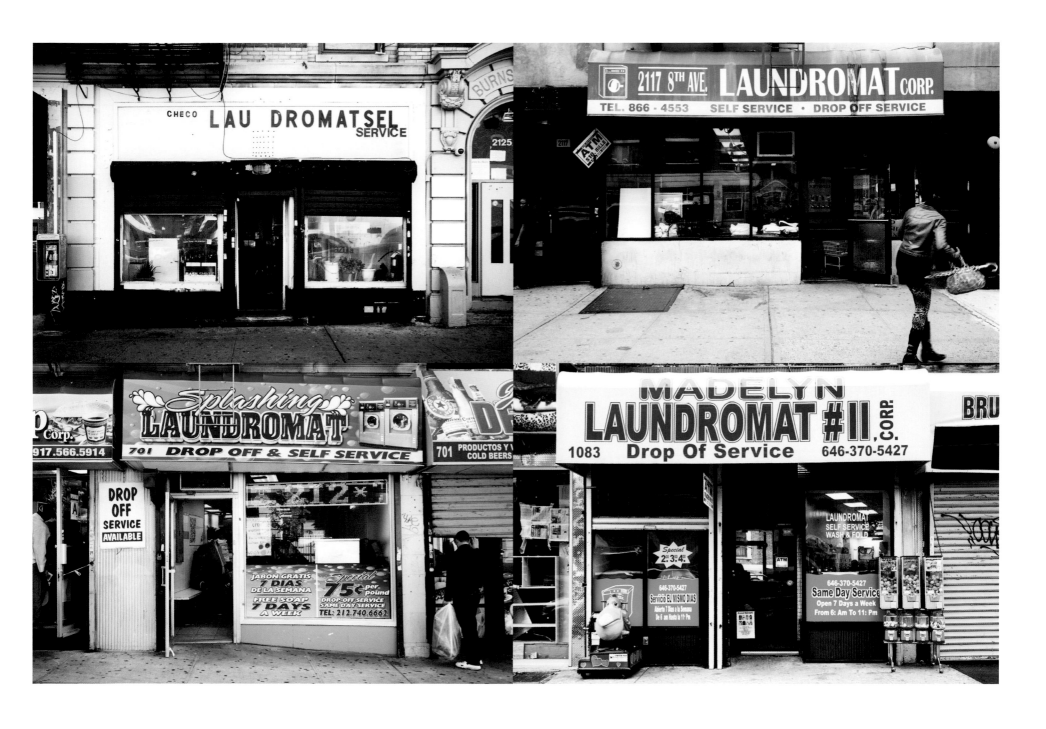

2125 Amsterdam Avenue

701 West 180th Street

2117 8th Avenue

1083 Saint Nicholas Avenue

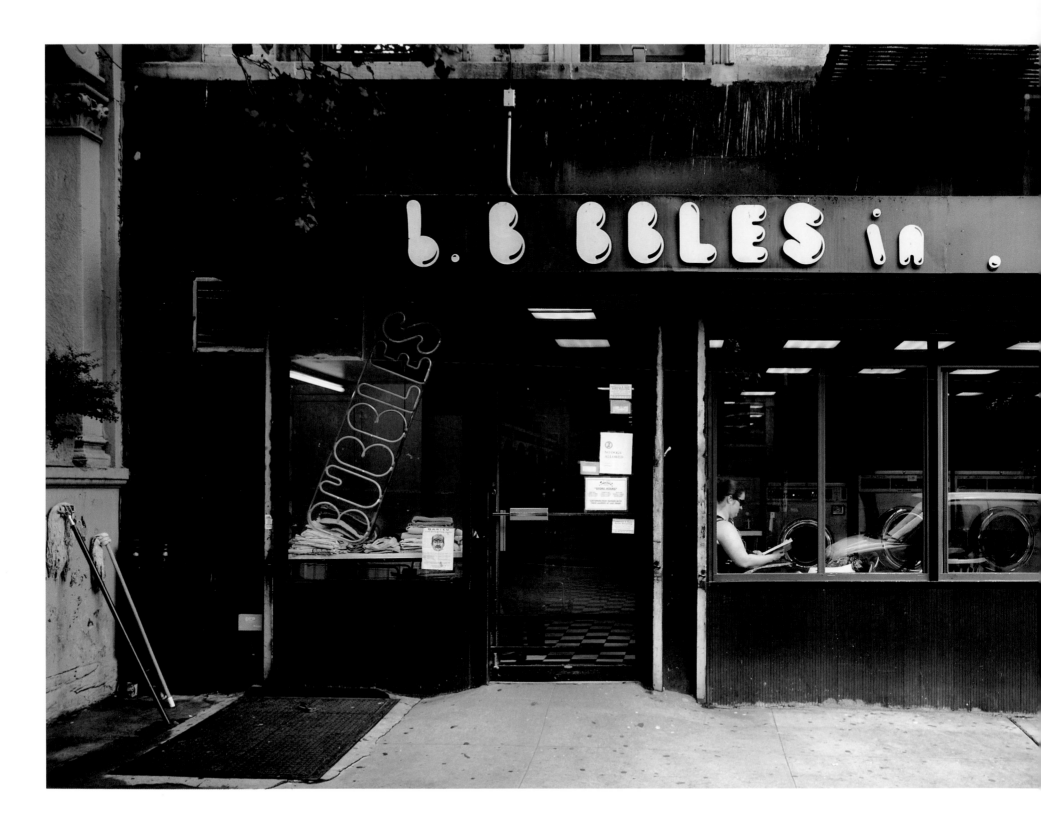

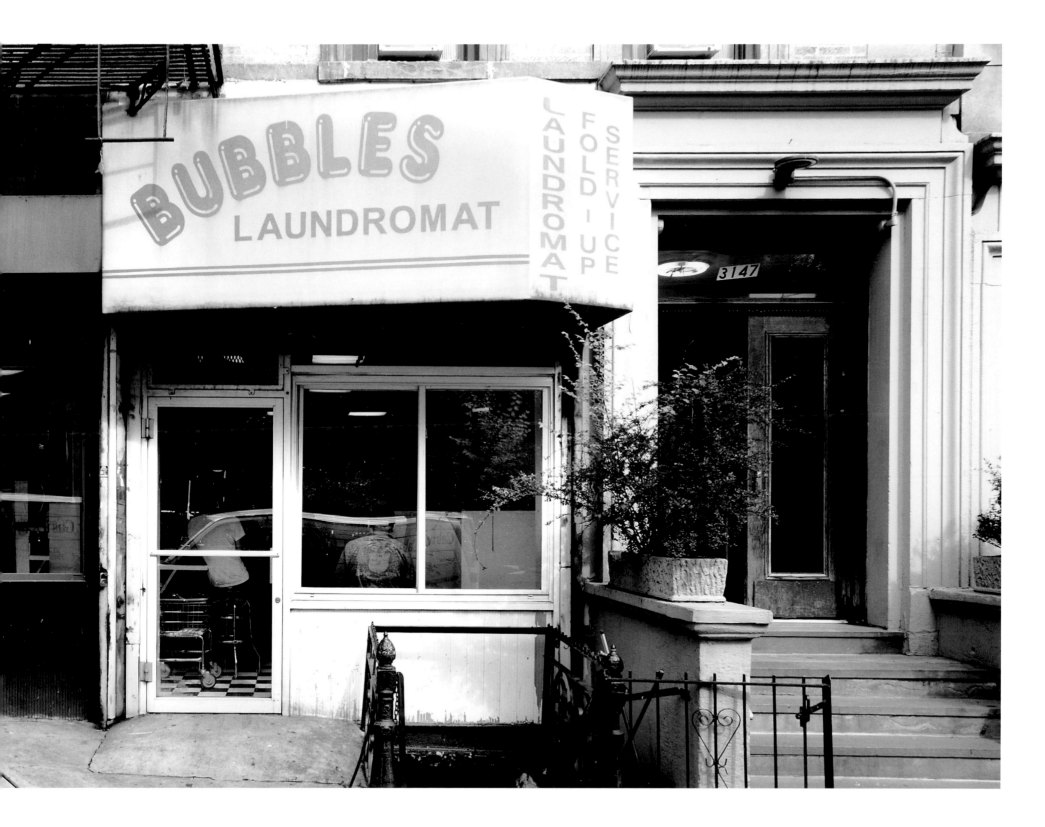

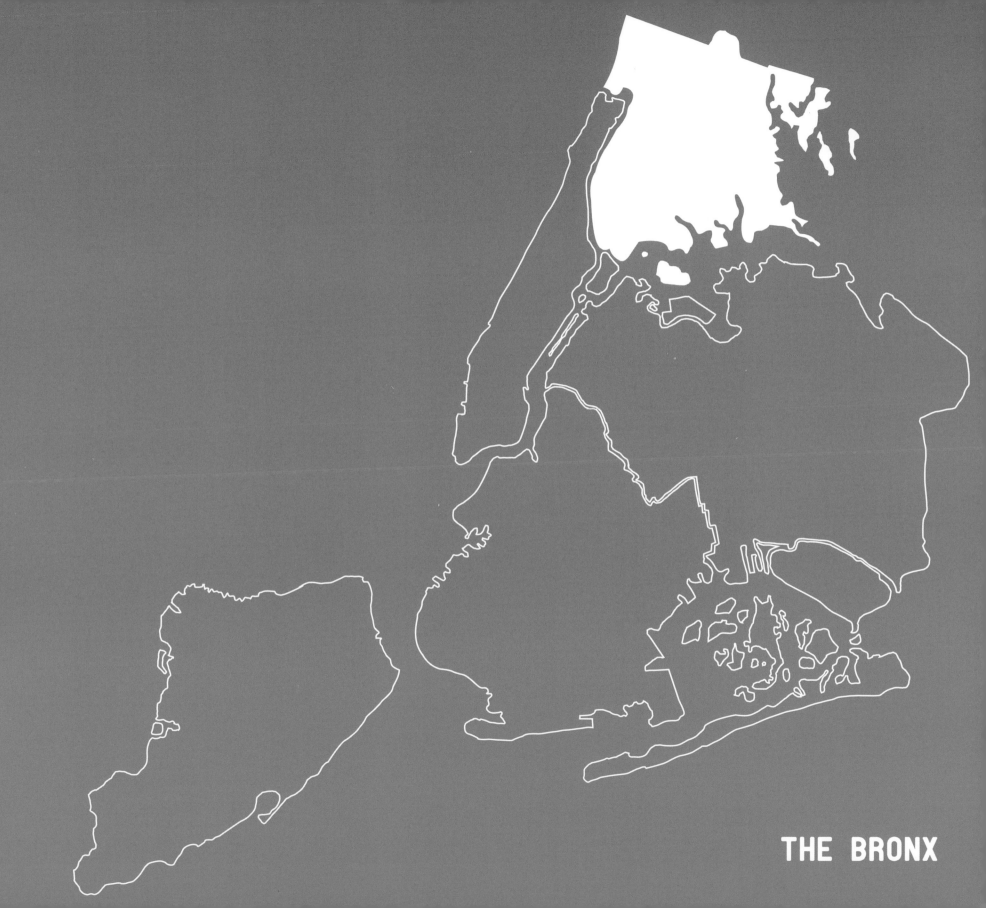

THE BRONX

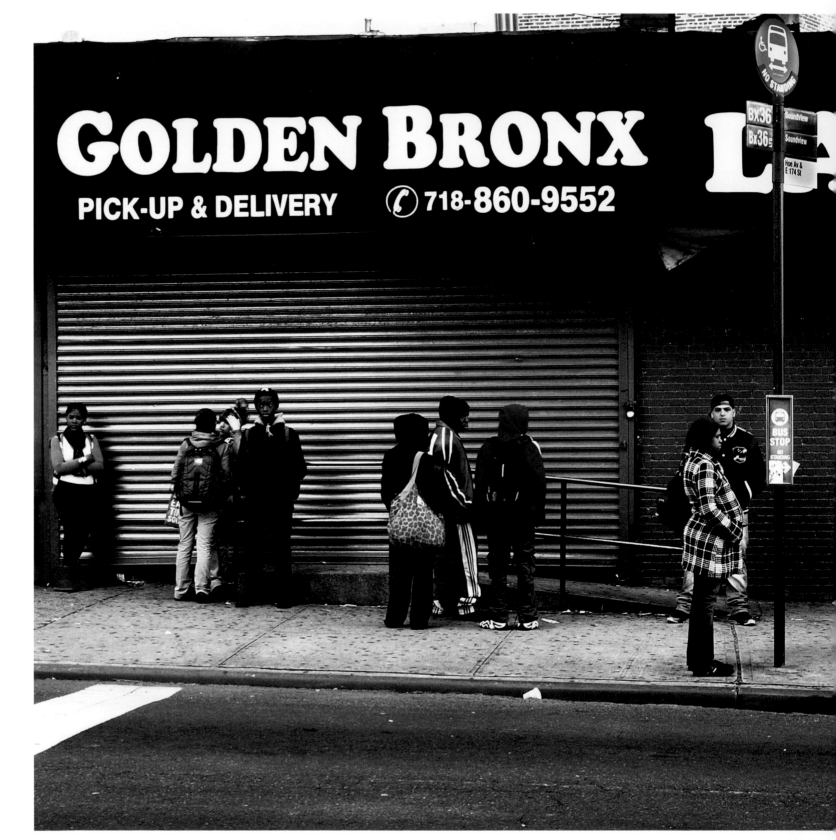

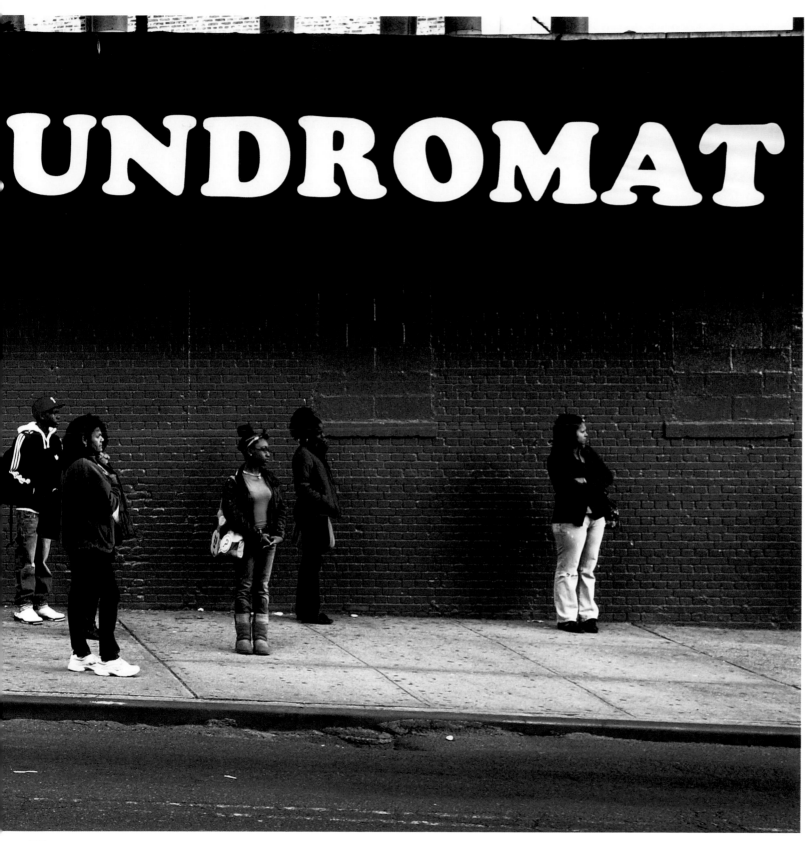

933 East 174th Street

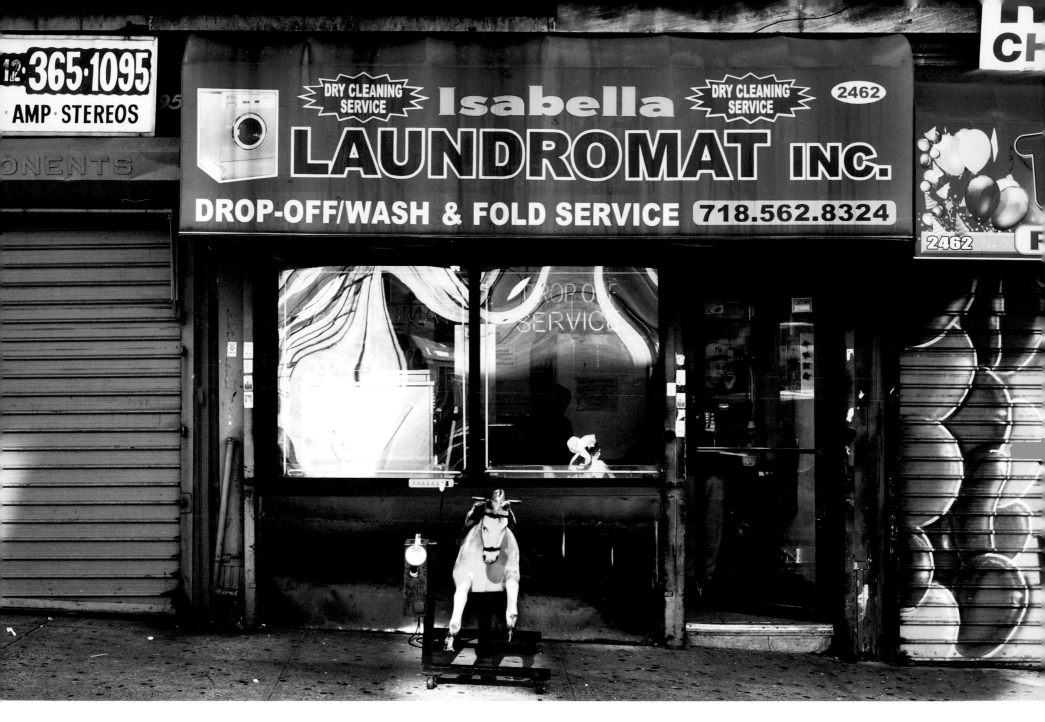

2462 Valentine Avenue

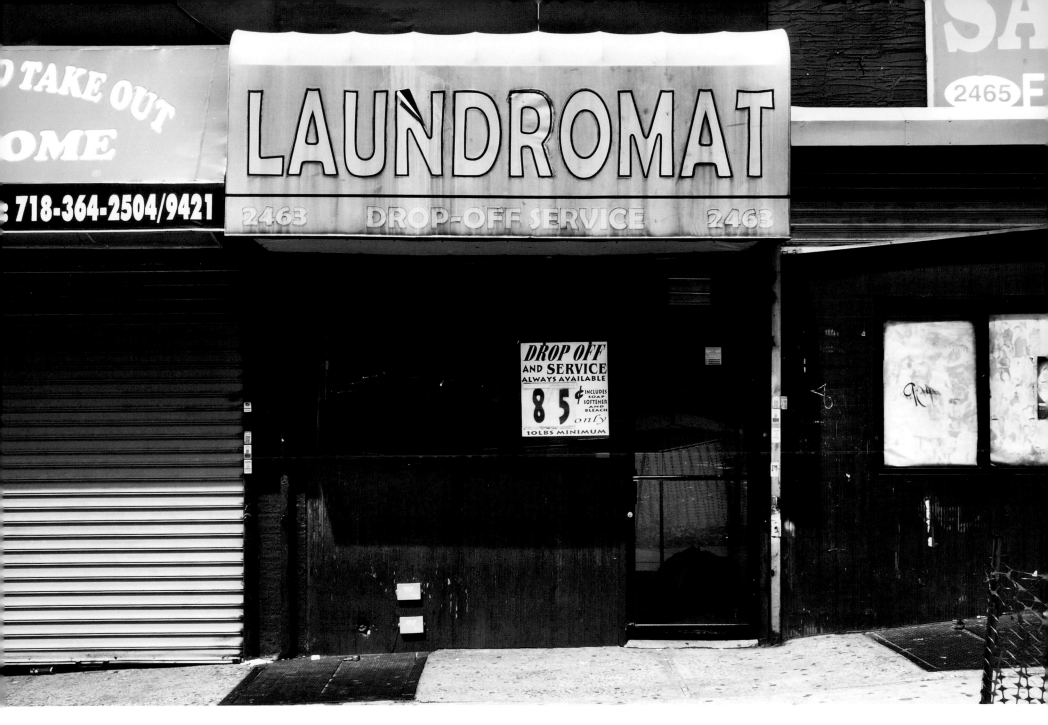

2463 Martin Luther King Jr. Boulevard

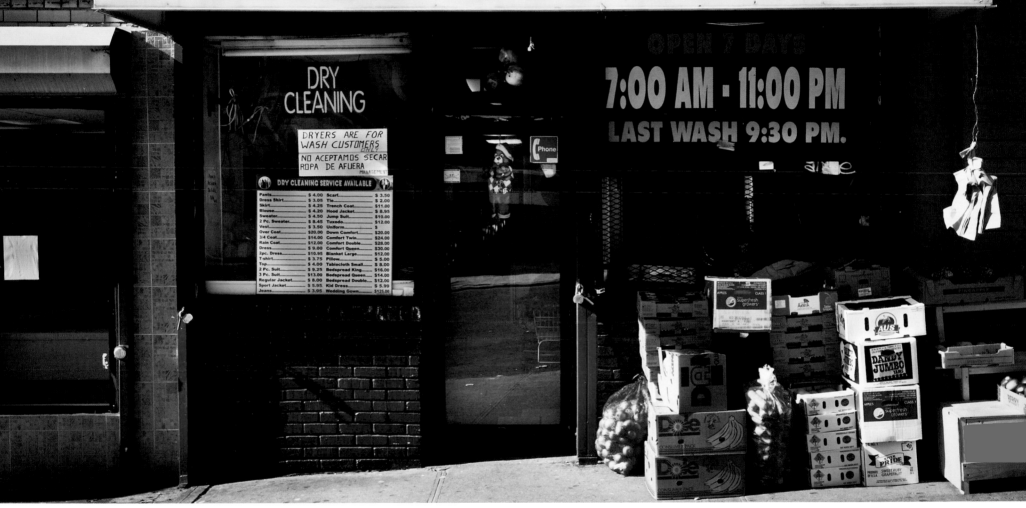

316A East 188th Street

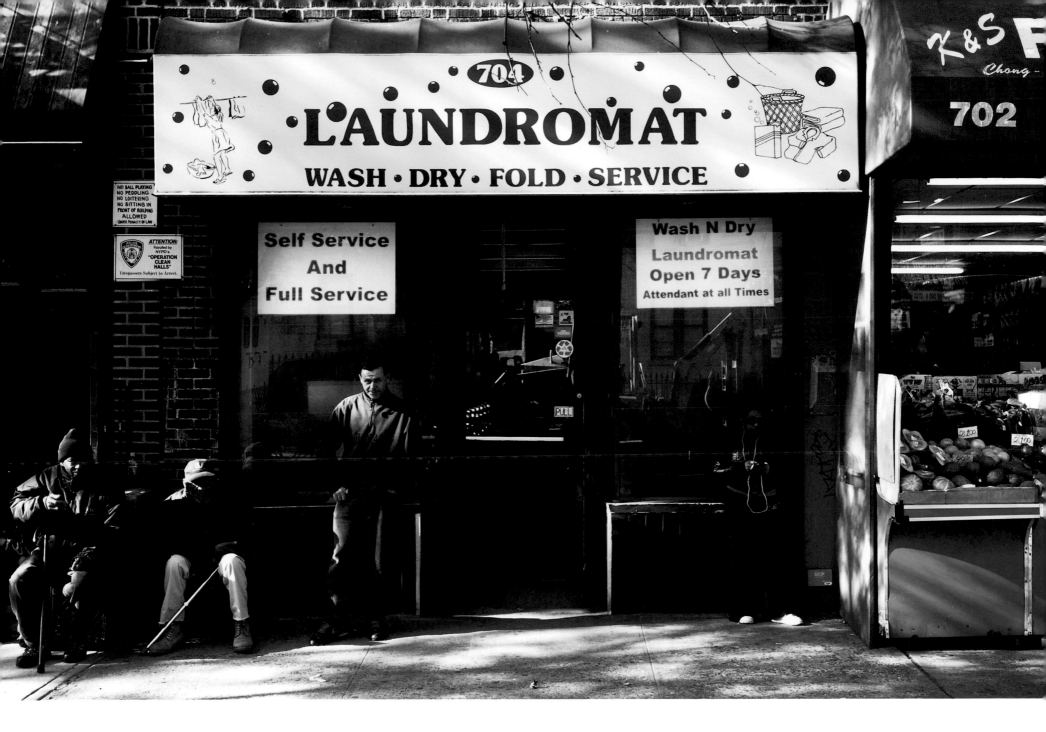

704 East 187th Street

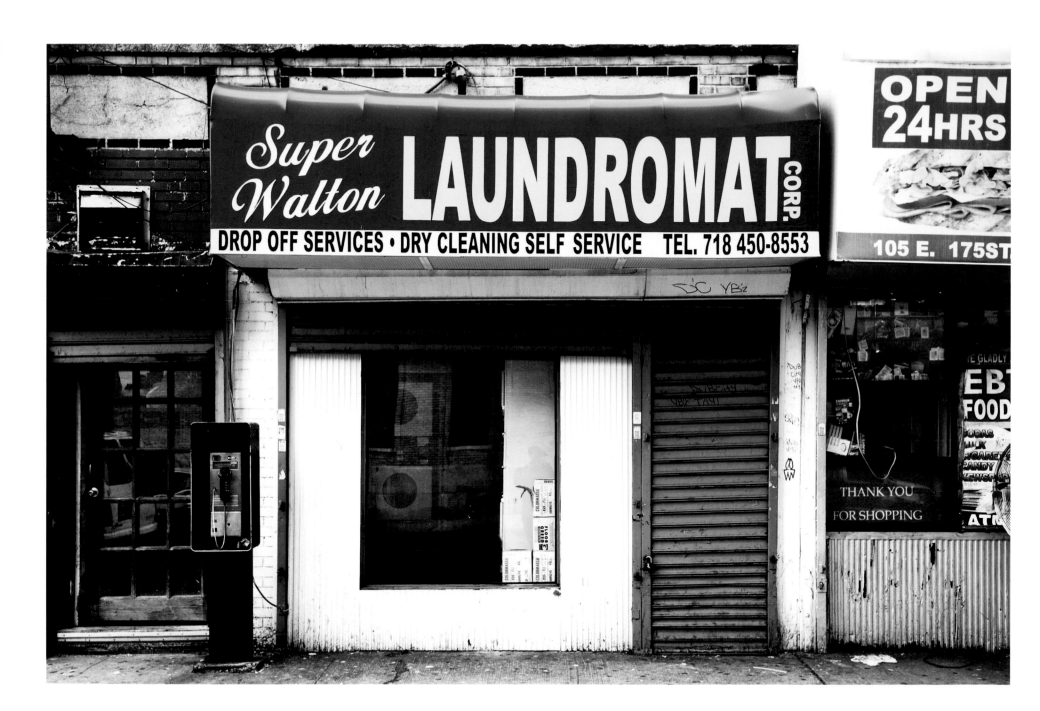

1750 Walton Avenue

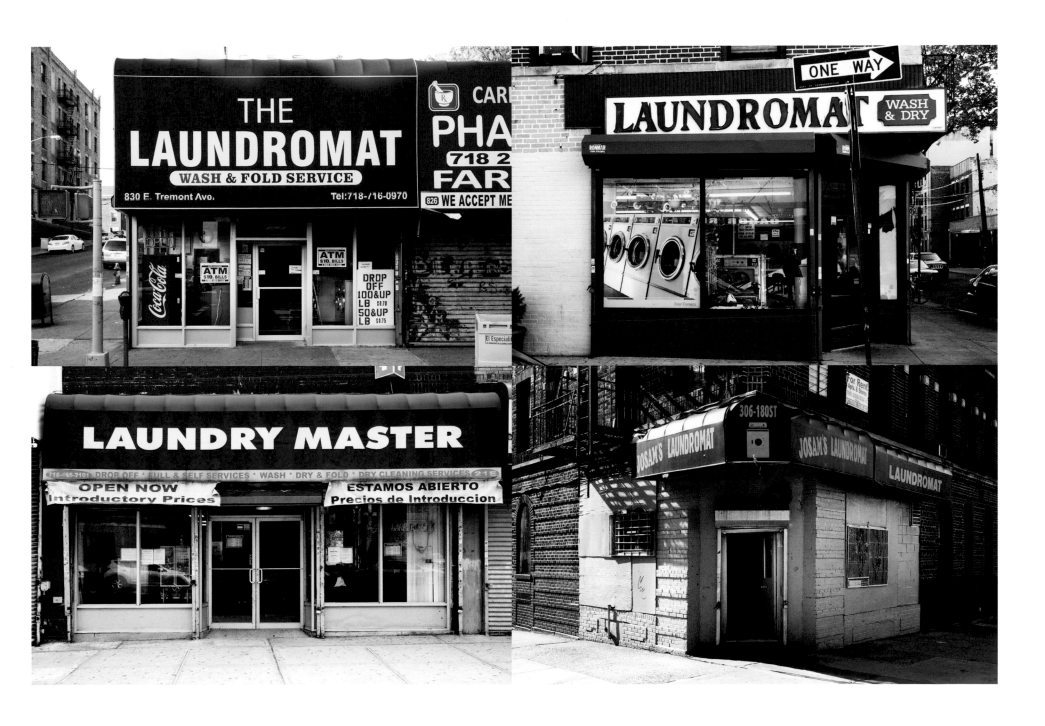

830 East Tremont Avenue

21 East 175th Street

634 East 186th Street

306 East 180th Street

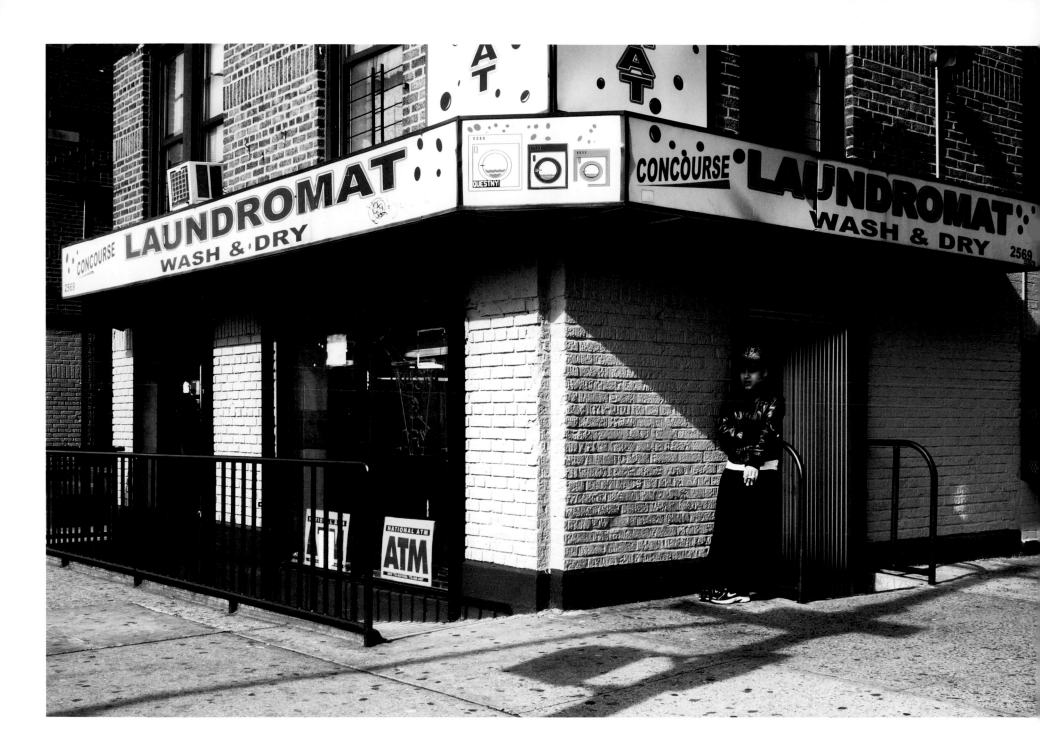

2569 Grand Concourse

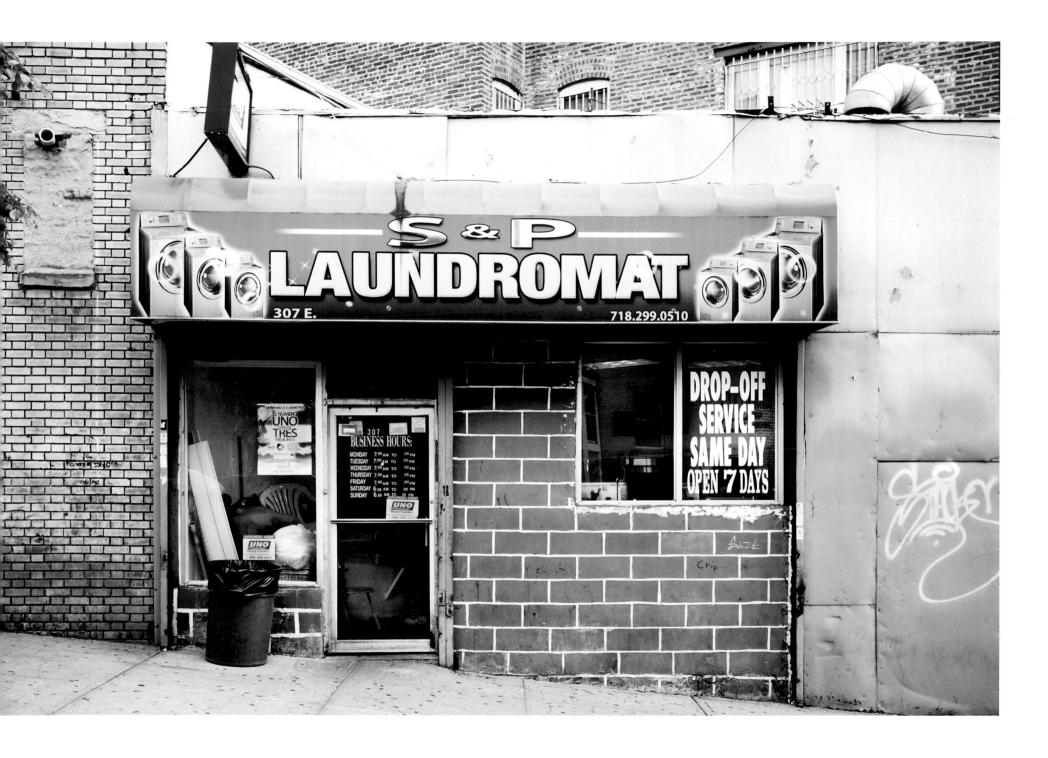

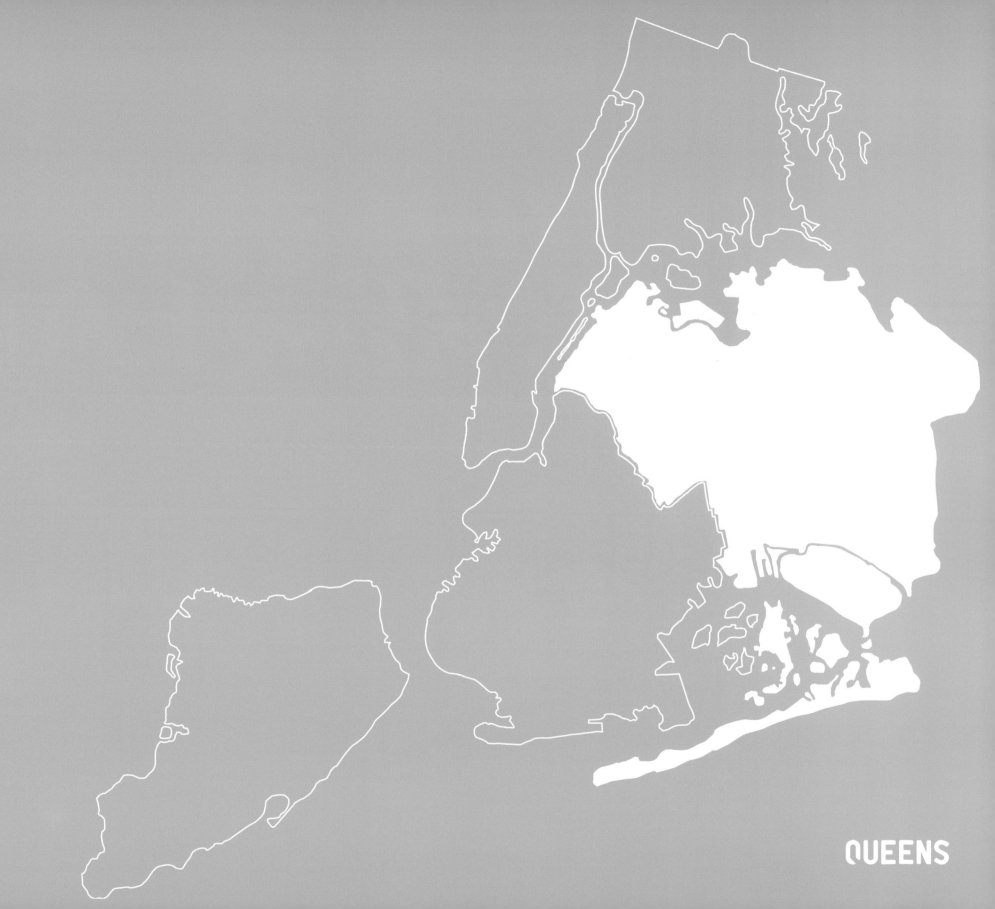

QUEENS

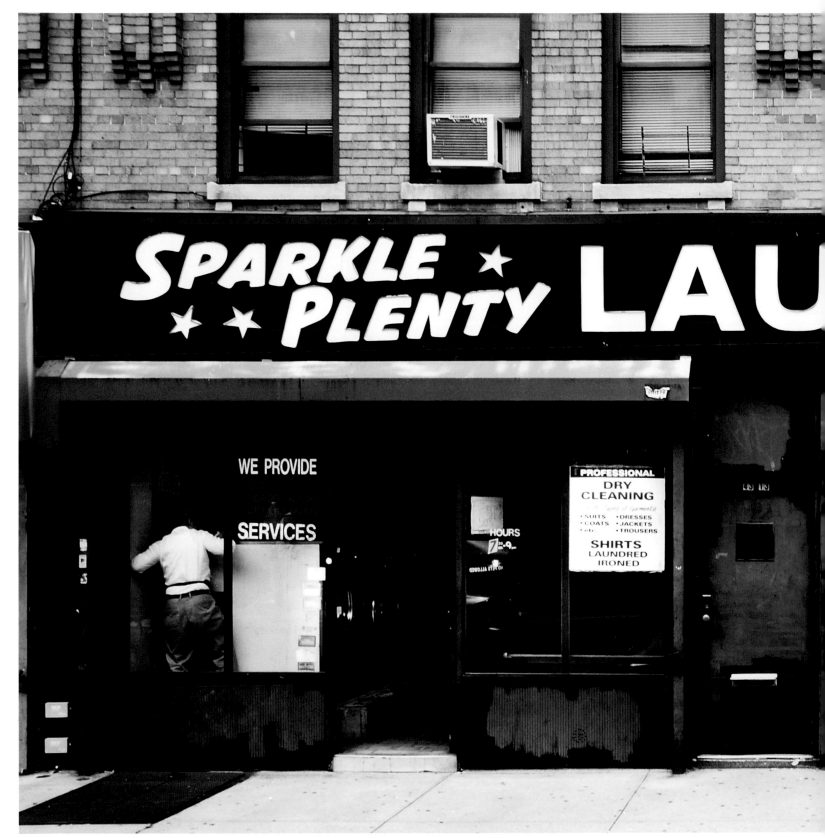

118

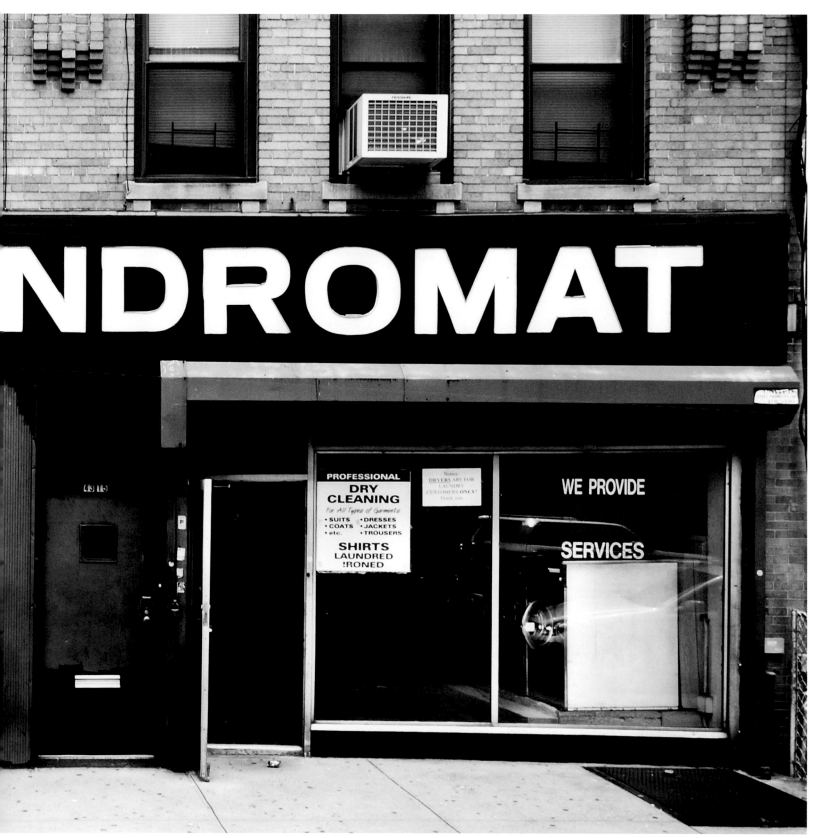

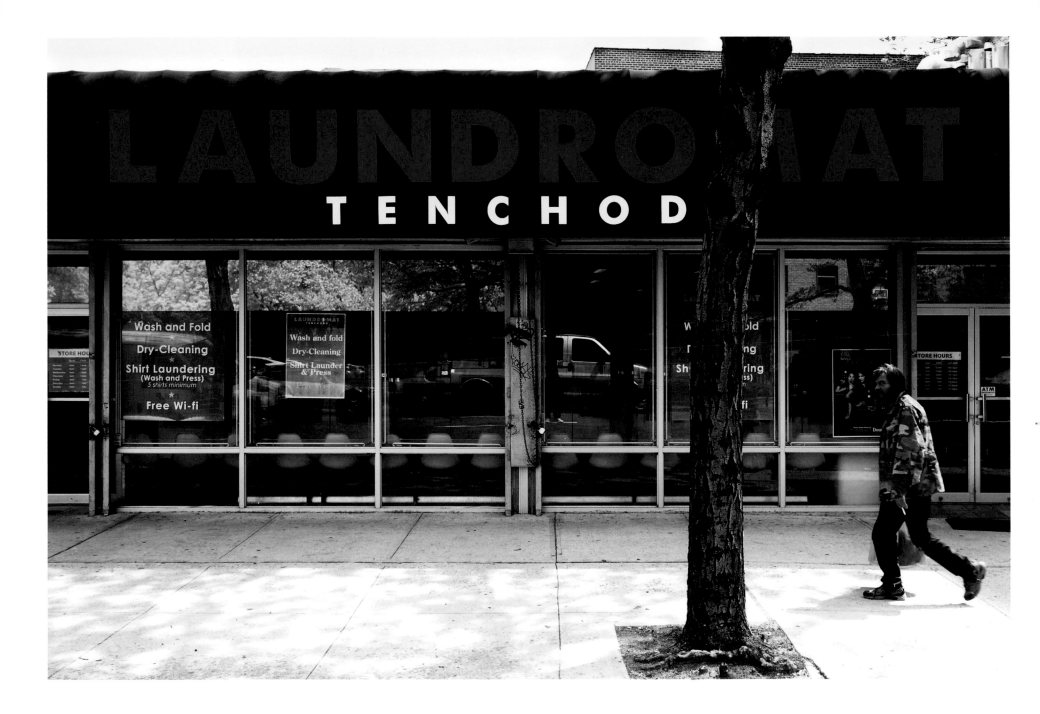

33-33 Crescent Avenue

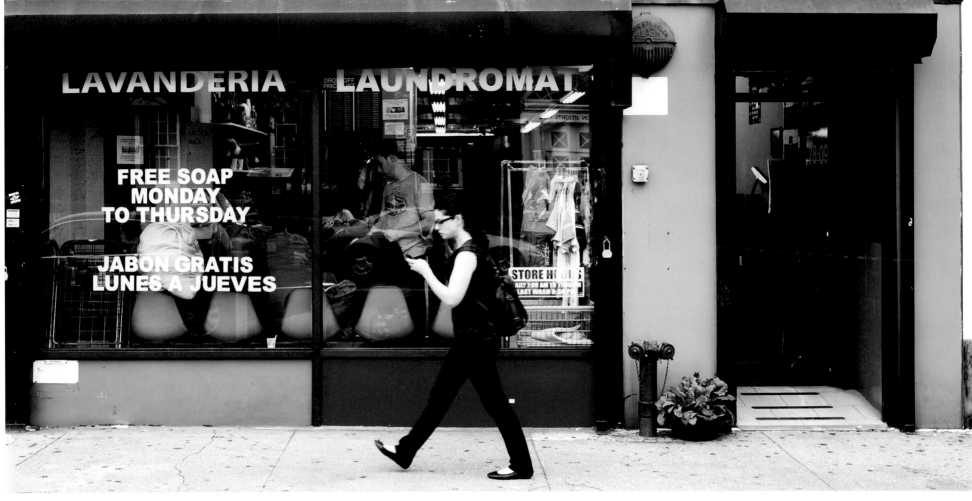

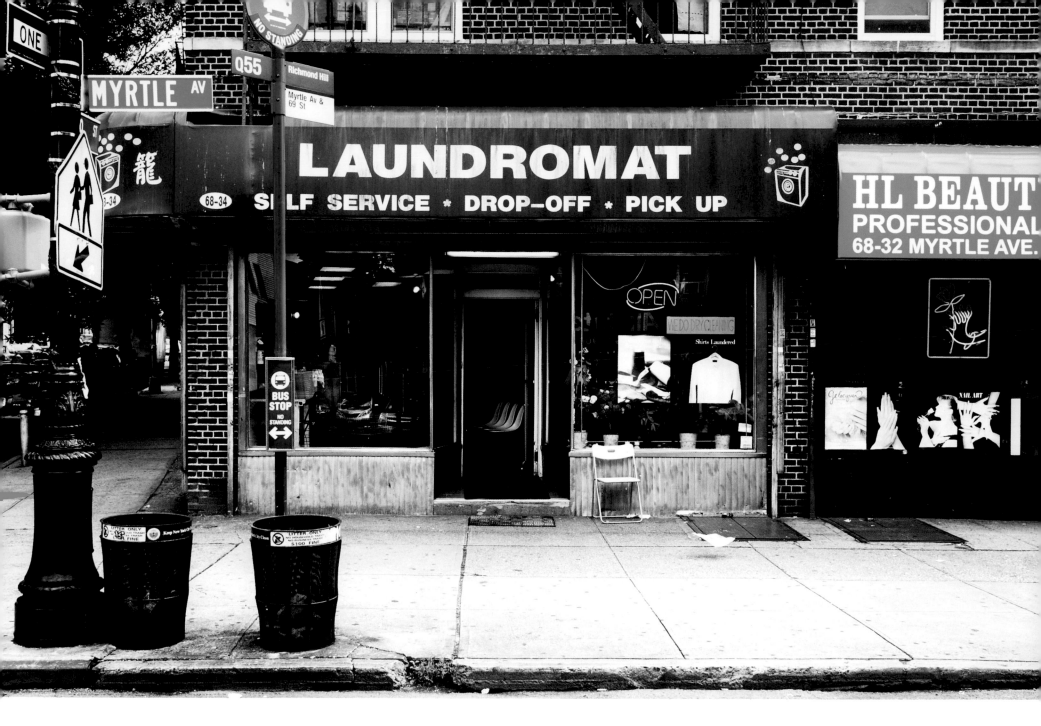

68-34 Myrtle Avenue

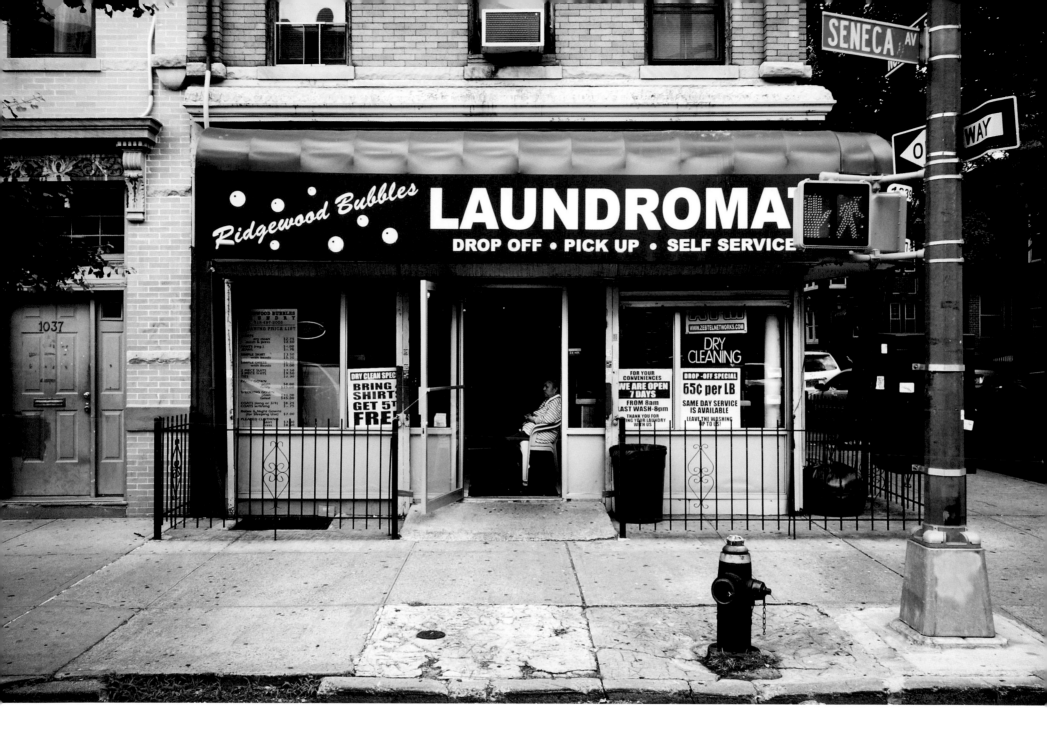

1039 Seneca Avenue

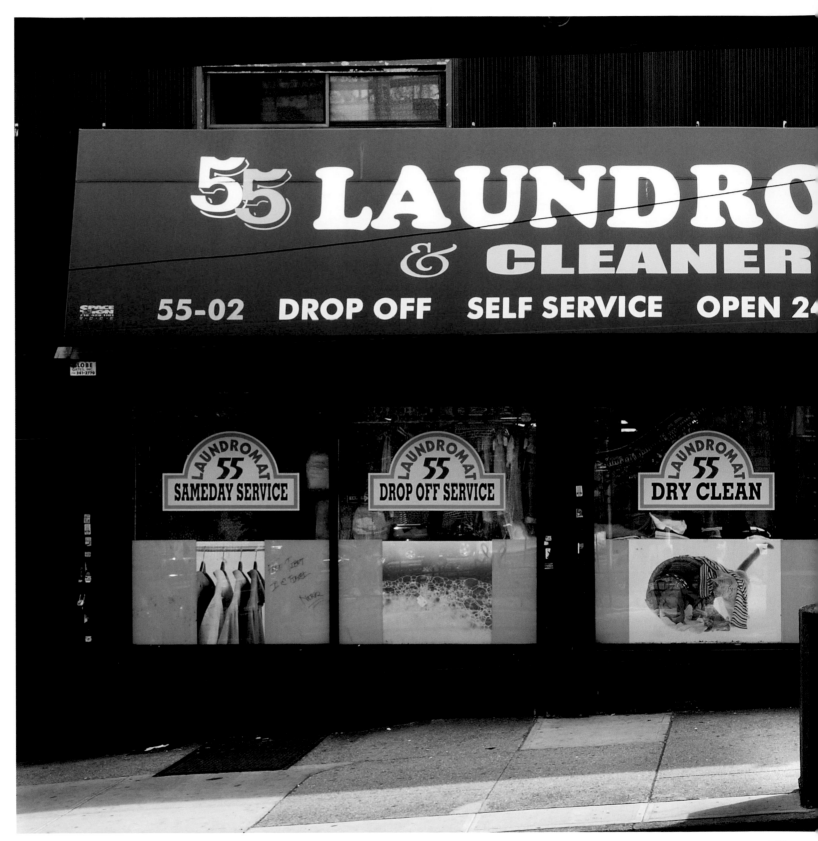

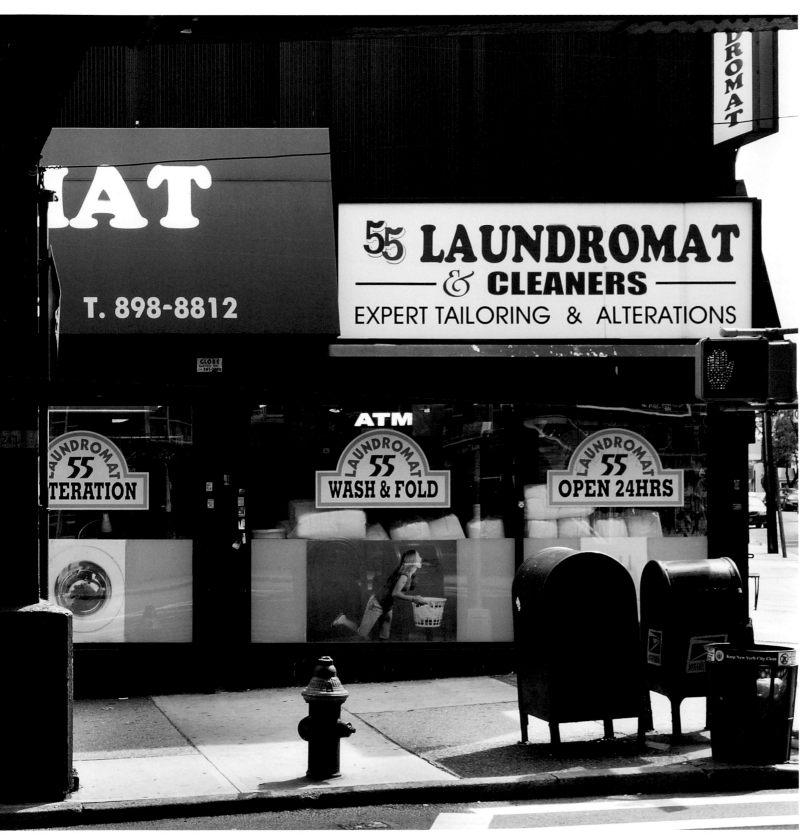

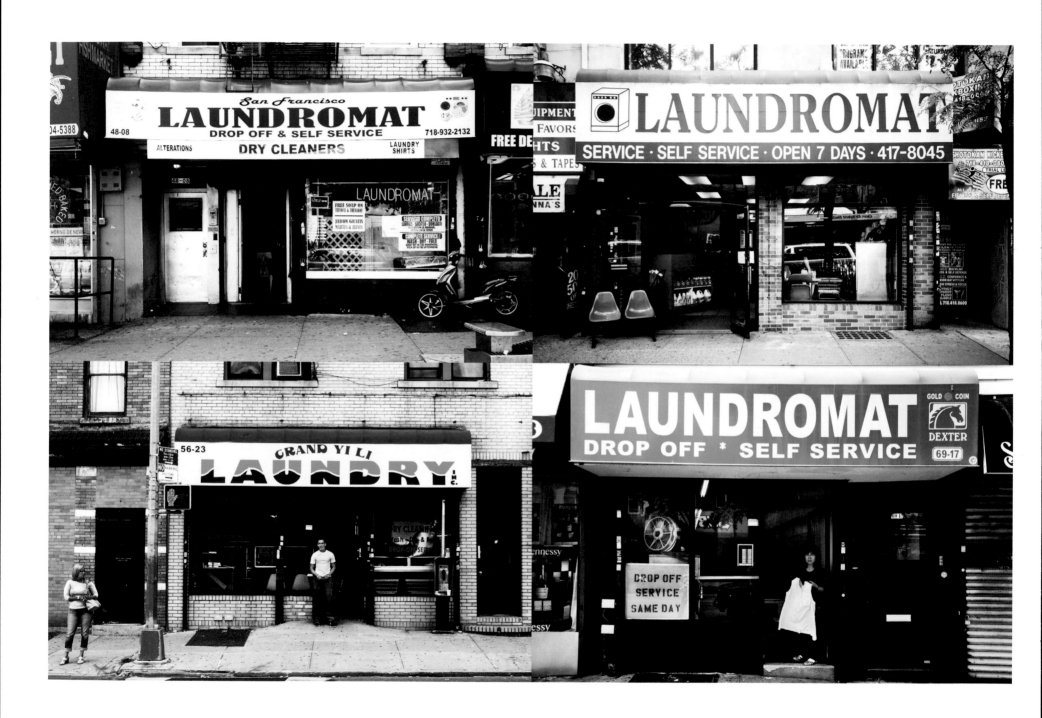

48-08 Broadway

56-23 Metropolitan Avenue

60-90 Myrtle Avenue

69-17 Myrtle Avenue

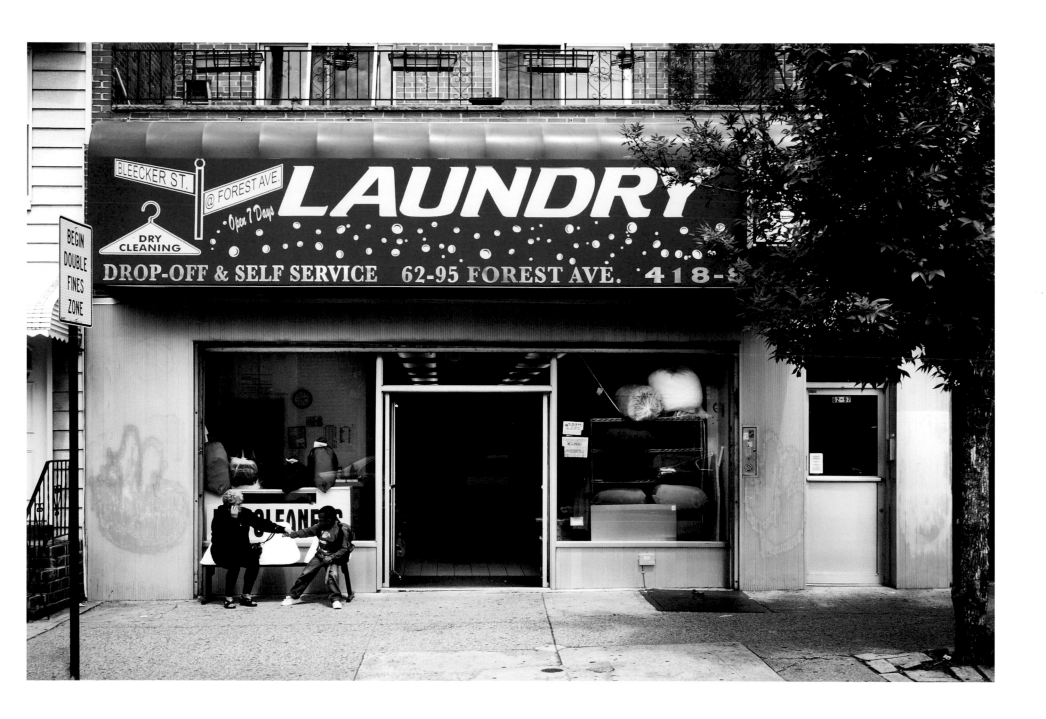

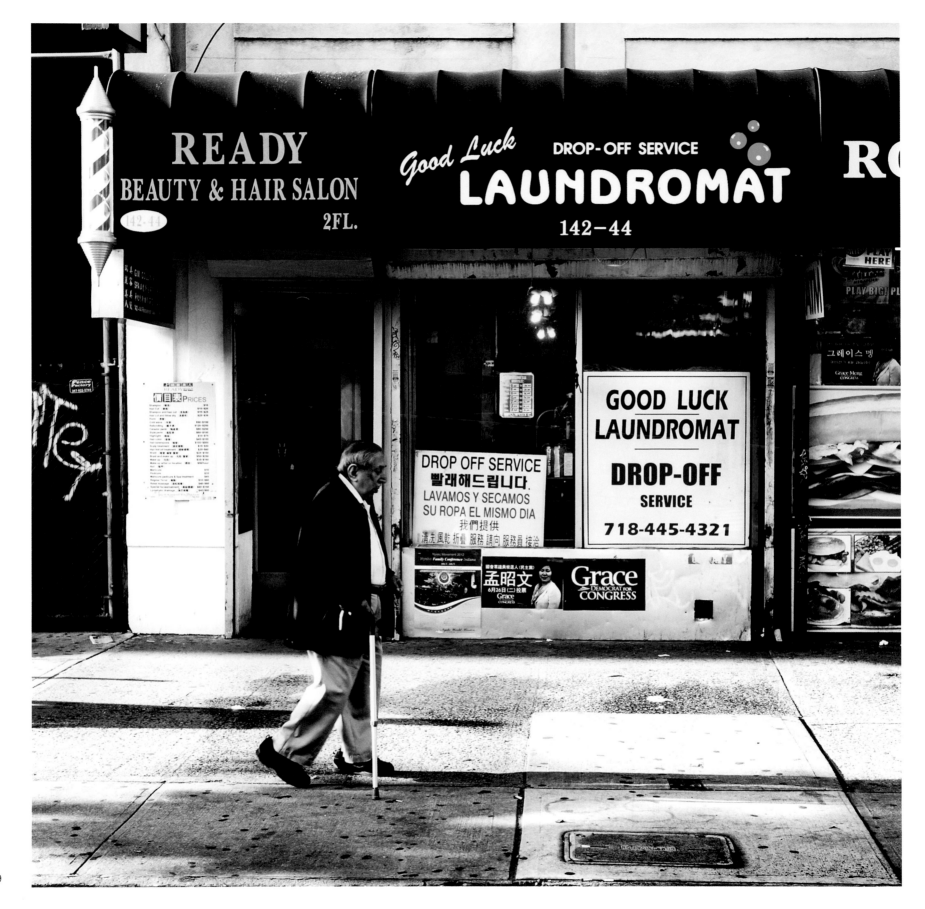

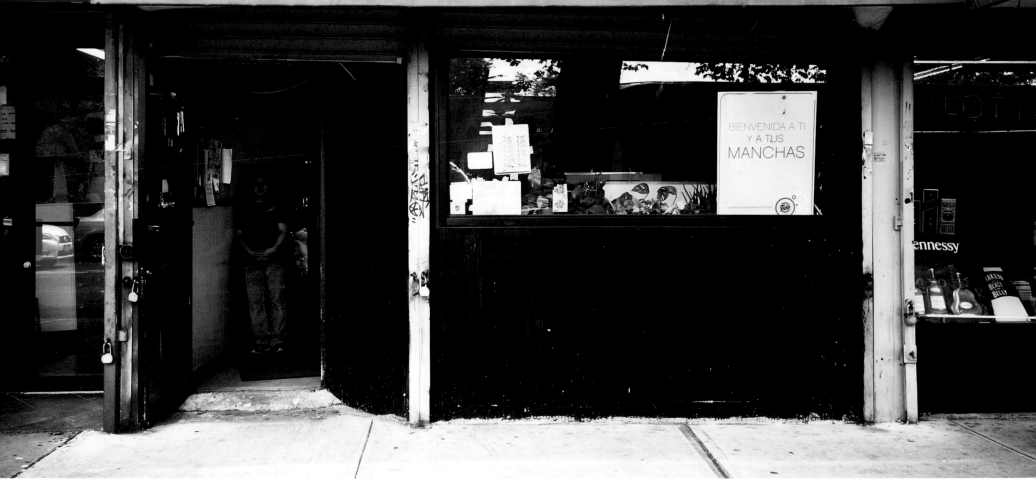

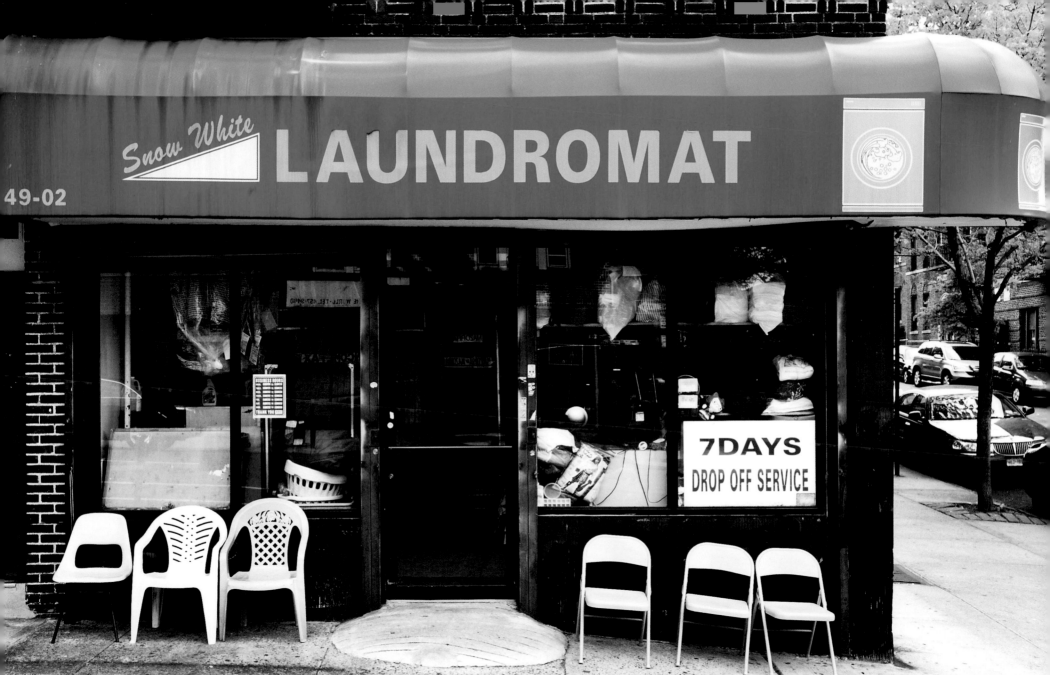

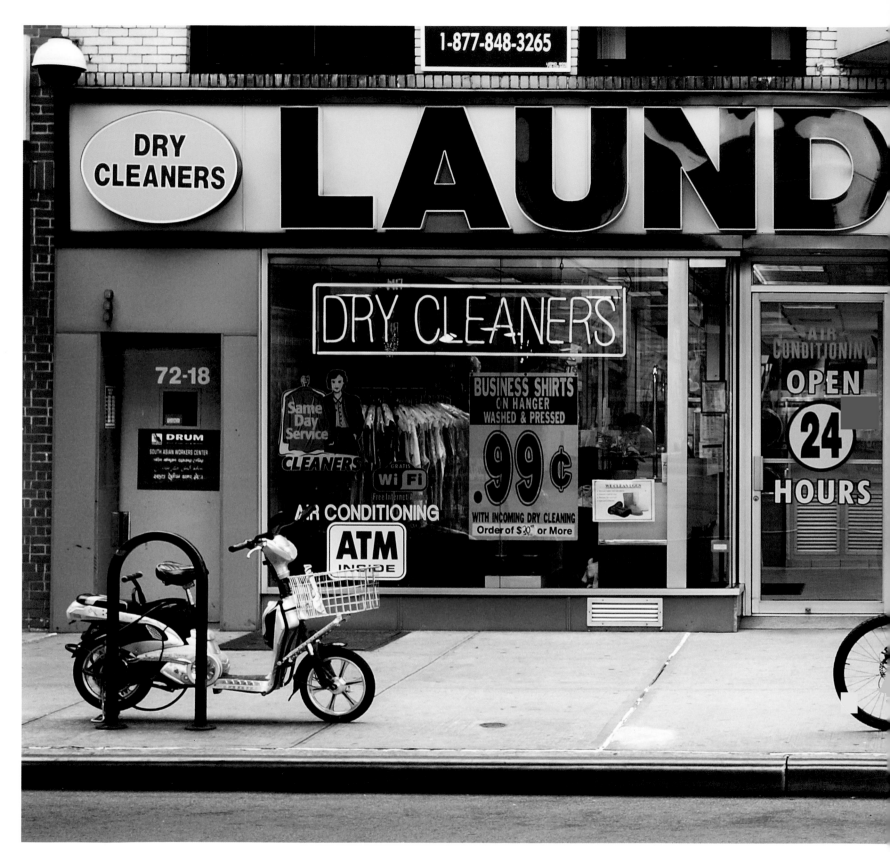

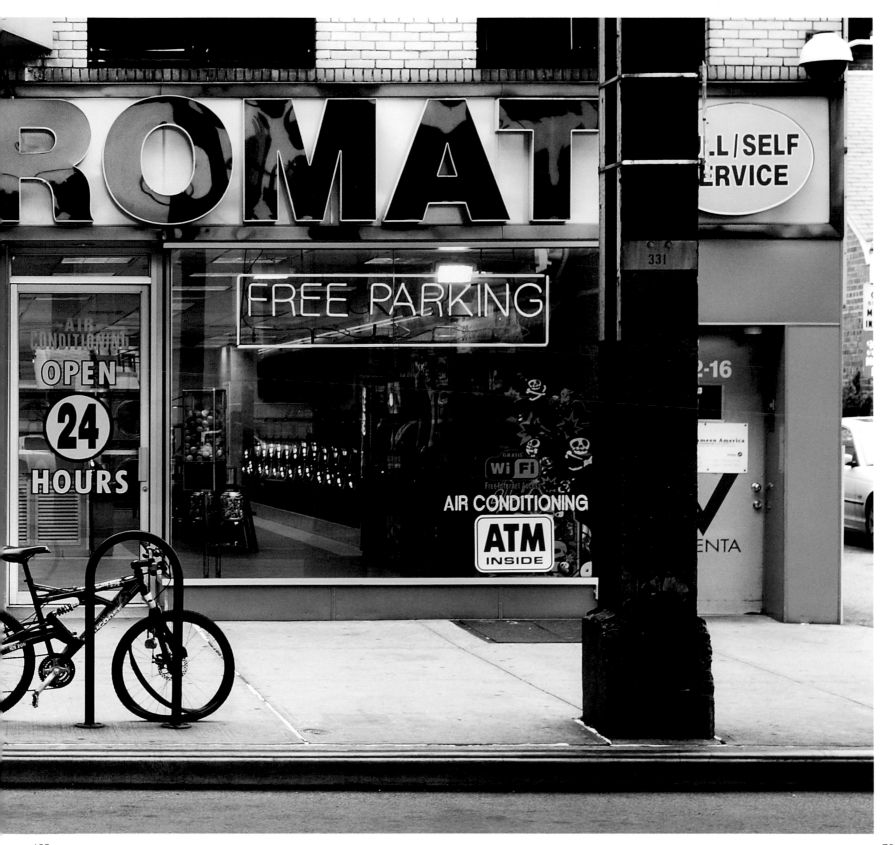

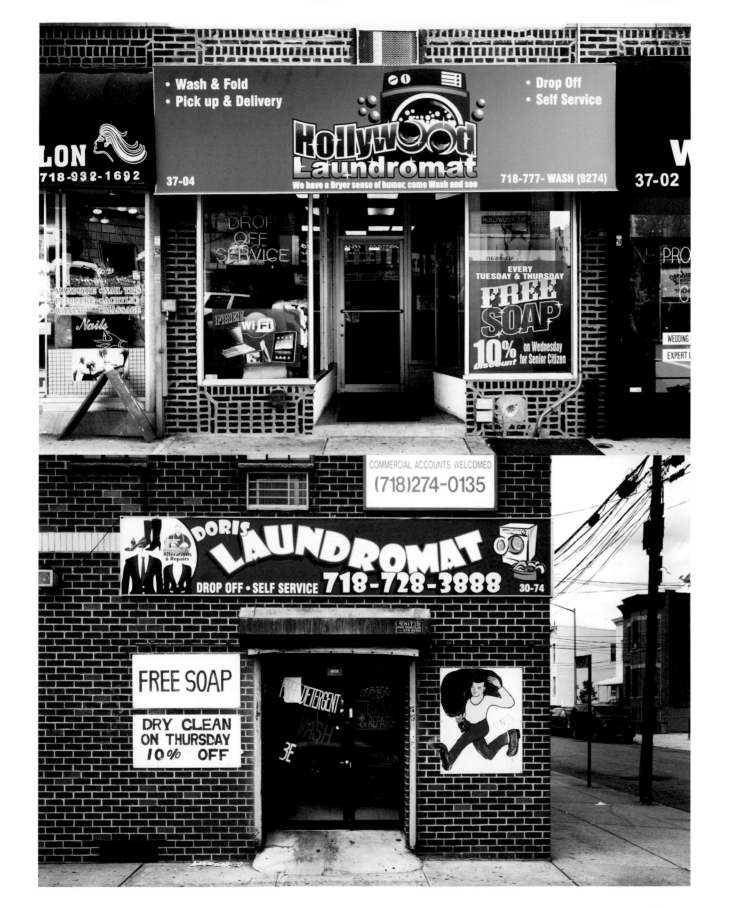

37-04 31st Avenue

30-74 21st Street

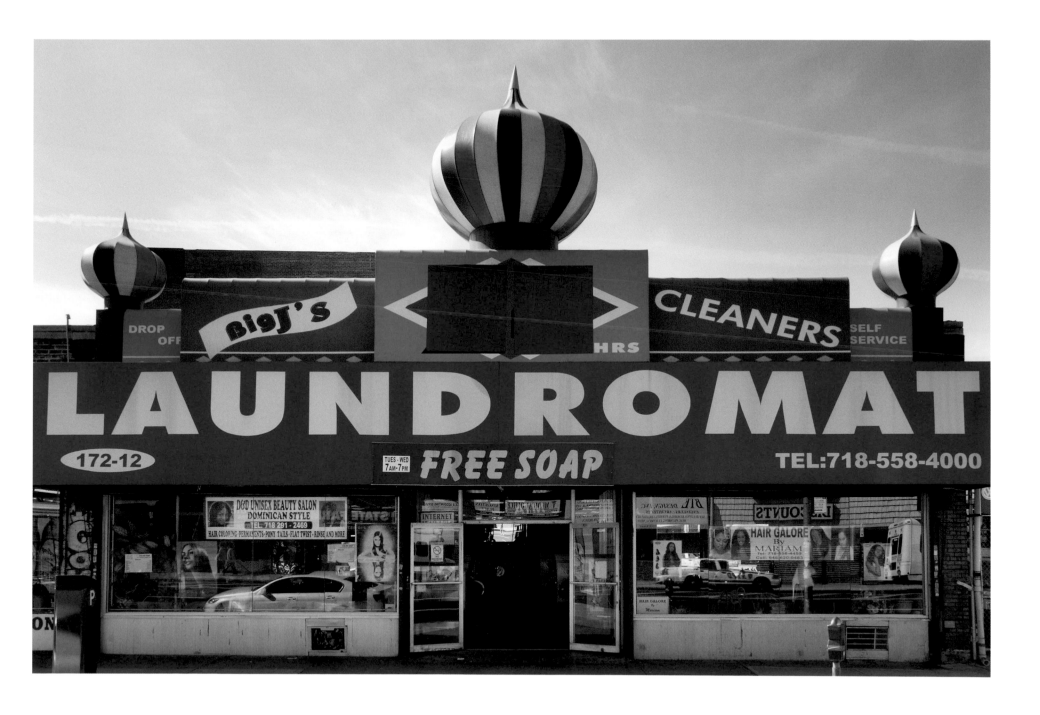

172-12 Hillside Avenue

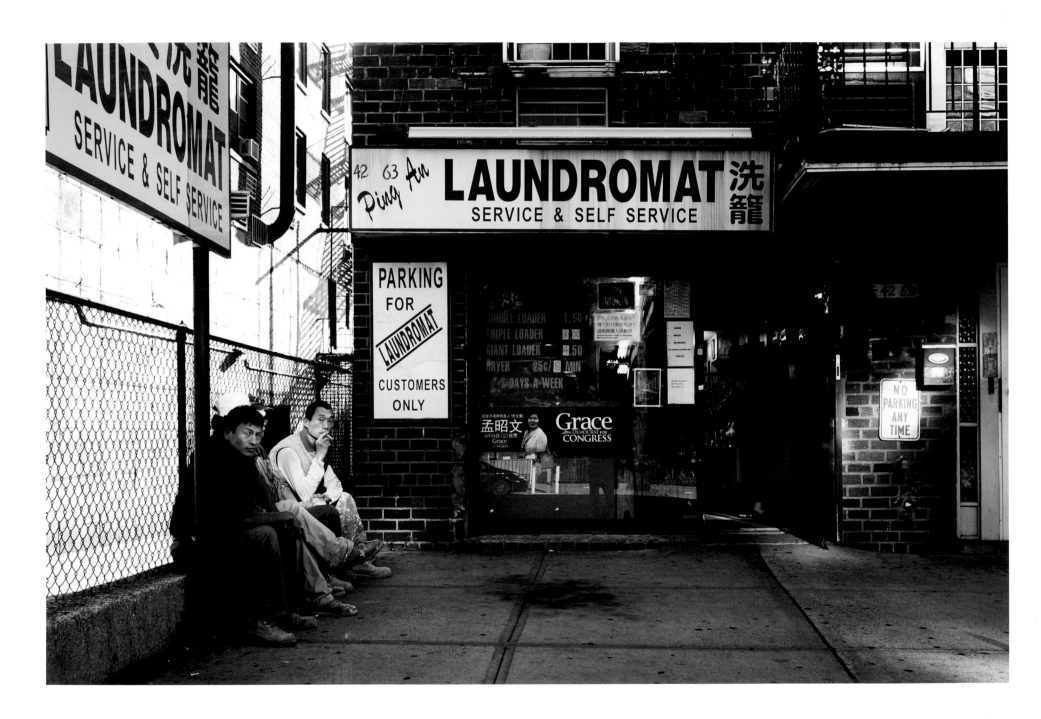

42-63 Main Street

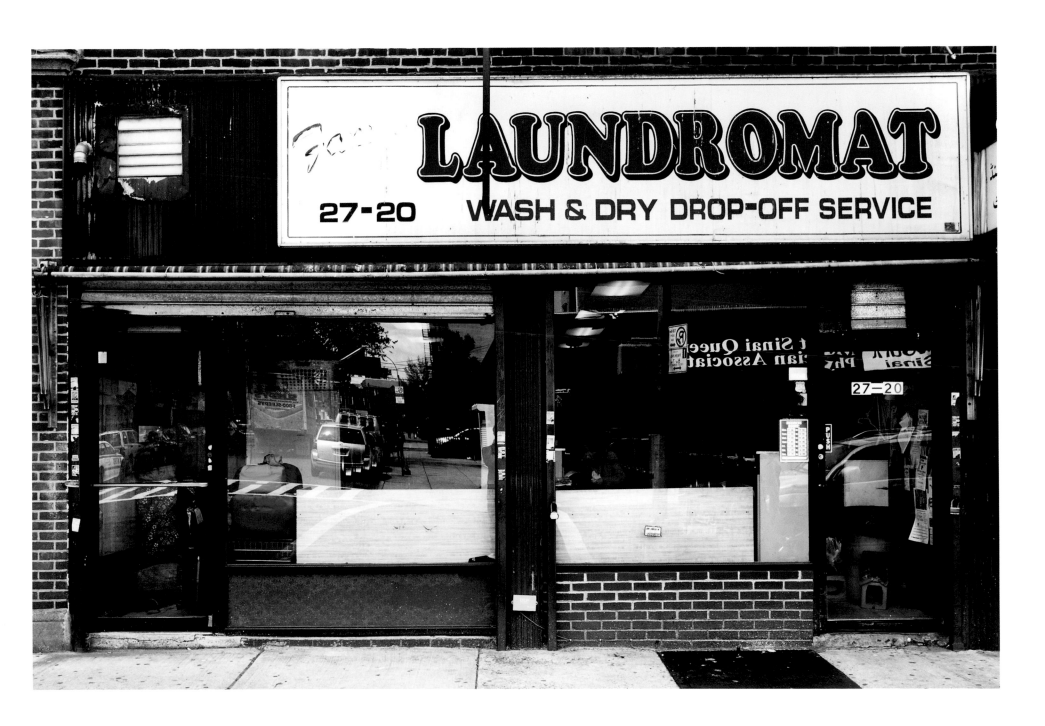

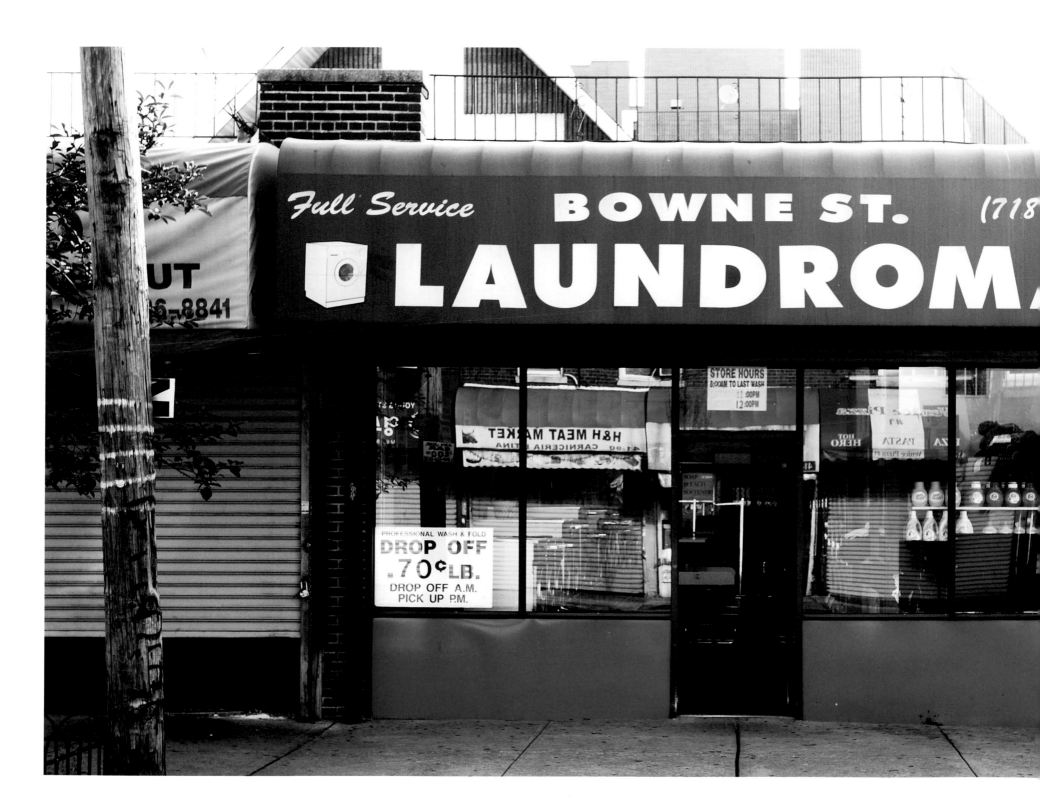

138

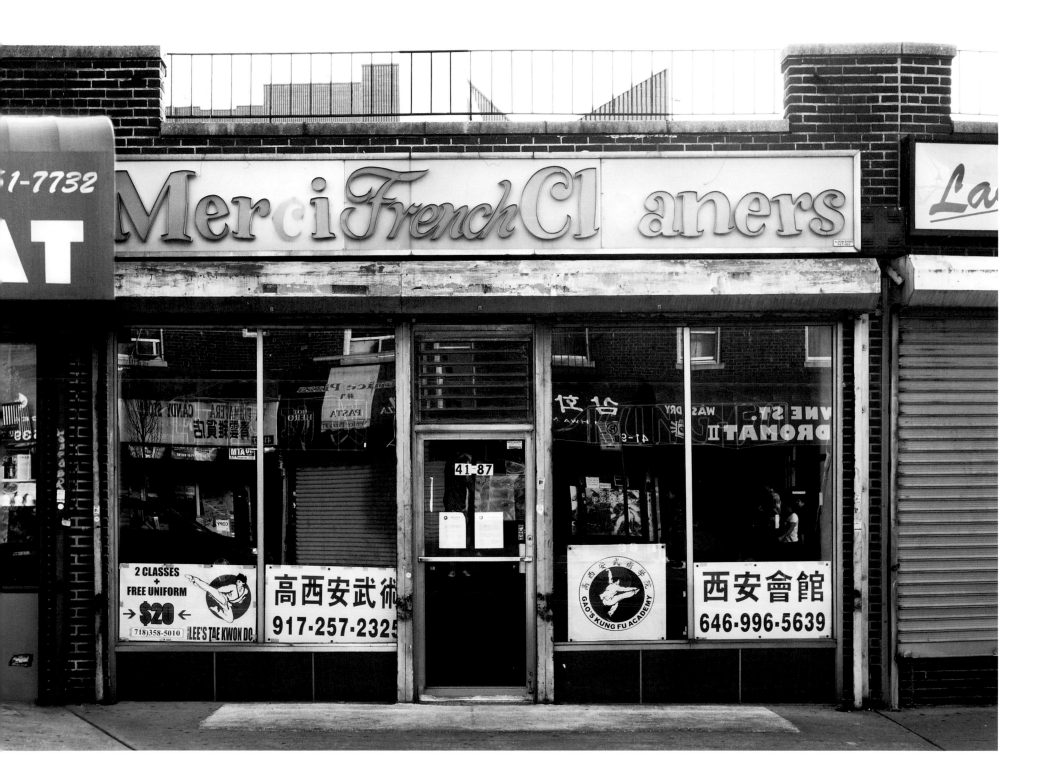

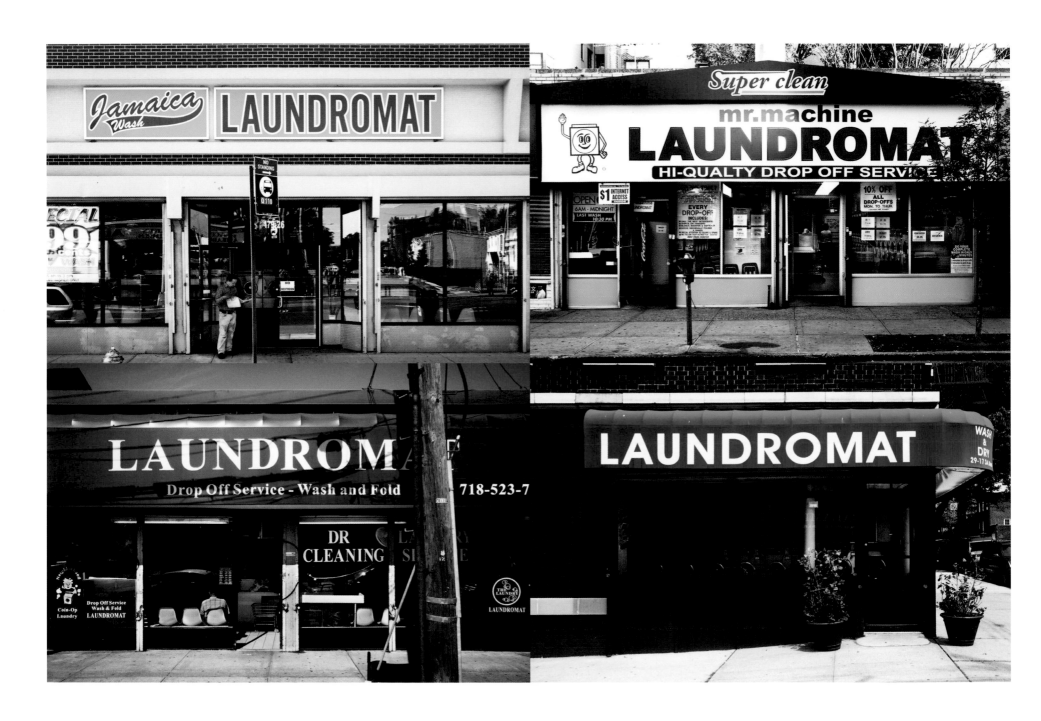

179-26 Jamaica Avenue

88-10 183rd Street

140-11 Cherry Avenue

29-17 34th Avenue

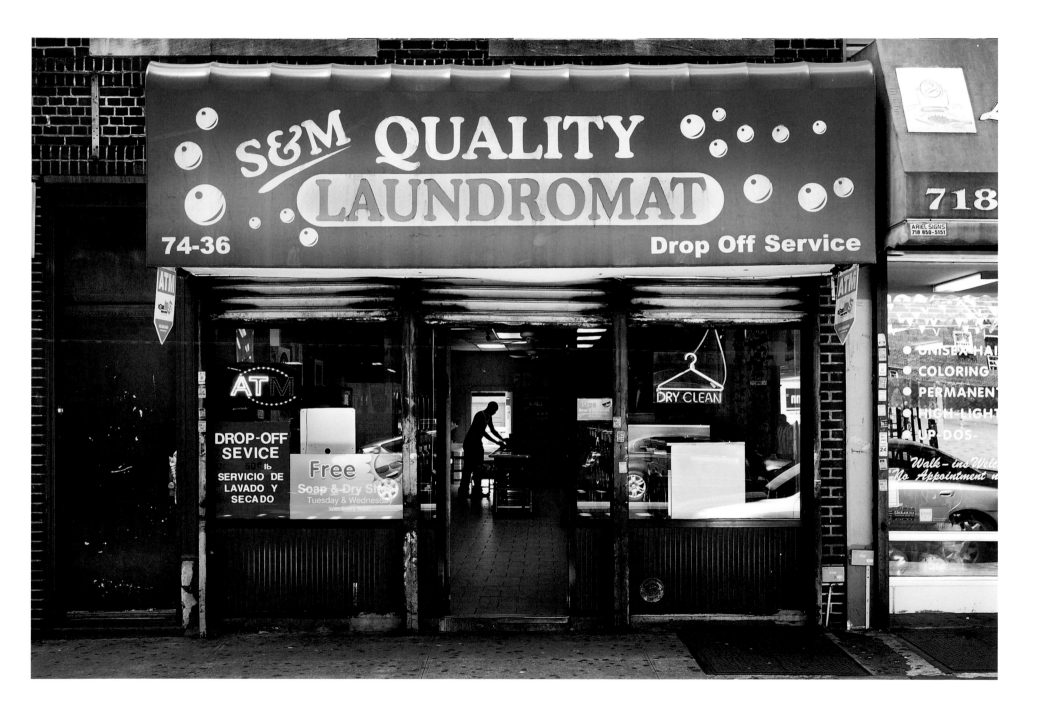

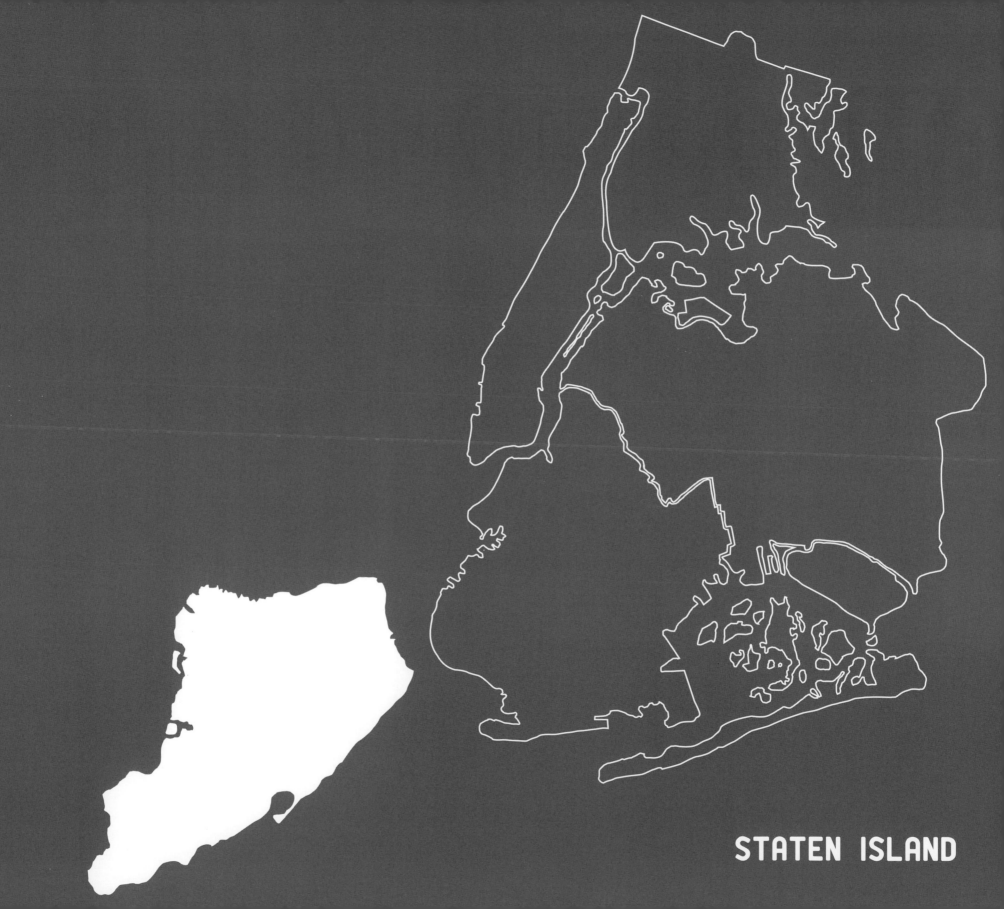

STATEN ISLAND

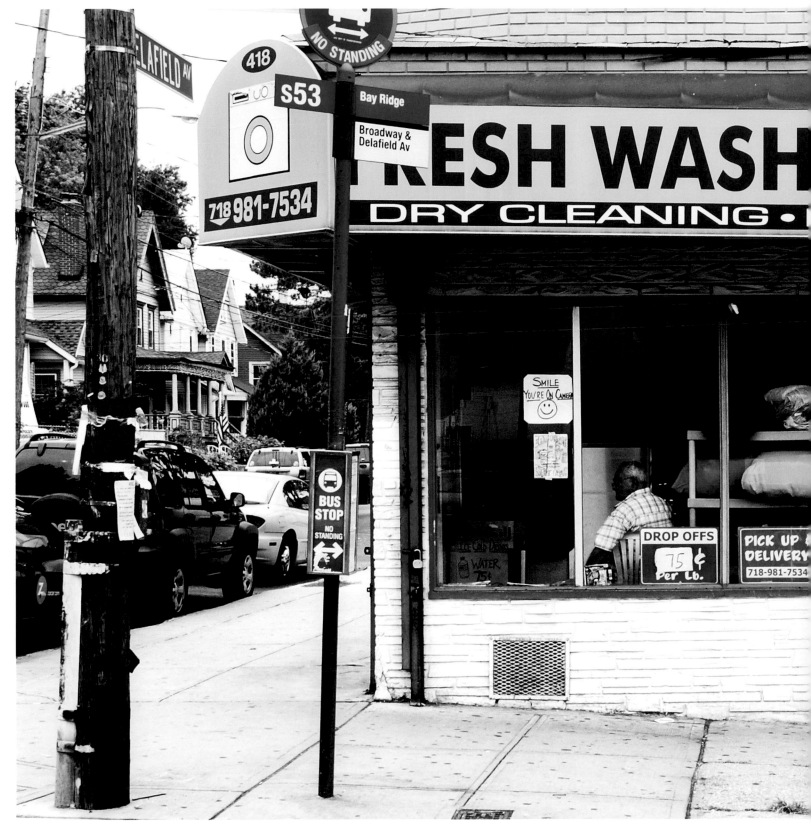

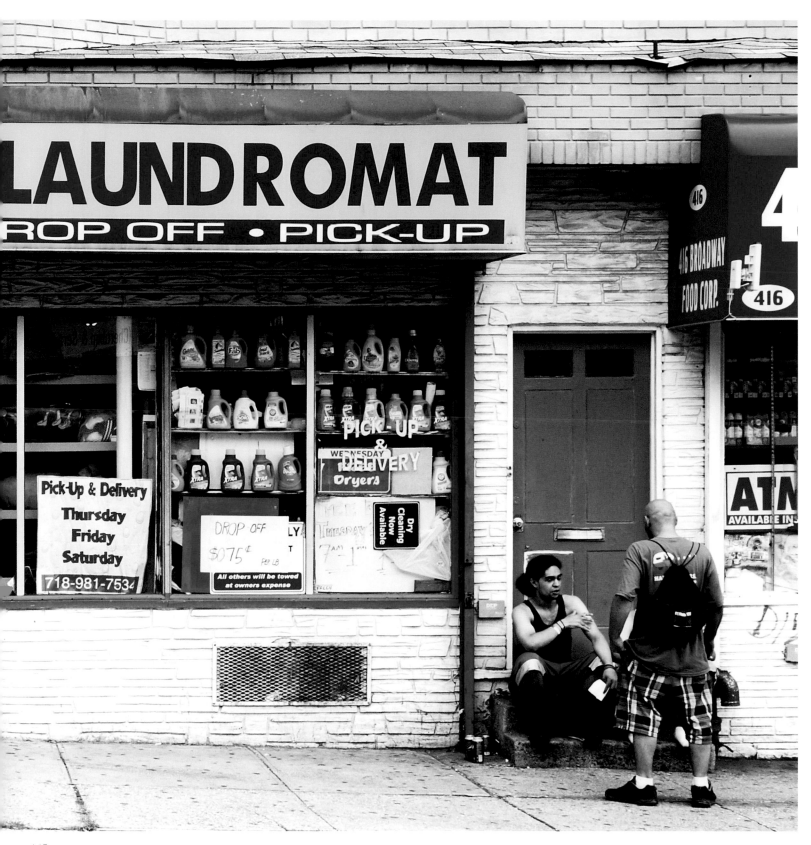

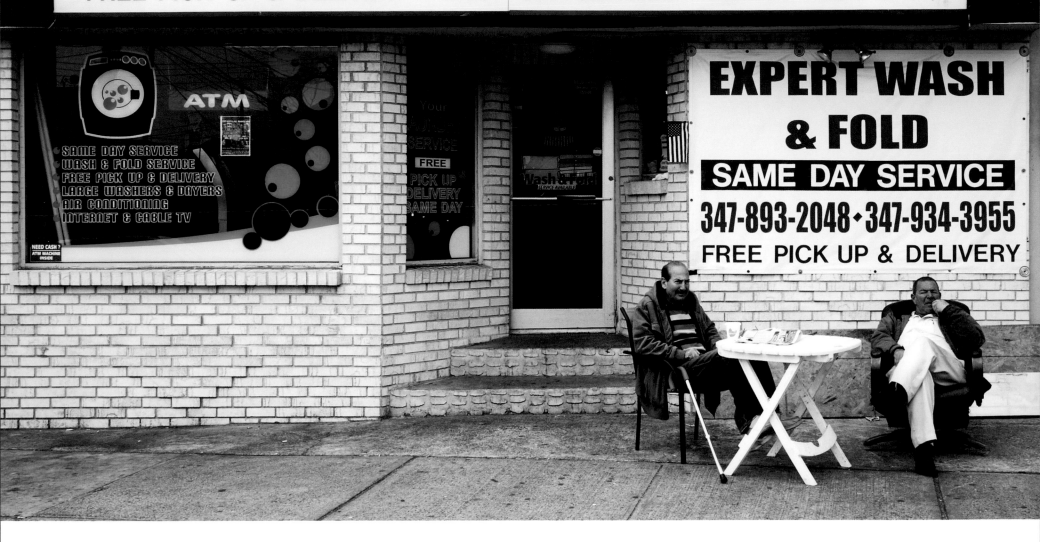

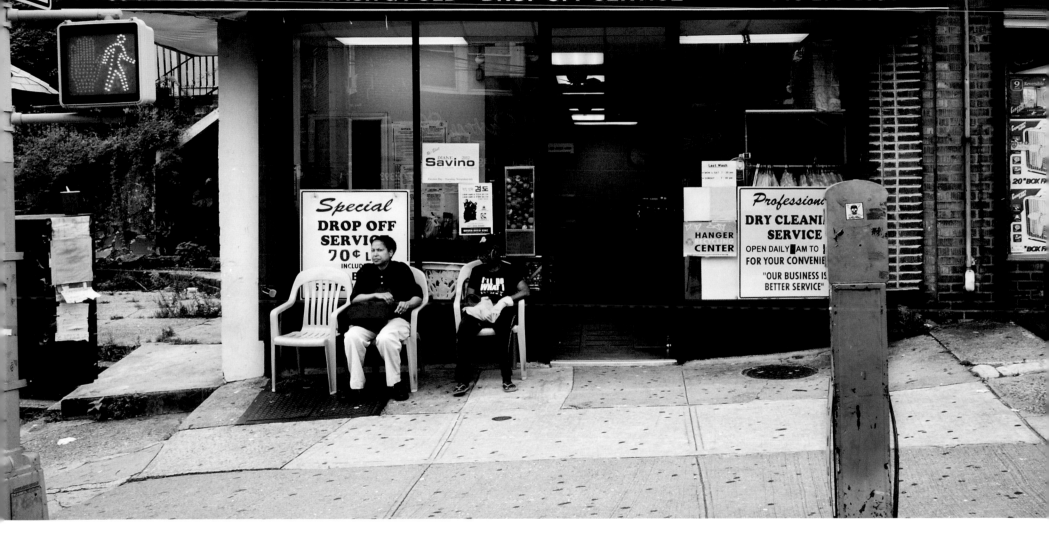

66 Victory Boulevard

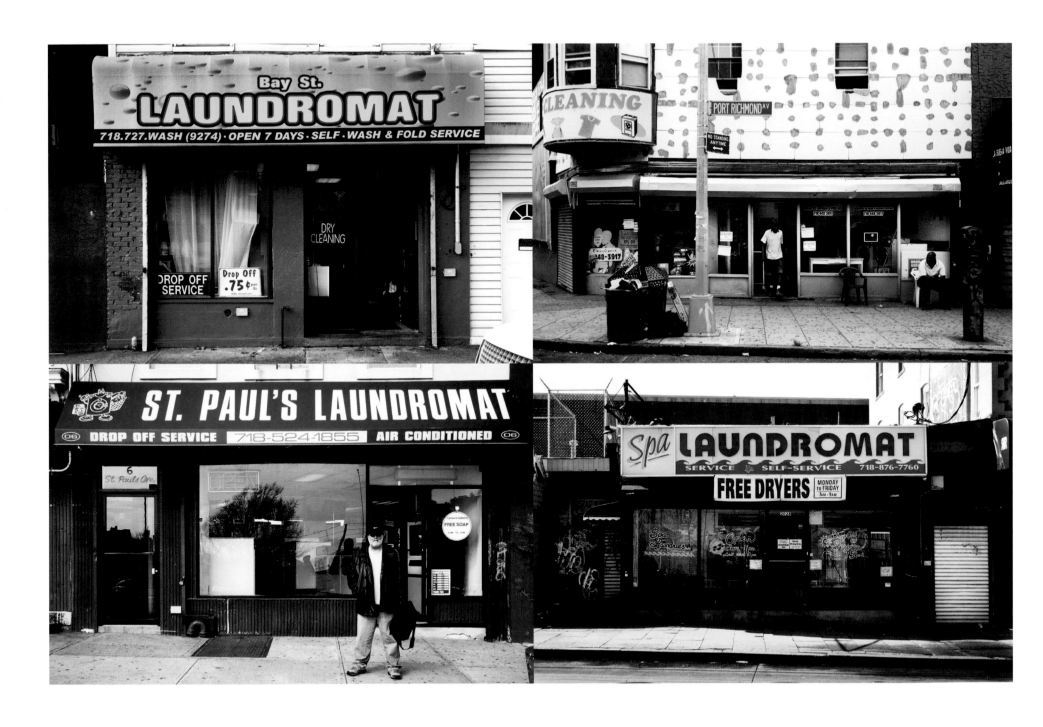

852 Bay Street

6 St. Paul's Avenue

176 Port Richmond Avenue

2035 Richmond Terrace

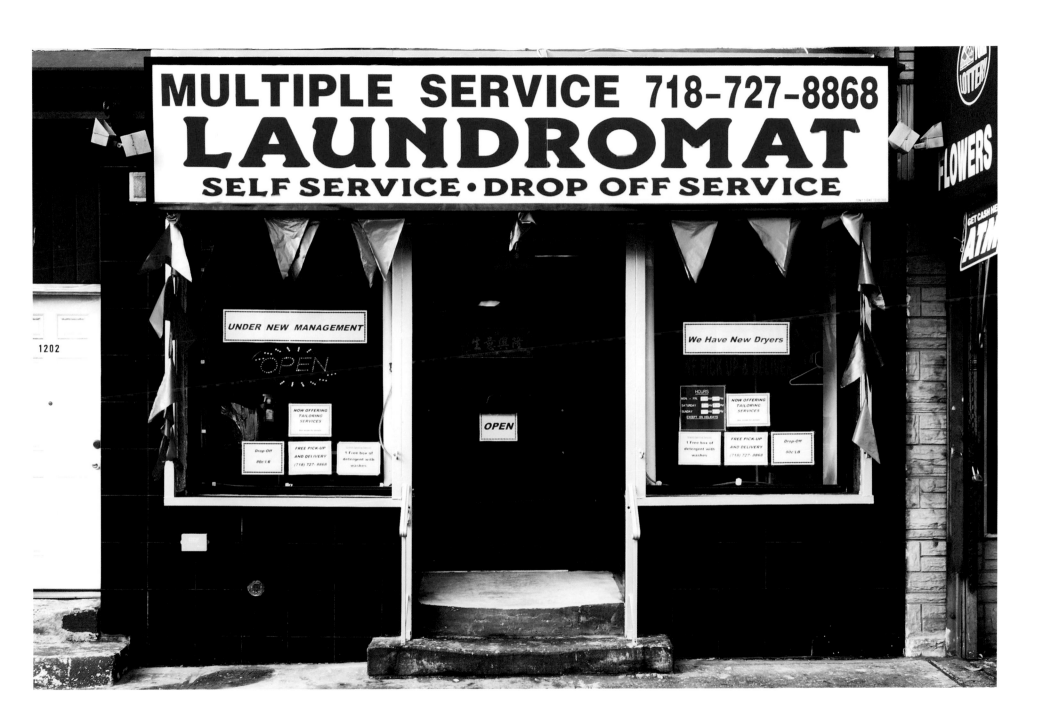

ALL WASHED UP: THE AMERICAN LAUNDROMAT

"New York City has 2,654 laundries—self-service ones like Clean Rite and dry cleaners who take in bags for fluff 'n' fold. That is one for every 3,151 people."
— N. R. Kleinfield[1]

Until Snorri Sturluson immigrated to New York City in early 2001, when he was 31, the few laundromats[2] he'd seen were those encountered as a young man traveling through Europe. To the American this might seem unbelievable, but in Sturluson's home town of Reykjavík, Iceland, laundromats didn't exist. Though they can be found in England, where they're better known as "laundrettes," and a clutch of random cities such as Copenhagen, Amsterdam, and Paris, where they're just a bit more common than the platypus, laundromats are principally an American phenomenon, invented by Americans for Americans, risen to prominence in the atomic boom that followed World War II, when America was at once consolidating its power and expanding its reach.

Despite its relative obscurity outside America, however, and despite its decidedly squalid complexion, the laundromat has held a curiously elevated status among the panoply of Americana erected in the collective European consciousness. This, of course, isn't to say the laundromat isn't equally fascinating to Americans. Scenes in at least 38 films made since 1980 feature laundromats, and a few before, many of them cult classics, if not masterpieces. From *The Trip* and *Midnight Cowboy*, to *My Beautiful Laundrette*, *Rain Man*, *Paris, Texas*, and *Wings of Desire*, to *Color Me Kubrick*, *In the Valley of Elah*, and such lowbrow stuff as *My Bloody Valentine* and *Ninja Assassin*, the laundromat has been presented as a locus of revelation, violence, romance, failure, psychosis, and ambition. Sometimes, as in *My Beautiful Laundrette*, the laundromat is the distilled nucleus onto which have been superimposed all of these, *plus*. But whether we leave these portrayals with a sense of gorgeous sadness, antiheroic tragedy, or dignity faintly soured, it's to them that we can usually trace the origins of our fascination with the laundromat, and with them that we can assure our fascination's continued sway.

The circumstances that led Sturluson to this study are a case in point. His friend Friðrik Weisshappel was so smitten with laundromats that he opened a number of eponymous cafés in Reykjavík and Copenhagen, decorated not merely with photographs of laundromats but with functioning machines, as well. No sooner had Weisshappel asked Sturluson to shoot pictures of the laundromats he'd seen on a recent trip to New York City than Sturluson was smitten with them, too. It was, Sturluson said, as if everything he'd gathered about America over the years—the loneliness and pathos of the Jim Jarmusch films he'd seen growing up in Reykjavík, the

mysterious lack that pervades the prose of Paul Auster, the shade of *Weltschmerz* in the songs of Tom Waits, and the city's ambivalent sense of gritty despair and taunting possibility that have drawn so many millions to it—all these contracted in a brilliant epiphany. There were literally thousands of laundromats in NYC. A few photos would be too many, but hundreds hardly enough. The collection, Sturluson saw, would be a portrait in montage even as it constituted a history, an anthropology, and a sociology, an imagistic commentary on the economics and politics of America itself. It would be an homage, on the one hand, to laundromats and the people who use them and an elegy, on the other, to an America that used to be.

The Real Deal

In nearly every case, the image of the laundromat in film has little to do with the laundromat on the street. And while the perspective may now and then approach reality, it's never far from caricature.

The laundromat I came of age in, and where untold hours of my life have vanished without a trace, isn't the laundromat of NYC, but of Oakland and Berkeley and Frisco.[3] I've since experienced many laundromats around the country, but no matter where they are, the differences between them remain slight. One laundromat may stand in a crumbling L.A. strip mall. Another may lurk off the road through some remote dusty valley. Another may be flanked by a Quik Stop and mom-and-pop locksmith at the edge of a West Oakland ghetto. And another yet may squat along some hipster avenue in the Lower East Side. One might never close, one might rarely open. This one might ooze with graffiti and roaches and lint balls and mice, and that one shine with ersatz cheer. And each may vary in its level of security, and each may differ in darkness or light, and each may feature its own salmagundi of culture and race. But what doesn't change, and what no one can escape, is the air that possesses each — and which, without exception, takes us all, often before we enter — of sadness, of smut, of hopelessness, of loss, of loneliness, of fear. Whatever we may say about laundromats, whatever goodness they may give, every single one I've ever known is an oasis of despair.

My experience with laundromats may vary from the experience of others to the degree that laundromats themselves vary, but I can't think of anyone I know who hasn't complained of their loathing for the places. Nor am I the only one to consider the power of the laundromat to crush the optimism of those who use them. Sam McPheeters, for instance, writing for *VICE* magazine, speaks of the dread that lurks in the pride he takes from his personal washer and dryer, that in the collapse of one or the other he'll be forced out to a laundromat.[4]

"Why are laundromats so brutally goddamned depressing?" he asks. "I use lots of other quasi-civic services—vets, car washes, supermarkets—but none inspire the loathing (inwards and outwards) as the mats of laundering. I dread the places. So do all my pals."

In one laundromat, McPheeters says, a bum stole his clothes after assuring him they'd be safe while he browsed in a nearby record store. (Had McPheeters seen Marla Singer, played by Helena Bonham Carter in *Fight Club*, snatch the clothes from a public dryer to sell to the thrift store across the street, he might not have been so trusting.) A vent in the ceiling of another laundromat had so much "hairy shmutz" growing from it that McPheeters couldn't keep from thinking it a "finger of filth" pointing at his soul. And where the attendant of a laundromat in Rhode Island once yanked McPheeters's "unmentionables" from a washer and scolded him for using too much detergent, another gave McPheeters a public dressing down because he'd changed bills for coins he didn't intend to use for washing clothes. In the end, McPheeters considers, laundromats "invite dark times." They're less centers of refreshment, he says, than nodes for grotesque biological exchanges. Like everyone who uses the laundromat, he taints the laundry of others with "bits of [his] own dander and DNA," while his laundry is soiled in exchange with Band-Aids and hair.

The local color piece about laundromats from which I gleaned my epigraph doesn't explicitly mention these aspects of the laundromat, but they slither nevertheless beneath its every word. An argument between a couple that started over how best to fold towels descended into questions of "hygiene." A retired subway worker is so lonesome he actually goes to the laundromat each day to make small talk with customers when he's not scribbling notes for his apocalyptic novel. A homeless woman regularly uses the place's pay phone to complain to the city about tenants in the properties she claims to own. She's "an upper-class person," she says, guised as a vagrant to hide her true identity: niece of Mayor Bloomberg, wife of Donald Trump. The piece also mentions the attendant's trouble with addicts trying to dope up in the toilet during graveyard shifts. It notes hustlers, too, selling bootleg DVDs, and pock-faced men ensorcelled by talk shows, and anorexic women studying to become guards, and, just once, near the end, the "smelly clothes" that are part and parcel of the joint's "soap, chatter, life."

For the people well-off enough never to have had to wash their laundry with the hoi polloi, an article about "smelly clothes, soap, chatter, life" is probably sufficient to the experience. But anyone who's spent real time in a laundromat knows the two are worlds apart. To say that a pile of rancid clothes is merely "smelly" is about as ridiculous as calling the county dump a "landfill."

This is the reality of the laundromat, or at least it was for me, many times, back in the day: You stuff your clothes in the washer with the grimace of a man dragging corpses from a field. Your socks look like foreign cheese and stink like dirty socks. Your skivvies are past description, piss-stained, skid-marked, one pair crusty with the jizz you didn't clean after you and your girl fucked in the stall of the women's room at the drive-in a few weeks back. A shirt's got both your blood and the blood of the guy you fought outside a warehouse party, and another shirt blood from the bloody nose that macked you at the end of a night snorting blow. There's all of the regular stains, too, on your shirts and pants—olive oil, coffee, spaghetti sauce, grass, cranberry juice, whiskey, house paint, dog shit, mustard, and the rest, plus the hair you've shed and the nail clippings one of your fellow scumbags stuck unbeknownst to you in the pocket of your shirt—real fucking funny, ha ha—and crumbs from a cinnamon roll, and the rubbery dust you swept off your paper erasing the bad lyrics you'd written for that new song, and, for Christ's sake, too, the blood on a sheet from the night your girl's period hit her in her sleep. You're so deep in the well of your disgust and shame that you hadn't noticed the woman who's arrived to remove her load from the washer beside you, a college kid, by all appearances, sort of pretty in that clichéd sexy-librarian way.

But now that you see her, all you can do is wonder with terror at how much of your life she's made from the cavalcade of excrement she's just seen. And O yeah. Here's the slimy mix of liquid and powder detergent and fabric softener and bleach on the top of each washer, where you deposit the stuff in receptacles covered with numbered rubber tops, yet another part of this whole thing that you despise, since you forget about the last time you ran your hand through the slop until you run your hand through it now, and since half the time or more you forget what it is you've just run your hand through till you see the bleach stain where you wiped it on your jeans.

None of this is to mention, either, the litany of minor atrocities I've been witness to at laundromats. The people who don't go to laundromats don't go for very good reasons. In the same way so many of us want to live the romantic life of the criminal without committing the criminal's crimes, we don't really want to know the soap's not so clean, the chatter not trivial, the life not free. We don't really want to see the sort of drug deals I've seen go down in laundromats. We don't really want to see the abuse I've seen, like the time I watched a woman take the slipper from her foot and crack its heel on the head of the boy beside her. We don't really want to see the men and women I've seen fight other men and women, or the children I've seen ridiculed and shamed and thumped and shoved, or the wallets and purses I've seen stolen, or the vandalism I've seen done. And while the attendant in the *Times* piece tells the writer about the remote controls left behind by customers, together with such items as iPods and crayons and keys, we don't hear about the things people like McPheeters and I have found, and certainly nothing about the pile of human shit waiting for me that day, in the dryer I was about to stuff full of clothes.

And anyway, even if the attendant had told the writer such a tale, it probably wouldn't have been written. To hear that the place we go to clean our clothes might also be the site of an ambush by a turd is past all reckoning. That's not funny. That's no joke. It's transgression of the most despicable sort. But whether the joker knew fully the dimensions of his act is beside the point. The act was a much closer reflection of the truth than seems possible at first glance.

The Toilet's Prettier Sister

Throughout the Middle Ages and well into the Renaissance, European cities were cities of waste. Paris, for instance, was so "filthy and glutted with mud, animal excrement, rubble and other offals … and unspeakable wastes" that people couldn't "journey through it either by carriage or on horseback without meeting with great peril and inconvenience."[5] The city's denizens didn't merely piss and shit and vomit in the streets right outside their doors. They also kept and bred "swine, sows, goslings, pigeons, and rabbits," among beasts of every other sort (all with their own bodily functions and needs), and butchered them wherever they would. The aforementioned entrails and offals were left behind not for hauling away by the municipal sanitation department—cities back then had no such thing—but simply to rot.

If the sight of this "ruin and destruction" provoked "great horror and greater displeasure in all valiant persons of substance,"[6] the stench that emanated from the waste was more unspeakable yet. The city had deteriorated into a state of such putrefaction that by November of 1539, François I, "King of France by the Grace of God," had become so repulsed as to sign into being the Royal Edict of Villers-Cotterêts, a law whose affect by any standard was truly formidable in breadth and scope. Article 4 forbade "all emptying or tossing out into the streets and squares of the aforementioned city and its surroundings of refuse, offals, or putrefactions, as well as all waters whatever their nature, and [commanded all citizens] to delay and retain any and all stagnant and sullied waters and urines inside the confines of [their] homes [until such time as they could] empty them into the stream and give them chase with a bucketful of clean water to hasten their course." Article 21 "enjoin[ed] all proprietors of houses, inns, and residences not equipped with cesspools to install these immediately If the lords and proprietors [had] not met the demands of the injunction, their houses [would] be handed over to us as confiscated property that [would] pertain to us, without exception and with no need of additional warning." And Article 28 also forbade "all butchers, meat vendors, meat roasters, small retailers as well as vendors of fowl and poultry, tavern keepers, laborers, artisans, and all manner of other persons whatever their state of condition from keeping in any area of our city or its surroundings, or having some other person keep or breed [the aforementioned

beasts] whether these be for sale, for nourishment, for the sustenance of households, or for any other pretext, rhyme, or reason." Finally, failure to obey any part of the edict was to risk not only the confiscation of property and chattel, but "suffering corporal punishment as well."[7]

In short, signed by "the King, Bayard, and sealed with the great green wax seal and silk ribbon," the Edict of Villers-Cotterêts was the first of its kind, decreeing as it did the privatization of waste and thereby setting in motion a truly staggering set of social, cultural, and environmental implications.[8] From then on, like Paris, the cities of Europe (and America, too) would steadily undergo a radical transformation. The butchering of animals and the waste thereof; the preparing of meals made from these animals and the waste thereof; and the digesting of the meals made from these animals, and the waste thereof—every activity and mode pertaining to the cyclical functions of digestion, defecation, urination, and regurgitation went from public to private, visible to invisible, seen to unseen, odorous and odious to odorless and empty.

Over the next five hundred years, the body and its functions, effectively outlawed, were to become increasingly secret and hence forbiddingly shameful. It wasn't, however, just defecation, urination, regurgitation, and the byproducts thereof that had been stigmatized. Exiled from public as well were the acts of bathing our bodies and cleaning the clothes with which we covered and protected them, together with their own specific byproducts, the "waters whatever their nature" censured in the Edict of Villers-Cotterêts.

By the twentieth century, François's drive toward the achievement of cleanliness, order, and beauty, which Freud said were traits indispensable to any civilization, had been effectively attained throughout Europe and America. The Industrial Revolution, while engendering its own set of dilemmas, had born advancements in engineering that included the electrical and plumbing systems that underlie the infrastructure of any major city. Prior to this, of course, we'd been able to perform our ablutions in private, but we still had to dispose of their products. And if we ourselves didn't get rid of those products, someone else did. With general access to toilets, washing machines, and sinks, however, and with the plumbing and sewage systems that connected these to rivers, lakes, and oceans, the only trace that remained of activity and product were the amenities through which we discharged them. The ideal of safety and convenience that François had envisioned for "all valiant persons of substance" no longer included merely the private and public spheres. The psychic sphere had now been made safe and convenient, too.

We all understand and accept that the toilet is the vehicle through which we discharge and dispose of the bodily wastes *we can control*. What hasn't been so clear, though, is the washing machine's status as the toilet's prettier sister. The washing machine, in other words, is the vehicle through which we discharge and dispose of the bodily wastes over which *our control is little to none*. Herein lies one source of the repugnance the laundromat inspires, and the swirl of queasy anxiety we feel inside it. The laundromat is the place we go to *publicly and communally* discharge the waste we're helpless to discharge in private.

The rise in the mid-nineteenth century of the Chinese laundry can be attributed, at least in part, to our dread before this prospect. Those who couldn't wash their clothes in private paid the only people who'd do it for next to nothing, who themselves labored inside compounds inside the hermetic communities to which they'd been banished. The introduction of the electric washing machine to the public sometime in 1904[9] affected the Chinese monopoly on the laundry market, though not so much that NYC couldn't keep busy the estimated 3,550 Chinese laundries still in business when the Great Depression hit.[10] J.F. Cantrell of Fort Worth, Texas, opened the first public, self-serve laundry facility in 1934, what he called a "washeteria,"[11] and in 1937 the Bendix Corporation invented the automatic washing machine that was basically the model for the washers we see in laundromats today.[12] But it wasn't until the postwar years of the 1950s, when business could return its full attention to the consumer, that the laundromat achieved its real prominence, and all those centuries of trying to kid ourselves that the emperor was wearing clothes dissolved into meaninglessness as surely as our filth dissolves in our washers' suds.

McPheeters was much closer to the truth than I imagine he knew when he spoke of the laundromat as a place not just of biological exchange, but of *shame*. Yet just

as this shame is but one facet of the complex emotions provoked by the laundromat, so too is the cognitive dissonance born from the union of our shame with *necessity*. Our feelings about using the laundromat don't matter one iota. We've still got to step inside, fully aware that once there—shoulder to shoulder with the filth of our bodies and lives, exposed just as surely as if we'd pulled down our pants in a public square— what we'd never reveal to our closest confidant, much less speak of, is plain to see for anyone who cares to look.

For half a millennium we've done everything we can to hide the evidence of our animal truth, of the fallibility of our bodies, of the law of flux (seen in the matter our bodies excrete and discharge, which, before the matter was discharged, was as much a part of our bodies as anything else that makes them), and hence the evidence of our *mortality*. The unpleasant sights and sounds of the laundromat, together with its disgusting smells, aren't the source of our unease, but merely symbols of that source, which is the fear of and refusal to accept the things that give life so much meaning: disintegration, decomposition, death.[13]

E Pluribus Unum

Sturluson's 187 photographs capture the laundromat's reality and essence in ways rarely seen. This is in itself a feat, because his technique, that of typology, is a proven one, perfected throughout the '60s and '70s by the husband/wife photography team of Bernd and Hilla Becher and since then variously elaborated on in the work of many, including Hans-Peter Feldmann (*12 Bilder, 11 Bilder, 9 Bilder*), Ed Ruscha (*Twentysix Gasoline Stations, Nine Swimming Pools and a Broken Glass*), Thomas Struth (*Strangers and Friends, Portraits*), Candida Höfer (*Libraries, Zoologische Gärten*), Thomas Ruff (*Portraits, Nudes*), and, most uniquely (and famously[14]), Andreas Gursky (*Andreas Gursky*).[15]

By choosing subjects that are social rather than natural, states Becherian law, employing a rigidly uniform style, and juxtaposing large numbers of photographs of individual examples of the same subject type, the photographer, if lucky, might on the one hand be able to "reveal the unvarying functional form of which each example [is] a unique variant,"[16] and, on the other, "represent the generic identity of the subject through the range of its particular incarnations."[17] If the photographer is also extremely talented, he might hope as well to achieve a typology that, as Peter Galassi said when contextualizing Gursky's work in the first detailed study of it, "is both a Platonic abstraction of stunning simplicity and an absorbing encyclopedia of Aristotelian fact."[18]

An initial flip through the opening photographs in Sturluson's typology won't likely call to mind philosophical hierophants. What the images almost certainly will do, however, is remind us of the Bechers *et al* and incline us to think they adhere strictly to Becherian code. Yet the images are deceptive, and this deception is a boon.

It's not just Sturluson's technique that's clever and tricky, but the ordering of his pictures. In addition to shooting most of the laundromats head on, thereby endowing them with an ostensibly "static" two-dimensionality, he's arranged them categorically, by location first and color second. The effects are as tensional as diverse. Page by page we move through the shots, lulled by the repetition of composition, color, and place into the same feeling of lethargic powerlessness that, ironically, we often feel in the laundromat itself. Through a cloudy window or open door we're here and there allowed a peek into the laundromat's interior, but never are we allowed to enter. Instead, like many of the bystanders in these pictures, we only pass by the laundromat or loiter aimlessly before it. This sense of claustrophobic subjection is further intensified by Sturluson's insistent refusal to grant much perspective of the world around the laundromat. We're scarcely permitted the occasional slice of building adjacent to it, much less a greater view of the structure that houses the laundromat or the street it faces or adjoins. There's only the laundromat's exterior, by turns forbiddingly glum or grim.

Sturluson's refusal to allow us into the laundromat no doubt obstructs our ability to experience its complex reality. Chained to our place on the street, so to speak, we can only imagine what's inside. We know there's something happening, we know there's a world in there, filled with stories, however exciting or mundane, but their precise nature is never unveiled. It's as though we're seeing some activity rendered dim by the mists before it. While the open doors and windows grant us just enough detail to gain our attention and stir our thoughts, what we see is never

more than hints—a man in a wifebeater by a table; a shadowy woman behind a cart; a person's back; a man or woman slumped in a chair, despondent if not asleep; some lady scratching a lotto ticket; another woman staring into her gizmo; a man with a mop. In the end these bits are a travesty of the fruit above Tantalus. Hungry, but not for rot and mold, and thirsty, but not for the muck in a pond, we stretch disinterestedly out, hopeful, not desperate, intrigued, not transfixed.

For those of us like myself, whose experience with the laundromat is rich, these tidbits are just enough to raise some ghosts. We don't want to return if we don't have to, but, like old men groping through shoe boxes full of pictures in search of the life they want to believe they lived, we step back, only to realize that these images will never grant the gifts we seek. For those of us who haven't been inside a laundromat, or whose experience is thin, limited, say, to a few minutes spent on occasion delivering and retrieving a bundle of clothes, the conceptions inspired by these traces and hints are probably fueled by someone else's conceptions as fed to us through the images presented in television and film, resulting in a notion of the laundromat as something it isn't and couldn't be, false, if appealingly mythical.

At the same time, these façades, seen again and again as the pages turn, merge into a single impenetrable barrier. *Beware ye who enter here*, the laundromat seems to say. *Enter ye here at your own risk.* It's as though Sturluson, knowing full well the misery and woe the laundromat holds, wants to spare us that experience. The storefront's enough, his work seems to say, the cloudy window's enough, the shadow in the door enough. Because truly the laundromat's a limbo in which, once you're trapped, time stands still, and your life transforms into a maze of endless pointless circles, reflected, as in a house of mirrors, by the machines spinning round and round wherever you turn, the laundry inside the machines, tumbling and whirring and droning and tumbling, a sort of sonic trope for death, for the endless falling apart and flux to which the filth of our laundry attests, while everyone else just outside the door moves purposefully through their lives, though you can't remember how they do, you can't remember how you did, either, it's as though your memory of the world and your part in it were just a measly dream.

Sturluson's typology does all these things, and though that would be quite enough, amazingly it does more. We aren't looking at the laundromat itself, remember, only at the laundromat's façade. After a time, we find ourselves stopping to ask how it is that these pictures conjure all they do. How much can we get from picture after picture of windows and signs—*Laundromat, Laundromat, Laundromat . . .*?

As Galassi suggests in telling the story of Gursky's experience making his first mature work (*Klausenpass*), a first impression shows one thing, repeated study more: the unflinching gaze has power to penetrate mystery. *Klausenpass* depicts from a distance a promontory in the mountains of Switzerland, around whose base, like insects, we can see twelve tiny people. At the time Gursky took the shot, he claims to have been unaware of anything but the land. Not until he'd developed the film, he says, did he realize either the fortuitous confluence of events he'd captured or the technique that would come to define his unique typology. Galassi says:

He thus rediscovered one of the oldest, simplest, and most rewarding pleasures of photography—*the patient delectation of details too small, too incidental or too overwhelming in their inexhaustible specificity to have been noticed, let alone pondered, at the moment of exposure.* From the comfort of the armchair we enjoy the illusion of omniscience, *a power of analysis and reflection unavailable to any actual participant*: the world can seem richer and more generous in disclosing its meanings when we are freed from its pressing fullness to contemplate its fixed, flattened image on piece of paper [my emphasis].[19]

The hundreds of photographs that Sturluson gives us in *Laundromat* are rife with just these sorts of details. It's not only storefronts and signs we see, but the wealth of minutiae in, on, and around them. And it's in these details that the real stories hide, waiting to be plucked by the discerning eye, whose focus is oftentimes renewed, for

example, by the sudden appearance of a laundromat seen in profile. This, in part, is the function of Sturluson's periodic compositional splits. The spell of complacency by which we're taken after a time is broken by a jarring change of perspective. This new perspective, in turn, asks that we question the perspective we thought we had. *Maybe I should take another look*, we think. *Maybe there's something I missed.*

Inevitably this will be the case. The children in one photograph, for instance, bring to mind an earlier shot featuring a little boy in costume. And sure enough, going back, I see the boy isn't merely in costume, but in a *Batman* costume. The photo was made on Halloween, I suddenly realize, mid-autumn, a time of decline, a time of collapse and decay, the heart of the season in which transpire all the things the laundromat's the emblem of, our laundry, too, as it goes piece by piece into the washers, like the leaves fallen from the trees we can't see, swirling at the doorway of this doomed enterprise, in a country whose systems are themselves breaking and broken. Already the poignancy's too much, but when I look again and see that the sign in the window, handwritten, hanging immediately below a dirty American flag, says, *GOING OUT OF BUSINESS*, the sadness and pathos and irony of the image are brought to pitch against the child's fevered joy, and I'm engulfed. This same kid, I think, or maybe his toddler brother or sister, could be inside the place at this very instant, getting stuffed into a washing machine, like the toddler in the surveillance video I watched on YouTube, whose parents stuffed him into a washing machine and turned it on and laughed. The toddler wasn't just in the laundromat. *He was in the machine*, getting tossed round and round and round, a moment that would doubtless define his life, if not merely haunt it for years to come. But the kid in this picture is not inside the machine inside the laundromat getting tossed round and round and round. He's out here on the street, a superhero running with a smile on his face.

In another photograph we see a man clearly broken, hoary and hunched before the walker to which he's tied his plastic bag. The image would be painful enough, and tell a story that needs no embellishment, and yet, as if part of some cosmic hoax, the name of the laundromat, written on the window and the marquee above the man, is *All Washed Up*.

And many of these photographs include symbols of things in direct opposition to what the laundromats themselves represent—parking meters, telephone poles, el train pillars, and bus stop signs: all these point to the future, to the people we might talk to and the places we might go, opportunities and destinations whose possibilities disintegrate the moment we step into the vortex that is the laundromat.

Neither can we ignore the absurd promises implicit in so many of these pictures. What are we to make of the palm trees, bubbles, and waves on the sea with which it seems the proprietors of these wretched places are striving to ward off disaster, as they would with ancient idols? What are we to make of the words on their signs like "Hollywood," "happiness," and "luck"? Surely these people can see the thousands of patches of gum stuck to the sidewalks before their ventures, naysaying with such mute power whatever puny efforts they might make. Black wads of gum, hundreds and sometimes thousands before each door, say, *You don't watch out, pal, you'll be stuck here forever.*

But the best detail of all, I think, is the one we're prone to notice last. It's Sturluson himself, indelibly merged into so many of these images, ghostly, almost invisible, like the people we never see in the laundromats we never use. Hovering faintly in the mirrors the storefronts have become, Sturluson gazes back at us, sometimes through the camera, sometimes beside it, a picture of Plato and Aristotle both, really, there to remind us that "far from rising above the muck . . . we are thoroughly mired in it, particularly when we appear our most clean and hygienic."[20] We may not use the laundromat, Sturluson says from within his pictures, but we're as much a part of it as those who do.

D. Foy

Notes

1 N. R. Kleinfield, "24 Hour Cycle." *The New York Times*, January 15, 2010, http://www.nytimes.com/2010/01/17/nyregion/17laundry.html?pagewanted=all.

2 "Laundromat" is a moniker developed, like "Kleenex" for "tissue" or "Xerox" for "copiers," from the name given to Westinghouse's washing machines by the PR man George Edward Pendray. The Laundromat logo and trademark was filed on July 20, 1966, and was first used in commerce on October 26, 1940. The term is service-marked and therefore generally capitalized. I've always considered it a common noun (i.e., "washroom," "laundrettes," and "laundry facility"), however, so I spell it without capitalization throughout.

3 I never liked calling San Francisco "The City," not even after I'd lived there for years.

4 Sam McPheeters, "The Brutality Report: Laundromats," *VICE* (blog), December 27, 2011, http://www.vice.com/read/brutality-report-laundromats.

5 Dominique Laporte, *History of Shit*, (Cambridge: MIT Press, 2002), 4–5.

"Varron,"† says Laporte, "in book II of *de Analogia* [suggests that] the word latrine is said to derive from the word laver [to wash] (*Ex quo apparet latrinam a lavando dictum esse*)."
And according to the *Online Etymology Dictionary*, it is: "latrine: c.1300, probably from L. *latrina*, contraction of *lavatrina* 'washbasin, washroom,' from *lavatus*, pp. of lavare 'to wash' (see lave) + -*trina*, suffix denoting 'workplace.'"

Laporte's study is really quite amazing. Here's part of its description from the MIT Press website: "Debunking all humanist mythology about the grandeur of civilization, *History of Shit* suggests instead that the management of human waste is crucial to our identities as modern individuals—including the organization of the city, the rise of the nation-state, the development of capitalism, and the mandate for clean and proper language."

†: This is Marcus Terentius Varro, and the book is *De Lingua Latina; Analogia*, 1470.

6 Dominique Laporte, *History of Shit*, (Cambridge: MIT Press, 2002), 5.

7 Ibid., 4–8.

8 Rodolphe el-Khoury, introduction to *History of Shit*, x.

9 "Electric Washing Machine the Latest. Housewives can do Washing in one-third the Time," *Des Moines Daily Capitol*, November 12, 1904.

10 Judy Yung Chang, Gordon H. Lai, and Mark Lai Him, eds., *Chinese American Voices: From the Gold Rush to the Present* (Berkeley: University of California Press, 2006), 183.

11 Joseph Nathan Kane, Stephen Anzovin, and Janet Podell, *Famous Firsts: A Record of First Happenings, Discoveries, and Inventions in American History* (New York/Dublin: The H.W Wilson Company, 1997), 127.

The history behind the first laundromat is murky at best. Online research will obtain at least four names associated with the opening of the first "washeteria":† J.F. Cantrell (Routers and CNN concur with Kane, Anzovin, and Podell), C.A. Tannahill, Noah Brannen, and Andrew Clein.

A January 1936 article in *Modern Mechanix* ("World's First Washeteria Opened") says, "A new idea promptly put to work has resulted in a fast growing business for Mr. C. A. Tannahill of Fort Worth, Texas. He decided women who did not have room for a modern laundry in their home would be glad to pay to do their own washing in a place that did. He established the world's first washeteria, and found he was right."

Brannen's name came up only once during my research, on the *Wikipedia* page, "Self-service laundry," the citation for which lists a family geneology, "*Brannen History 'Genealogy'* by Noah Quinton Brannen." The geneology itself, however, doesn't appear to be accessible online via standard means.

Clein's name, too, came up just once during my research, also on a *Wikipedia* page, "Washing machine." The attribution is strange. After stating that "The first laundromat opened in Fort Worth, Texas in 1934," with a footnote citing *Encyclopedia of Modern Everyday Inventions* as its source, the following sentence states, without any further mention, "It was run by Andrew Clein." The page has been revised over 500 times by nearly 1,100 users, but no one has disputed this attribution, much less investigated it.

And where both Cantrell and Tannahill are credited with opening the washateria on April 18, 1934, the *Wikipedia* page (and ostensibly the Brannen genealogy, too) lists the date as simply "1936."

Curiously, all four attributions agree that the first washeteria was opened in Forth Worth, Texas.

†: The *Oxford English Dictionary* lists the word's spelling as washeteria with washateria as an alternative; conversely, *Random House Unabridged Dictionary* lists the spelling as washateria with washeteria as the alternative.

12 An advertisement in the *Saturday Evening Post*, October 30, 1937, flogs a washing machine from Bendix. In another print ad from 1940, we learn: "Introduced in October, 1937, at a price more than twice that of the average conventional type washer, the Bendix, in less than three years, stands first among all washing machines in consumer experience." The models for sale in this ad were priced from $114.50. (For sale on Amazon.com [http://www.amazon.com/Bendix-Automatic-Washing-Machine-Laundry/dp/B005DGO5HA], the ad doesn't identify the paper that carried it.)

13 "Death," said Wallace Stevens, "is the mother of beauty."

14 One of Gursky's photos of the Rhine River, *Rhine II* (1999), sold for $4,338,500 at Christie's (New York) on November 8, 2011. It's the costliest photograph to date. (Christie's page for Sale 2480, Lot 44, accessed September 4, 2012, http://www.christies.com/LotFinder/lot_details.aspx?intObjectID=5496716). In February 2007, Gursky's 2001 photo, *99 Cent II Diptychon*, sold for $3,346,456. A second print of the same had already sold for $2.48 million in November 2006, and, prior to that, a third for $2.25 million. (David Schonauer, "The First $3M Photograph." *American Photo*, March 7, 2007, http://web.archive.org/web/20070318090710/http://www.popphoto.com/photographynewswire/3911/the-first-3m-photograph.html.)

15 With the exception of Feldmann and Ruscha, all of the artists listed here were students of the Bechers at the Kunstakadamie in Düsseldorf, Germany.

16 Peter Galassi, "Gursky's World," in *Andreas Gursky* (New York: The Museum of Modern Art, 2001), 11.

17 Ibid., 16.

18 Ibid., 11.

19 Ibid., 23.

20 Promotional copy for *History of Shit*, MIT Press website, http://mitpress.mit.edu/catalog/item/default.asp?ttype=2&tid=3835.

THANK YOU

Alex Martin

Alexis Ross

Björn Baldvinsson

Casey Zoltan

Craig Cohen

D. Foy

Daniel Power

Dave Shelley

David Byrne

David Mullett

Daymond John

Einar Pétur Heiðarsson

Eric Troop

Eva María

Friðrik Weisshappel

Greg Ames

Jeanine Durning

Keith Wager

Known Gallery

Krzysztof Poluchowicz

Leslie Dixon Jr.

Lily Baldwin

Lydia Holt

Martin Parr

Meghan Hickey

Melida Prado

Michael Hermann

Nina Ventura

Patrik Andersson

powerHouse

Spessi

Thomas Ahern

Tim Barber

Tómas Sturluson

Wendy Herlich

Will Luckman

LAUNDROMAT

Published in the United States by powerHouse Books,
a division of powerHouse Cultural Entertainment, Inc.

37 Main Street, Brooklyn, NY 11201-1021
telephone 212.604.9074, fax 212.366.5247
e-mail: info@powerhousebooks.com
website: www.powerhousebooks.com
snorribros.com

First edition, 2013

Library of Congress Control Number: 2012952687

ISBN 978-1-57687-623-7

Book design by Krzysztof Poluchowicz

10 9 8 7 6 5 4 3 2 1

Printing and binding by Pimlico Book International, Hong Kong